Art and War

Art and...

Contemporary art can be difficult. Reading about it doesn't need to be. Books in the *Art and...* series do two things.

Firstly, they connect art back to the real stuff of life – from those perennial issues like sex and death that trouble generation after generation to those that concern today's world: the proliferation of obscene imagery in the digital age; our daily bombardment by advertising; dubious and disturbing scientific advances.

Secondly, *Art and...* provides accessible theme-based surveys which energetically explore the best of contemporary art. *Art and...* avoids rarefied discourse. In its place, it offers intelligent overviews of art - and the subjects of art - that really matter.

Forthcoming:
Art and Death *Chris Townsend*
Art and Sex *Gray Watson*

Art and War

Laura Brandon

I.B. TAURIS

LONDON · NEW YORK

Published in 2007 by I.B.Tauris & Co Ltd
6 Salem Road, London W2 4BU
175 Fifth Avenue, New York NY 10010
www.ibtauris.com

In the United States of America and in Canada distributed by
Palgrave Macmillan, a division of St Martin's Press
175 Fifth Avenue, New York NY 10010

PB ISBN 978 1 84511 237 0
HB ISBN 978 1 84511 236 3

A full CIP record for this book is available from the British Library
A full CIP record for this book is available from the Library of Congress

Library of Congress catalog card: available

Typeset in Agfa Rotis by Steve Tribe, Andover
Printed and bound in Great Britain by TJ International, Padstow

Contents

Illustrations

Abbreviations

AFS	Auxiliary Fire Service
ATS	Auxiliary Territorial Service
AWAC	Airborne Warning and Control
CAFCAP	Canadian Armed Forces Civilian Artist Program
CNN	Cable Network News
CND	Campaign for Nuclear Disarmament
CWM	Canadian War Museum
DND	Department of National Defence (Canada)
IRA	Irish Republican Army
IWM	Imperial War Museum
MX	Missile Experimental
NATO	North Atlantic Treaty Organization
NGC	National Gallery of Canada
RAF	Royal Air Force
RCAF	Royal Canadian Air Force
RSPCA	Royal Society for the Prevention of Cruelty to Animals
SSSI	Site of Specific Scientific Interest
WAAC	War Artists Advisory Committee
WDAAC	War Department Art Advisory Committee
WPA	Works Progress Administration (US)
YBA	Young British Artists
YMCA	Young Men's Christian Association

Acknowledgements

This book inevitably has been informed by my employment at the Canadian War Museum in Ottawa, Canada, as its curator of war art, a position I have held since 1992. The connections I have made though my work have been immeasurably helpful in the preparation of this study, which, however, reflects my own opinions. As much as possible, I have seen the originals of the works discussed but in some cases this has not been possible and the image is analysed from illustration. In these cases, despite research, the owner of the composition has not always been identified, something I would like to rectify.

Many colleagues and friends have helped me. I would like to express my thanks to the former and present staff of the Imperial War Museum who have always supported my war art research including, in particular, Mike Moodie, Roger Tolson, Angela Weight, and Jenny Wood. Thanks are also due to Lola Wilkins and her team at the Australian War Memorial. Readers familiar with our joint publication *Shared Experience, Art and War: Australia, Britain & Canada in the Second World War* (2005) will recognize the source of some of the material in Chapter 5, which is used with permission.

I would also like to express my appreciation to my colleagues at the Canadian War Museum and especially to Catherine Woodcock of the museum's military research centre. Thanks are also extended to the very helpful library staff of the Museum of Modern Art in New York, especially Jenny Tobias.

I acknowledge gratefully those colleagues and artists who helped me find missing pieces of essential information. For meticulous editing, thanks are due to John Parry and to Susan Lawson, to whom appreciation is also extended for keeping me focused on the task at hand, and Steve Tribe. The bibliography and index are the painstaking results of Ellen McLeod's dedication. The Beaverbrook Canadian Foundation provided

generous and very welcome financial support for John and Ellen's efforts and for the illustrations. As a Canadian art historian specializing in war art, I owe the foundation a great deal.

I would also be remiss if I did not acknowledge the researcher's dream source for useful information such as artists' dates – the Internet. Books like this are assisted by this electronic tool.

Appreciation for their continued tolerance and support is offered to my long-suffering family. The book is dedicated to the memory of my father, imperial historian Gerald S. Graham, who has influenced me in more ways than he ever anticipated.

Introduction

When the war in Iraq began in 2003, many observers believed that the conflict would be so different and so distant from their everyday reality that it would ultimately bear comparison only with the visual language of the more space-age and militaristic cartoons and comic strips. The art historian Robert Storr evoked this view in his introduction to the catalogue (September 2003) for an exhibition of Nancy Spero's Vietnam War series.[1] Citing a special edition of *Popular Science* on the twenty-first-century soldier, he describes 'laser equipped space stations knocking out missiles in the upper atmosphere ... robotic figures in Spandex-like uniforms', with 'no bloodletting' and 'no cries.'[2] This war has, in contrast, been mercilessly bloody, violent, emotionally destructive and, sadly, compelling; a spectacle like no other.

We could glimpse the true reality of the Iraq war in the burnt and abused bodies of the four US security guards killed on 31 March 2004. Dragged through the streets of Falluja, their blackened remains were hung on a bridge over the Euphrates. Participants took photos that many newspapers around the world printed the next day. This showing-off reflected an age-old tradition of battle – one that most people had hoped was a thing of the past.

Storr suggests that Spero's work provided 'a very different picture' of war to that which he had anticipated in 2002 but her war art, like the Spaniard Francisco de Goya's, was in fact timeless in its ferocious personal response and in its depiction of brutality. Spero may not have seen the Southeast Asian conflict in person, but television had taken the war into living rooms in most countries and she saw it there and in newspapers. In the Iraq war, it was the coalition's awareness of the media's power to inform opinion that gave them so much control of the presentation of the war at the start. Now, the Internet continues to subvert this hegemony as the American-led coalition struggles to contain continuing and ever-visible post-war chaos and violence.

This Introduction looks at four interconnected issues – how to define war art; whether it constitutes a genre; whether it must be propaganda; and how broad it is, especially today. The last section looks at the organization of this book.

What Is War Art?

Out of curiosity, as I began writing this book, I looked for 'War Art' in my 1986 edition of *The Oxford Companion to Art*. There was no such entry. Instead, I found the subject under 'Battle-Piece'. I next turned to the Internet: the thousands of listings I found there suggest that 'war art' is now a common term. Undoubtedly, this newfound identity is one reason for this book's existence. It is the first to look at the topic internationally through time as more than battle pictures, an aspect of national history, or military illustration.

Yet the field of war art is immense and worldwide, somewhat akin to religion in the way war inspires people to create in order to understand. Countries foster war art in the interests of nation building, and it exists in all societies and cultures. This volume cannot hope to address such a vast subject in its totality. Consequently, I have limited it primarily to the art of the West, particularly the USA and the UK, and it is by no means a compendium. It emphasizes modern and contemporary art. The history of war art, however, is not purely British and American, so I bring in the significant role of artists from other western countries. We cannot, for example, discuss twentieth-century war art and ignore the Spaniard Pablo Picasso's *Guernica* of 1937, perhaps the century's most powerful anti-war statement.

While this book is not encyclopaedic, it does attempt to broaden the field beyond its association with high art and to counter certain prevalent assumptions about war art. While it looks at war art for what it is, it also notes the social, intellectual, cultural, political, and psychological contexts out of which it emerges. It also shows how the technology of war has permeated the history of war art as a whole – futurism, for example – and how war art has used technology – in more recent times, the electronic kind – to further its own specific messages. More important, perhaps, it concludes that the First World War, as the first massive conflict to affect the lives of millions for generations, transformed the history of war art. Regardless of developments in approach, the impetus for artists of all stripes and working in all media to express their support for or anger at war expanded exponentially in the four years between August 1914 and November 1918.

The *Oxford Companion*'s entry on battle pieces surveys the powerful first-century BC Assyrian stone reliefs; discusses the beautiful, but often horrific, seventeenth-century prints of Jacques Callot, the so-called *Miseries and Misfortunes of War*; and concludes with the British official art programme of the Second World War. The focus of all the art discussed is battle, and the battles of the past 3,000 years dictate the chronology.

The Internet's wider view includes commercial military paintings, anti-war art, cartoons, and posters alongside compositions that respond to battle. This approach reflects the current worldwide immersion in wars everywhere expressed in the recent work of British artists Jake and Dinos Chapman. In 2000, they reinterpreted Goya's etching series, *The Disasters of War* (1808–1813), by marrying its visual record of past military horrors with today's experiences of genocide, ethnic conflict, civil war, and massacre. The twentieth century was the bloodiest in history, and the twenty-first, as the Chapmans' work implies, gives no sign that the bloodletting will end.

The close relationship between the words 'war' and 'art' is not new, even if their use together is recent. In 1919, many of Canada's official war paintings of the Great War conflagration then just ended appeared in a rather magnificent volume entitled *Art and War*. The essay there by the London *Observer*'s art critic, Paul Konody, is similar in approach to the *Oxford Companion*'s entry on battle pictures; it too begins with Assyrian sculptural reliefs, and it concludes only twenty-five years earlier than the *Oxford Companion* piece, with Canada's official art of the Great War – the first such programme of its kind ever.

While art and war have a long history together – even if 'war art' is a recent coinage – this book aims to bridge the gap between the two endeavours. While war art rightfully includes paintings about battle, it is more importantly about how war and art relate. These connections take many forms, over and above the subject of battle. Nonetheless, for simplicity's sake, this book conflates the two words. 'War art' means art shaped by war. Within this model, as this study shows, war inspires permanent and impermanent art that may be propaganda, memorial, protest, and/or record.

As is abundantly clear, the evidence for war art's existence lies in the paintings, drawings, and sculptures about brutal conflict that date from the beginning of civilization to the present day. In this book, I assume that what survives has been part of a selective process, which has allowed some works to be saved and others to be lost by chance and destruction, although there also may be 'forgotten' compositions. Interference and choice may of course have played a role. This book is unusual, however, in exploring the visual evidence of war more widely. It highlights some of the superb photographs of battle such as the Mathew Brady American Civil War depictions and examines several of the massive war memorials of the twentieth century such as the British First World War monument at Thiepval, France, challenging preconceptions about war art. It also recognizes that war art consists not just of masterpieces by well-known artists but may include, for example, an anonymous poster by an anti-war protester.

The chronological span of war art is enormous. War is part of the human condition, and as long as humans have created works of art they have depicted this aspect of their lives and deaths. Some of the greatest masterpieces have emerged from some of the most brutal events in history. Goya's etchings, *The Disasters of War*, capture the almost-unspeakable violence meted out on soldier and civilian alike in the Peninsula War. The

1. Paul Seawright,
*Valley: from Hidden
Afghanistan* (2002).

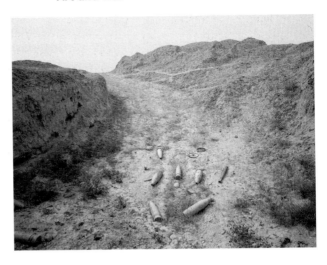

German Otto Dix's extraordinary denunciation of war, *Flanders*, painted in 1934–1936, epitomizes the horror that was the First World War. The brutal imagery of American Leon Golub's late 1960s' paintings on the Vietnam War pits technology against the nightmarish human suffering it causes. In contrast, the lyrically beautiful photographs of British artist Paul Seawright only gradually reveal the terrible beauty of war in the recently battle-ravaged landscapes of Afghanistan.

Is War Art a Genre?

It is extremely difficult to define war art clearly in purely art-historical terms. It does not readily fit within familiar art-historical constraints and parameters, those categorizations of style, development, and label – genres – that have straitjacketed all art since the mid eighteenth century and given us our view of the modern canon. While changes in artistic practice play a role, war art, more than any other subject of art, is hostage to events that do not relate to changes in materials, the move of an influential artist from one locale to another, and influential styles.

The shock and awe of brutal conflict itself can engender change in artists and patrons seeking a creative language to express the immensity of the experience. The British First World War painter Percy Wyndham Lewis, for example, created two very different renditions of the same subject. Lewis was the central figure in the short-lived vorticist movement, whose artists, inspired by the pace of modern life, sought to marry the dynamic state of urban, industrial, and technological progress with cubist and futurist approaches to art. He received commissions from both the British and the Canadians, executing *A Canadian Gun Pit* (1918) for Canada[3] and, slightly later, completing a

similar, slightly smaller but more typically vorticist work, *A Battery Shelled* (1918–1919), for the British.[4] Both drew on a visit of December 1917 to Vimy Ridge in France, the site of a crucial Canadian victory the previous April. Lewis suggested that the Canadian commission demanded a representative work; it is certainly descriptive, like most of the large Canadian canvases. The other piece reduces soldiers to automatons in a scene of overall destruction – far more in keeping with British hopes for more avant-garde work. Soldiers may well have identified with the detailed gun pit in the Canadian piece, but the British work showed what war did to them. Nevertheless, this latter piece was viewed by some as an exploitative, dehumanizing, and even immoral approach to the subject of real courage in wartime.

War art does not really make up a traditional 'genre' of art history. It encompasses many other genres – associated in particular with painting – such as landscape, portraiture, scenes from daily life, and still life. History painting – the nineteenth century's highest academic category of painting – has also traditionally encompassed war art. So is it then some kind of super-genre? Even beyond genre, encompassing its many, very different and newer forms of creativity is also a challenge. Does it include ephemeral protest art against the war in Iraq on the Internet? Or Mrs Smith's handmade, quilted assembly of poppies, graves, and names from the First World War? Or the art-therapy paintings that a Second World War veteran completes in his nursing home?

A work of art, regardless of medium, that deals with war is undoubtedly war art. Nonetheless, art history's qualitative standpoints complicate even this conclusion. Looking at war art as just art is extremely limiting. A formal analysis that focuses on a piece's approach, subject, and meaning marginalizes the reasons for its existence and ignores the ways in which viewers receive it. Assuming that there is something that in some collective way is war art, a far more useful approach looks at the context of its creation and at the meanings that have become part of it. These angles encompass the input of both artist and viewer. However, the findings of any such study are, by definition, time-specific and subject to change.

Thus it is far easier to discuss the sort of art that war inspires than to fit it into a genre within the traditions of art history and artistic practice. Some art born of war is very good art and an indicator of an artist's achievement; some is mediocre and survives only because of its subject matter. If we remove war art from discussions of genre, we can look at it instead as an expression of culture. In this context, it no longer has to synchronize with the modernist trajectory of art. (Modernist critics dismiss much war art for its traditional, figurative qualities.) Instead, we can examine it as reflecting sociocultural attitudes to conflict over time. This is my approach to art and war in this book.

This method has informed the study of war memorials, especially those of the First World War in Europe and ones that commemorate the Holocaust. The current study examines the markers of war both in formal terms and in the light of the various meanings that observers have ascribed to them over time. The idea that the meaning a

viewer derives from a work is as much about his or her reaction to the piece as about the work itself is appropriate for war art. People who have profound misgivings about military undertakings tend to respond to compositions that speak to the futility and horror of conflict. The First World War generated a great deal of work from artists who shared this viewpoint, and much of their output still evokes high praise. The American John Singer Sargent's *Gassed* of 1918–1919 – a massive canvas some two and a half by six metres and replete with bodies of the dead and wounded and of the living and disengaged – has a room to itself in London's Imperial War Museum. Viewers who appreciate such pieces may not respond so favourably to the 'rivet-counters,' whose past and recent dramatic reconstructions of moments of 'derring-do' fetch high prices and grace countless military magazines and journals. This art, too, however, has a place in this book.

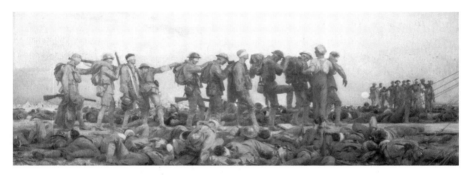

2. John Singer Sargent, *Gassed* (1918-1919).

Is War Art Propaganda?

War art is influenced by issues of power and has often served nation-building exercises. Louis XIV of France, for example, in the eighteenth century commissioned enormous pictures of his successes in battle for his palaces such as Versailles, which speak to royal power. In England, Blenheim Palace and its gardens commemorate military achievement. In the twentieth century, virtually every nation embroiled in the two major world wars commissioned war art for remarkably similar reasons. The Canadians even planned a massive memorial building – modelled on the Pantheon in Rome – to house forty-four immense canvases depicting their First World War experiences. Canada was then a small, self-governing British Dominion. It was an act of extraordinary chutzpah, although the impoverished wake of the conflict made the building unrealizable.

Not only was power at the root of Louis XIV's battle pictures; so too was 'spreading the party line'. Success breeds success, but it needs advertising. This is the essence of propaganda. Britain's Second World War art programme went out of its way to

encourage the painting of non-violent and rather parochial scenes of Britons 'doing their bit', intended to inspire people to protect their countryside and ways of life.

How truthful is war art then? Is it fiction? Does this matter? Many works reconstruct events that the artist saw and experienced but rendered later. Photographs, official reports, and war diaries may assist this reconstitutive process, but the desire to paint a good picture may compromise its veracity. We expect war art to be truthful – in so many cases, after all, the artist was there – and it is sometimes hard to accept that a piece may be not an eyewitness account as much as a synthesis of things seen, remembered, and read about. More difficult, perhaps, as in the case of British artist Peter Howson's Bosnian rape scene of 2003, is to comprehend how this form of fiction has validity as a record of war.

How Broad Is War Art?

War art is a very broad and growing realm of activity and offers a wealth of material, some of it not readily accessible, even in our electronic age. The decision to focus in this book on Britain and the USA, but without totally ignoring the major contributions made by other nations' artists and war art programmes, provides a structure for considering the current abundance of material. Nonetheless, this book argues that war art is as much an expression of culture – and not specifically visual culture – as an account of one aspect of art history.

In a world that is culturally connected by increasingly electronic means such as television and the Internet, it is impossible to align any study of this nature along strictly national lines. Once upon a time, geography limited wars, and conflicts engaged, for example, the French and the English, or the Spanish and the Dutch. Today war is global, and the current 'war on terror' affects everyone. No art being born of war today is immune to globalization. We can struggle to identify something specifically national about war art now, but deep down we should realize that the best war art does not respect national borders.

Because war is global and enters everyone's living space via television and the Internet, it has become a major subject for women artists. No longer unable to view the worst of battle, and as somewhat outsiders in terms of its history, female artists have attacked the subject with a ferocity that is, to put it bluntly, astounding. Once it was the male outsider who writ the cost of war large on canvas and paper, but now it is, as often as not, a woman who responds in art to the tragedy of conflict, finding in it horror but also, on occasion, a strange and compelling beauty.

Because war art is so vast and still expanding, this book cannot possibly be comprehensive. It does not, for example, provide a complete bibliography on war art, although what it presents is extensive. The three main reasons for this selectivity are relatively simple. First, most writers have examined war art from a generally nationalistic

and limiting viewpoint. There are books on British, Canadian, and Australian war art, not to mention South African, German, Japanese, and American. Many of these relate to official or commissioned programmes. In similarly nationalistic veins, the better-known war artists have had exhibitions at the institutions housing their war pieces, with monographs and catalogues accompanying them. Second, many artists who choose war as a subject also select other topics. In general, their war art is part of a larger body of work and appears in books that cover all their endeavours. This publishing activity comprises a great deal of printed material overall. And this textual material is not a balanced literature. Third, other, less well-known artists choose war as their theme, but their work receives little attention. Virtually invisible to scholars and researchers, their contribution remains in archives.

In fact, archival and library collections are essential for researchers of war art. To cite one example, the Political Art Documentation and Distribution Archive in the library of New York's Museum of Modern Art contains information on the sort of ephemeral art inspired by the Vietnam War that might not have otherwise survived. The Internet has also changed the study of war art. The many official collections of military art at least partially accessible on institutional sites convey something of the scale and span of war's influence on art. Indeed, this book would not have been possible without this source. While the Internet offers a virtual cornucopia of war-influenced art in a multitude of media, a book, however, can offer only a taste of it and perhaps some ways of looking at it.

Organization of *Art and War*

In general, chronology is the organizing principle for this study. Each chapter includes an introduction and a survey of major works by specific artists. As much as possible, an endnote cites an accessible location – i.e. institutional, not private – for each work. All the artists in the book appear in the index, where the entry provides their birth and death dates. The index also refers to all cited works.

Part I of this book ('A Long, Rich History') examines the development of war art, beginning with the ancient art of the Near East and following through to AD 1600 (Chapter 1) and then looking at the period to 1900 (Chapter 2). These two chapters aim to establish some kind of canon of war art and provide context. The canon already exists, as we can see in the reuse of significant war art in contemporary practice; Goya and Picasso's masterpieces are a case in point. Artists continually return to the past works of earlier painters or photographers. They recognize that, while civilizations rise, fall, and crumble, war is an indelible part of the human condition; destruction and killing are the same throughout history; and there are only so many ways to depict it effectively.

Part II considers 'The World Wars' of the twentieth century: the First, or Great (1914–1918), and the Second (1939–1945). It shifts the book's focus from art as a

whole to painting and looks at the First World War experience of the United Kingdom and Canada (Chapter 3) and the Allies and Central powers (Chapter 4). Chapter 5 is about the Second World War and the war art programmes in Australia, Britain, Canada, and the USA.

Part III examines 'War Art since 1945'. Chapter 6 looks at the period to 1989 and Chapter 7 examines the past fifteen years. Artists worked in both traditional and more exploratory media, such as video and installation in the post-war years but much of the best US war art has emerged since 1945 out of protest and is, in essence, anti-war art; the official art of American wars is not generally as well known or well respected, partly because much remains in official military collections. The chapter also looks briefly at Australia, Canada, and Germany.

Part IV ('Rendering and Remembering') broadens the study to incorporate non-painting forms of war art, most of it in the twentieth century. Chapter 8 examines other visual expressions – photography, posters, cartoons, the Internet, and military magazines – that comment on the conduct and consequences of war. One section centres on the immense influence of photography on war art's development, starting with the evocative Crimean War pictures of Englishman Roger Fenton. The chapter also considers the production of official war posters. It examines the intense relationship between war and art in editorial cartoons in newspapers and magazines, ranging from the First World War Dutch illustrator Louis Raemaekers to the active cartoonists Jeff Danziger of the *New York Times* and Steve Bell of Britain's *Guardian*. This chapter also explores war art's relationship to technology, as in protest art on the Internet. It also touches on commercial military art and its enviable and profitable presence in the so-called limited-edition print and military-history magazines.

Chapter 9 examines memory and war art since 1914, with a focus on monuments and memorials such as Maya Lin's Vietnam Veterans Memorial (1982) in Washington, DC, and Daniel Libeskind's 2001 Jewish Museum in Berlin. The chapter also looks at war art and its relationship to trauma, particularly the connection between memorial art and the Holocaust in memorials of the Second World War. Most war sculpture in the twentieth century takes the form of monuments, and thus sculpture is also a subject here.

Part I

A Long, Rich History

Chapter 1

Ten Thousand Years
of War Art to 1600

Prehistory

Any understanding or recognition of war art presumes a prior knowledge of the war culture that has underwritten its creation. War art does not exist without war. We can only assume that our prehistoric ancestors fought each other – fighting seems part of the human condition. As hunters and fishers, they had weapons – the spears and arrows that brought down an animal being equally adept at killing and wounding humans. A small, twenty-centimetre-wide rock painting in the Gasulla gorge near Castellón, Spain (c.8000–3000 BC), depicts a ritual dance involving bows and arrows that could be a war or hunting dance. We simply do not know – we have virtually no familiarity with the military or warrior culture of the time. All we do know, from examples in south-west France, is that many identified cave dwellings are high up and inaccessible, so the inhabitants probably had to defend themselves.

In the fourth millennium BC, some of our ancestral hunter-gatherers settled in the valleys of the Euphrates and Tigris rivers in present-day Iraq. They began to grow, store, and trade crops and to domesticate animals for food. With settlement and trade came territory – and a need to defend it because it provided sustenance. A clearly identifiable legacy of settlement is conflict. Another is art for display that bears messages about power, social condition, memory, and, of course, war. And the two legacies of settlement – conflict and art – are connected and merge and remerge in the art-historical trajectory from then until now.

The art of conflict seems not to have any clear associations with nomadic peoples. Before the period that produced cave paintings, nomads tended to generate small, portable art objects that they could handle rather than display. The celebrated stone carving the *Venus of Willendorf* (25,000–20,000 BC) is a prime example.[1] She fits

comfortably into a hand, and her curves adjust to the palm's concavity. Her role, however, is a mystery. And we cannot securely guess whether she served as protection or fertility or perhaps exemplified an aspect of her owner's spiritual or martial life.

This chapter offers a forced march, as it were, through highlights in the history and development of war art – from Mesopotamia and Egypt, through Greece and Rome, with a side trip to China, and then back to Europe, through the Middle Ages and the Renaissance.

Mesopotamia

Faced with a prehistoric culture that hardly reveals itself, we begin our study of war art in Mesopotamia – specifically in Sumer – in a period of growing Middle Eastern settlement when independent, trading city-states begin to flourish. In the art of ancient Mesopotamia, several thousand years before the birth of Christ, we encounter the first visual depiction of war. We also apprehend a visual depiction of peace on this early artefact – the rightly celebrated *Royal Standard of Ur*.[2] The 'peace' depicted here, with its portrayal of victory celebrations and the spoils of war, may be more about war than about peace, and its title sheds more light on early twentieth-century understandings of what constitutes peace than on the Sumerian social state.

The *Royal Standard of Ur* is a somewhat mysterious small, blue, box-like object. It resembles a Toblerone chocolate bar without the segments being narrower at the top than on the bottom. Found in a large grave cemetery at Ur, an ancient city in southern Iraq, it dates from about 2600–2400 BC. It is breathtakingly beautiful. A luminous mosaic of white shell, red limestone, and blue lapis lazuli, this small, delicate structure positively glows. Its British discoverer, Leonard Woolley (excavating 1922–1934), assumed it to be a standard of some kind – a combination of flag and moral compass suitable for carrying on public occasions. Others think it perhaps the sound box of a musical instrument. When Woolley and his colleagues first saw it – in a centuries-old rubbish dump near Ur's temple or ziggurat complex – it was in pieces, its wooden frame having long ago decayed and mingled with the city's detritus. What we see today is a restoration that the British Museum houses and maintains.

Ur's rubbish dump provided gravesites for thousands of people. Unable to build on the site, the citizens buried their dead there instead. And they interred with them many very beautiful objects. Woolley concluded that many graves contained royal corpses, but there is no conclusive evidence that Sumer had a monarchical social structure like twentieth-century Britain's. A system of city-states seems more likely, linked possibly by kinship, certainly god-fearing and hierarchical, but not necessarily possessing a single, all-powerful ruler. All we can securely deduce is that there was wealth in Ur and that its residents buried many of their dead with jewellery and objects that confirm a rich, complex, and creative society. We also know that there were soldiers in Ur. The crushed

skull of a soldier bearing a copper helmet indicates battles in Sumerian society and that its people expected protection. He is one of six people in his grave.

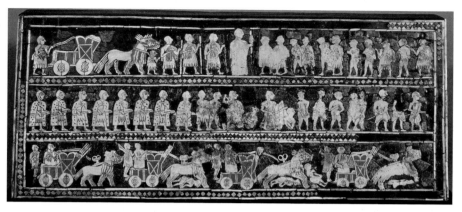

3. *Royal Standard of Ur* (war side) from the Sumerian Royal Graves of Ur.

The *Royal Standard of Ur* resembles a rather ornate comic strip. The 'war' panel, like 'peace,' has three lines, along which a procession of figures, horses, and chariots appears to advance. Many scholars believe that this panel depicts a Sumerian military victory. 'Peace,' in contrast, illustrates the fruits of victory: lines of prisoners and servants carrying the booty of war – precious objects and food – along with captured animals. Poses repeat themselves, and figures – particularly horses drawing chariots – overlap, to suggest quantity. The stylized figures and animals appear somewhat flat, as if squashed. Torsos twist, with both shoulders and arms clearly visible. The work conveys a sense of movement through the horses, which, if we read from the upper left to the lower right of the 'war' panel, change from a calm, walking stance to a dynamic and active pose that suggests a gallop.

From the *Standard*, we learn that war was part of Sumerian society and that many people participated in it both on foot and in horse-drawn chariots. The *Standard* indicates the sorts of weapons that soldiers carried – spears seem common – and the kind of clothing they wore in battle. Helmets are de rigueur. Men who do not wear them are perhaps prisoners of war or conscripts. Some of the figures are of different sizes – perhaps a sign of rank and an indicator of a relatively sophisticated martial society. In the lowest register, the most conclusive evidence of battle is the presence of three naked, dead bodies under each of the three groups of galloping horses.

This first surviving visual evidence of a tradition of war art includes much of the sort of iconographic material and content that still surfaces in certain kinds of war art to this day. Alone among the genres of art, war art has tied itself closely to narrative

presentations that provide documentary evidence about the conduct of war, the nature and materiel of its practice, who was there, what they did, who died, and what the outcome was. The quality of the *Standard*'s craftsmanship also tells us that visual depictions of war have long conveyed valuable information. Sumerian culture possessed a form of writing, but most people were probably illiterate and dependent on visual imagery for enlightenment and understanding. We do not know how much of that visual material was martial, but, as the *Standard* tells us, the society understood that war brought loss of life but also riches and considered it a worthy pursuit. The *Standard*'s beautiful working and decoration suggest that the conduct of war was a normal, even important part of life. Significant too was its role in societal memory. If Woolley was right, the *Standard* had a notable memorial and instructive function. The successful outcomes of war, however, were also to evoke remembrance through visual means in the next life: the *Royal Standard of Ur* was, after all, buried in a grave.

About 2300 BC, the loose group of cities of which Ur was part came under the domination of Sargon of Akkad, and the concept of royal power became entrenched. With it emerged a visual culture that glorified the person and deeds of the great ruler. War was an integral part of Akkadian society, and its successful waging worthy of permanent depiction. The *Victory Stele of Naram-Sin* in the Louvre in Paris depicts Sargon's grandson leading his armies up a mountain.[3] They diagonally criss-cross the two-metre-high sandstone block (possibly a memorial) three times, led by their exceptionally large horn-helmeted leader. Their wounded enemies have fallen at their feet. The stylistic precedent here is Sumerian art, but the detail and realism of this low-relief carving suggest more sophisticated skill and craftsmanship. Each figure – some fifteen are discernible – has an individual portrayal. Certain characteristics of the three main elements – leader, victors, vanquished – recur throughout subsequent war art. The ruling figure or leader stands out and appears heroic – strong, upright, unbowed, and well dressed. The victorious troops are not wounded or dying but determined, athletic, and well armed. The enemy is beaten down, dead, or dying. As well, the work conveys a sense of height – standing in, perhaps, for invincibility and victory – by the mountain peak, above which glow sun-like forms representing Shamash and Ishtar, the Akkadian gods of justice and of love and fertility, respectively, but also, in Ishtar's case, of war.

War was now an integral part of Near Eastern society – nowhere more terrifyingly perhaps than in that of the dominating Assyrians from the north. War and conquest had made their kings into military commanders and their territory into a garrison state. Cruel and merciless, the Assyrians had a penchant for atrocity that provoked fear throughout the ancient world. They used art to document their success, their military culture, and their power. Awe-inspiring stone relief carvings decorated their palaces. *Ashurnasirpal II at War* (c.875 BC), a limestone relief sculpture a metre high and now in the British Museum, depicts the king in his chariot drawing his bow.[4] Around him Assyrian foot soldiers cut the throats of their wounded enemies while others draw their

bows. There is only one act of humanity in the scene, where an enemy soldier tries to protect a comrade from certain death by stabbing by one of the king's men by pulling him away out of harm's way. In this shallow-relief carving, the enemy does not seem weak or lacking in defence capability. Its soldiers shoot arrows from the ramparts of their fortress; they too have chariots and horses, and the same weapons as the Assyrians. The message, however, is that the Assyrians are superior and invincible.

The Assyrian empire gradually faltered in the face of renewed revolt in the southern Near East, in particular from Babylon. Newly secure, King Nebuchadnezzar built a remarkable temple dominated by a processional way made of blue glazed tiles decorated with lions, the symbol of the Mesopotamian goddess of love and war, Ishtar. The reconstruction of the processional way in his Babylonian temple (now in the Pergamon Museum in Berlin) ends at the *Ishtar Gate* (c.575 BC).[5] On the walls, we see no scenes of gratuitous violence as in the earlier Assyrian reliefs; instead we infer the force of military might from the two long lines of elegant yet snarling golden lions on either side of the route. This is military power that denotes its presence through subtle symbolism and through the visible expense implied in the gorgeous structures that support and invoke this emblematic material. Here, war art presents itself not in images of cruelty, suffering, and fear but in the sophisticated skills and abilities of a culture that knows how to wage war but does not need to advertise the fact. War art, as we continue to discover, need not be obviously about war but can find distinctive or subtle expression, as the Assyrian and Babylonian cultures so differently show.

Egypt

The history of Egypt in the centuries before Christ's birth follows a similar trajectory to that of Mesopotamia. Agricultural settlement on the banks of the massive Nile River provided stable conditions for developments in written language and the arts. Deciphering some two centuries ago of hieroglyphic writing – a pictorial means of communication – helped unlock some 3,000 years of Egyptians' stories and spiritual life. Egyptians were hierarchical, deeply religious, obsessed with the afterlife, but also militaristic.

King Narmer forcibly joined Upper and Lower Egypt. The *Palette of Narmer* (c.3000 BC), literally used to hold eye make-up, includes an image of the king overcoming his enemies.[6] The style of execution, closely associated with the Old Kingdom (c.3000–2000 BC), is one that dominates the balance of Egyptian art. Here we see figures in profile, their shoulders turned to the plane of the picture surface, and the pictorial elements carried in bands, with the lines that comprise the bands also supporting the figures. Also typical, the king is much larger than the other figures (fallen and beheaded enemies and his own soldiers) and guarded by a hawk – the sky god, Horus. In this, the palette introduces the concept of divine kingship in its imagery.

The Old Kingdom and the Middle Kingdom (c.2000–1500 BC) saw some fifteen dynasties, replete with kings or pharaohs and periods of civil strife. We associate the young Tutankhamen (reigned 1361–1352 BC) with some of the most brilliant art of the New Kingdom, from his celebrated death mask of gold and semi-precious stones to the painted chest buried with him to ensure a comfortable afterlife.[7] The outside and lid of this beautiful object carry delicate red, brown, and black, embroidery-like scenes set against a yellow background. One side panel shows the young pharaoh vanquishing his enemies. The sumptuously dressed and equipped young king is pulled in his elegant chariot by a pair of rearing and splendidly decorated horses and dominates the scene because of his size. He takes up the central third of the narrative. Behind him are three far smaller rows of chariots and soldiers to indicate his troops. In front of him, in the remaining third of the panel, is a chaotic scene of fallen enemy soldiers and horses. The centuries-old banded arrangements of the past have been replaced by the wild abandon that provides the extraordinary dynamism to this scene of conquest.

Greece and the Hellenistic World

The Aegean peoples in the same period are akin to nomads: sea-based life did not allow settled communities until at least 2000 BC. The centre of early development was Crete, most notably with the justly celebrated palace at Knossos (1600–1400 BC). War, however, was not apparently a major part of Minoan civilization. In Mycenae, on mainland Greece, the remains of fortress-palaces, exemplified by the Lion Gate (c.1300 BC), record a contrasting, defensive culture. *The Warrior Vase* (c.1200 BC) depicts a file of soldiers whose huge eyes recollect the Assyrian style.[8] The vase's date coincides with the final conquest of the Mycenaeans by the Dorians (a proto-Greek people who gave us the Doric column). Its design curiously resembles the soldiers depicted on the Norman *Bayeux Tapestry*, discussed below – art frequently evades art history's assumptions of gradual progression.

Greek achievements in science and the arts went hand in hand with chronic war between the many city-states. As a result, while the rule of kings gradually gave way to democracy, statesmanship and military valour received high esteem. Human activity became the measure of all things – gods differed from people only in being immortal. If humankind warred, so did the gods. In their buildings, the Greeks included battle scenes. Many pediments and friezes on their numerous temples feature military conquest and sculptures of fallen warriors. Often, as in the Temple of Zeus at Olympia (468–460 BC), the scenes were symbolic. *The Battle of the Centaurs and Lapiths* on the west pediment symbolizes Greek victories over the Persians.[9] As the Greeks valued pursuit of the ideal, over time the warrior figures become increasingly handsome and well-muscled. Success in combat led to an orgy of building.

When Athens, led by Pericles, finally overcame its old enemy, the Persians, it marked

this newfound success and stability by rebuilding the Acropolis (448–432 BC). The Parthenon, its main building, was a temple housing the cult statue of Athena Parthenos, which gave the city its name. Athena, of course, was the goddess of war, and many of the figures that decorated the Parthenon allude to the city-state's warrior culture. In 404 BC, the Peloponnesian War led to the defeat of Athens, and most of the Greek city-states subsequently fell to Philip of Macedon. His son was the celebrated Alexander the Great, and the artistic style associated with him is Hellenistic. Hellenistic art draws on Greek precedents in its detailed linearity, but its complex dynamism and energy set it apart.

The great frieze of the battle of the gods and giants on the *Altar of Zeus and Athena, Pergamon* (c.175 BC) illustrates the dramatic realism of Hellenism.[10] The son and successor of Attalus I, the ruler of Pergamon in Asia Minor, erected the altar to glorify his father's victories. This massive structure has a platform about thirty metres square. It marks the historic battles of Attalus's reign in an allegorical frieze more than two metres high, with gods and giants representing his armies and his enemies, respectively. Each figure twists and turns in action, and the richly complex, deep undercutting of the marble – especially in the drapery – allows for a dramatic play of light and shade that energizes the scene of battle. Emotion is also present in the faces – anguish, fear, sorrow, pain, courage, and determination. While this presentation suggests a narrative,

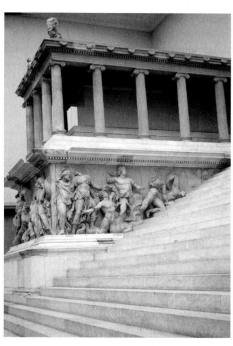

4. Restored West Front of the Altar of Zeus and Athena at Pergamon (c.175 BC).

it in fact shows but the single, climactic moment in the battle, with the various events happening simultaneously, at the instant of victory.

The *Altar of Zeus and Athena, Pergamon* is a remarkable concluding masterpiece in the story of pre-Christian art as it relates to war. But the art forms developed before Christ reverberate through the next two millennia and dominate their forms. This remarkable altarpiece in effect lays this groundwork. First, by making it the most impressive structure in the acropolis, the king rendered war and its successful conduct the measure of his society and of public concern. Second, by so closely allying his

victorious troops with their gods, he also sanctified battle, thus making war and religion inseparable. Third, in artistic terms, by electing to depict the battle comprehensively at the moment of victory (success, failure, death, and dismemberment are all present), the sculptural programme paves the way for the battle paintings and depictions of war on canvas that are the hallmark of the next two millennia.

Rome

Roman art owes much to Greek art, and many Greek sculptures are actually Roman copies. Roman use of mosaic extended the Greek precedent – a useful floor surface – to intricate wall decoration. Rome's was a wealthy empire, and public and domestic decor reached a high point. Mosaics and painting were artistic media ideal for the less ambitious architectural plans of people's homes. The subjective influences remained Greek, however. *The Battle of Issus*, from the House of the Faun at Pompeii (c.80 BC), depicts the rout of Darius and his Persian army by Alexander the Great.[11] Its dramatic feeling is Hellenistic, but its three-dimensional rendering of space – as in the horse, whose hindquarters, central to the composition, dramatically distract the eye from the piece's frieze-like trajectory – suggests a more plebeian Roman realism.

Presentations of military success in Rome also derive from Greek and Hellenistic models. The ten-metre-wide marble *Ara Pacis Augustae* (13–9 BC) in Rome commemorates the pacification of Spain and Gaul (France). It represents an interesting take on conquest, as its imagery evokes the fruits of peace rather than the battles that ensured victory. It is in the Roman world, particularly of the Emperor Augustus, that we first see clearly the effective sleights of hand that make peace out of war. It is in the early Christian era that we glimpse the subtle attributes of propaganda that help keep conquered peoples in line. The Roman world also loved triumphal arches – a form that continues into the twentieth century. The *Arch of Titus* (AD 81) in Rome, for example, has sculpted relief panels that tell of the Emperor Titus's triumphal return from the conquest of Jerusalem, a campaign that lasted from AD 66 to AD 70. The forty-metre-high *Column of Trajan* (AD 113) in Rome inspired the French Emperor Napoleon to copy it to commemorate *his* victories.[12] On the Roman column, a 200-metre-long encircling frieze rising up its height depicts Emperor Trajan's two successful campaigns against the Dacians. It presents 150 separate episodes and several thousand figures. Art historians note Trajan's column because some of its figures are less than realistic, marking the return to a more symbolic way of depicting people that is characteristic of much medieval European art.

China

During the same pre-Christian period, equally complex societies were developing in other parts of the world that put art at the service of war. Because they have limited

influence on the overall trajectory of this book, which is not an all-encompassing global survey of war art, we will look at just one fascinating example of that art.

The tomb of the Emperor Qin (221–206 BC) is at the northern foot of Lishan Hill in Lintong in Shaanxi province. Qin defeated all rival ducal states and unified China by establishing the first centralized feudal dynasty. His is the largest mausoleum ever discovered in the world. While there has as yet been no excavation of his tomb, his buried terracotta army is impressive. So far, three pits that cover 20,000 square metres have revealed some 8,000 life-sized warriors. Extraordinarily lifelike and detailed, these figures were modelled on real people. The Emperor believed that even in death he would continue to rule so would need to take his army with him. He had convinced the living world of his power and influence and believed that the same was possible in the afterlife. The scale of his enterprise continues to astound.

The Middle Ages

The break-up of the Roman Empire led to a long period of chaos in Western Europe as various 'barbarian' tribes fought for control. These so-called Dark Ages lasted from about AD 400 to AD 1400. After the fall of Rome in AD 395, most early Christian and Byzantine art (representing the western and eastern portions, respectively, of the former empire) initially eschews military imagery, despite the many biblical stories centring on battle, war, and their paraphernalia. Paintings, mosaics, and sculptures of this early Christian world describe the spiritual world. Nonetheless, they reuse classical forms for their own purposes. An example is a small ivory carving of *St Michael the Archangel* (early sixth century).[13] The figure's prototype was probably a Roman figure of Victory. We can deduce this from St Michael's flowing and animated drapery and the carefully delineated feathers on his wings. He even looks pre-Christian, with his curly Roman hairstyle.

The so-called barbarians, however, introduced their own art forms, which mixed and mingled with the still-dominant classical forms of Europe. Often highly ornamental, their designs tended to exclude the human figure and focused instead on complex and often emblematic forms. This is particularly apparent in richly decorated Gospel manuscripts. The dominance of classical forms is not surprising, since the built empire that the Romans left behind dominated the urban and rural landscapes of the time and still does to some extent. Most artists were monks with a vested interest in the subject matter.

The *Bayeux Tapestry* (1070–1080) represents a unique departure from the art of the first millennium in Europe.[14] Made of embroidered wool on linen, it is 51 centimetres high and 70.4 metres long. Perhaps most surprisingly, it remains intact. It tells the story of Duke William of Normandy's conquest in 1066 of England, where he subsequently became king. The embroidery is unique for a number of other reasons, especially because it depicts a real event shortly after it happened without symbolism or allegory: William and his men, their ships to cross the English Channel, their weapons, and their

dwellings all appear as they were at the time. It is not only a beautiful work of art, but also an incredible social document. Inscriptions in Latin (still the written language of Europe) comment on the events portrayed.

5. 'Duke William Exhorts His Troops to Prepare Themselves for the Battle against the English Army'. Detail from the *Bayeux Tapestry* (1070-1080).

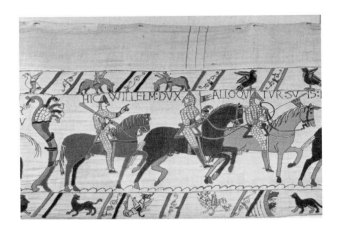

There is little of the realism of Rome in this extraordinary work. The figurative elements are flat and decorative. The soldiers and cavalrymen all look the same. Much as in Egyptian or Mesopotamian art, we see them in profile and at times, as with the bowmen, with their shoulders and arms turned to the picture plane like so many squashed beetles. We also see a re-emergence of the banding of earlier times. The main story appears in a central band, while, below and above it, heraldic creatures and animals form a continuous line of complementary decoration. The achievement of the Pergamon altarpiece – the telling of a single moment of time – gives way to the earlier narrative sequencing of events. It is as though the artistic traditions of the Near East had mixed with the decorative requirements of the northern tribes – whether Vikings, Visigoths, or Celts – to create a uniquely direct, uncomplicated, and certainly not symbol-laden new art form. Here, there is no concern for the afterlife or the spiritual world but rather a pragmatic description of an epochal military campaign that had happened very much in the here and now but required commemoration. The work was also most likely that of women: perhaps the first female war artists in history.

The *Bayeux Tapestry* in many ways heralds the more secure Gothic world, which allowed for a more settled existence for many people and, in consequence, a great flowering of the arts. This is, after all, the period of the great Gothic cathedrals of Western Europe. Secure in their new stability, kings and popes sought to expand the Christian empire by means of the various Crusades, which bore violent results in cities such as Constantinople. Furthermore, the missionary zeal of church leaders led to 'crusades' nearer to home to root out so-called heretics such as the Albigensians in

south-west France, whom troops virtually annihilated in the name of Christianity. The fear-inducing medieval Inquisition is another grim feature of the period. Art, however, did not often record these battles at the time.

The Renaissance

The Renaissance in Italy, beginning in the fourteenth century, marks a turning point towards a more creative era. It saw a number of artistic innovations, both iconographic and technical, particularly in painting. In terms of iconography, we encounter military portraits, genre scenes, and battle paintings of a type not seen in any medium since classical times.

The Renaissance also introduced a great age of religious painting and over time transformed the iconography of war art, particularly as it is employed in the twentieth century. The two genres – war and religion – mixed in some respects, and still do. Sculptures of saints such as St George or St Michael on church fronts, for example, often depict them as soldiers, throwbacks to medieval chivalry perhaps, but some had earned sainthood through military action. By the time Andrea del Castagno painted *Pippo Spano* (c.1448), it was the general who now looked like a saint.[15] Clutching both ends of his horizontally positioned sword and with his legs apart, his armoured and muscular figure stands against a dark background, his feet appearing to project from the illusory niche.

The Palazzo Pubblico in Siena, Italy, signposts many more developments in war art. Simone Martini's elegant and richly garbed *Guidoriccio da Fogliano* (1328) is one of the earliest portrayals of one feature of the post-Gothic scene, the mercenary.[16] Confidently poised on his horse, Guidoriccio marches purposefully across the lush Italian landscape. Most important, this work is about a real person in a real time. Yet the passage of time has made it impossible to identify the landscape elements securely; nor can we be sure that the artist painted rider and landscape at the same time. In the same gallery, Ambrogio Lorenzetti's vast mural on good government (1339) reminds the Sienese that in a turbulent time peace is worth preserving.[17] A detailed description of the city and its people surrounded by countryside, the mural includes allegorical elements – figures representing virtues such as Temperance and Fortitude, essential for an agreeable existence. The use of allegorical elements in combination with reality to promote a particular message now becomes a recurring feature in war art.

Life in Siena, however, did not remain peaceful. The city lost a battle with Florence, which that city commemorated in a series of paintings by Paolo Uccello. The *Battle of San Romano* (c.1455) panel in London's National Gallery echoes any number of altarpieces of the era in its rich, pageant-like composition and colour.[18] A convert to perspective, Uccello uses the tool to suggest a substantial battlefield and many troops in action. Soldiers and horses retreat in order and disarray into the background hills, their

fallen spears and lances directing the viewer's eye sideways and backwards through the action. The artist no longer needs merely to suggest quantity on a two-dimensional plane.

Martini's mercenary in Siena, Guidoriccio da Fogliano, in style evokes classical sculptures. The remnants of these appeared all over Italy, but especially in Rome. These precedents also inspired sculpted equestrian portraits – notably Donatello's *Erasmo da Narni* (c.1445–1450), or *Gattamelata*, in Padua.[19] Here, the well-known mercenary leader looks like a Roman general; his pose and that of his horse are commanding, reassuring, confident, and not a little threatening, given their elevation above the plaza. More animated and ornate, but even more imposingly placed in terms of height, is Andrea del Verrocchio's equestrian portrait of

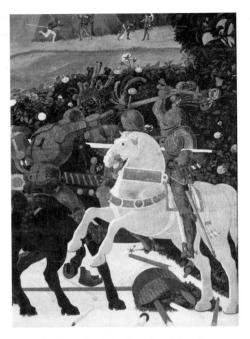

6. Paolo Uccello, *The Battle of San Romano* (detail) (c.1455).

another mercenary leader, *Bartolommeo Colleoni* (c.1483–1488).[20] Here, military power oozes from the rider's aggressive, twisted stance and the repressed energy of his heavily muscled mount. 'Look at me,' the rider seems to say, 'I control all this power.' The phrase 'reins of power' has rarely seemed more apt.

Twisting forms become the norm in figure studies in the fifteenth-century Italian Renaissance. In his engraving *Battle of the Ten Nudes* (c.1465), Antonio Pollaiuolo shows a variety of battling figures from different angles.[21] Every muscle is in tension, so that the intended sense of movement instead suggests a peculiar stillness. Pollaiuolo's engraving is an early example of a printing technique that, until the invention of photography, provided one of the few means to mass produce and mass distribute images. Twisting forms in space also characterize Luca Signorelli's fresco *The Damned Cast into Hell* (1499–1504).[22] This work features angels in armour led by St Michael, who hover above a battle scene where demons imaginatively torture the damned. This painting influenced Michelangelo's fresco of *The Last Judgement* in the Sistine Chapel, Rome (1534–1541).[23]

While *The Damned* is ostensibly a religious scene intended for a place of prayer, its subject underlines the close and abiding connection in war art between religious

iconography and military subjects. In the Italian Renaissance, however, artists in a militarized society often set Bible stories in their own warring times. Leonardo da Vinci, for example, was as much an inventor of war machinery as a painter of portraits and religious subjects. Indeed, he wrote some well-known instructions for painting battles:

> Make the conquered and beaten pale, with brows raised and knit, and the skin above their brows raised and knit, and the skin above their brows furrowed with pain ... and the teeth apart as with crying out in lamentation ... Make the dead partly or entirely covered with dust ... and let the blood be seen by its colour flowing in a sinuous stream from the corpse to the dust. Others in the death agony grinding their teeth, rolling their eyes with their fists clenched against their bodies, and the legs distorted.[24]

The period of art known as the Italian Renaissance is widely considered to conclude with mannerist Giulio Romano's classical myth-inspired frescoes of giants and grotesques wreaking havoc on the walls of the Palazzo del Te in Mantua (1524–1534).

The art of the Renaissance in northern Europe shows how a different culture produced a different religious art. While scenes of violence occur – Christ's Sacrifice on the Cross, for example – these works lack the militaristic overtones of some contemporary Italian examples. In the sixteenth century, German Albrecht Altdorfer's *The Battle of Alexander at Issus* (1529) is the first major piece of northern war art to feature a battle, but here it is the historical battle in which Alexander defeated the Persian king, Darius (see above).[25] As in a scene from the recent films (2001–2003) made by Peter Jackson of J. R. R. Tolkien's *Lord of the Rings*, from a great distance we see the battle laid out before us. Above, dark clouds mass above a rocky landscape as a brilliant sun sets like fire behind distant peaks.

In printmaking, the frigid musculature of Pollaiuolo's *Battle of the Ten Nudes* finds its equivalent in Albrecht Dürer's woodcut *The Four Horsemen of the Apocalypse* (c.1498).[26] Here, four terrifying figures – one a skeleton, the others in contemporary dress – gallop like an avenging army across the paper surface; the downtrodden lie crumpled and terrified on the ground below. Every inch of the paper contains agitated, explosive lines that enhance the energy of the scene. This is the style, technique, and approach of Verrochio's equestrian statue of Colleoni in a different context but in the same period. Dürer had visited Italy and here he harnesses the stylistic energy of the art that he saw there to the dramatic gothic influences that were his heritage and inspiration in northern Europe.

Chapter 2

War Art
1600-1900

The Seventeenth Century and the Horrors of War

European society militarized at home and overseas in the late Renaissance in response to wars of succession and conquest as the Holy Roman Empire broke up. In what is today the Netherlands, for example, single and group portraits and genre scenes by Rembrandt and others depict aspects of military life. The same was true of Spain, long-time colonial master of the Dutch. The Eighty Years War (1568–1648), which ended with Dutch independence, saw the Spanish commemorate a victory in Diego Velázquez's immense *The Surrender of Breda* (1634).[1] Until the 1630s, art was not criticizing war; there was no anti-war art.

The year before *The Surrender*, prolific French artist Jacques Callot released his extraordinary etchings (eighteen of them, including the title page) exposing the downside of conflict – the so-called *Large Miseries of War* (1633).[2] His seemingly emotionally neutral depiction of executions, hangings, killings, the practitioners of war, and their disengaged camp followers speaks not only to a brutality observed but also to a numbing of the mind and soul. In their quiet but immense power, these prints use art for the first time to protest the conduct of war.

Callot died in 1635, and his work responds to the Thirty Years War (1618–1648). A conflict fought principally in the central European territory of the Holy Roman Empire, it involved most of the major continental powers. Although the war pitched Protestants against Catholics, the survival of the Habsburg dynasty was also a central motive. Callot's prints, numbered sequentially, form a visual narrative on the war's human tragedies. The low-numbered prints depict recruitment and early battle experiences; the next ones, plunder, looting, and torture in farms, convents, homes, and churches; the final prints, brutal punishments and the resultant maiming and poverty. In total

contrast, in the last plate, a general rewards his good and loyal troops. The moral is clear: crime disguised as virtue (the war) brings reward but virtue itself (the victims) brings nothing good. The quantity of plates devoted to the bad and the ugly suggests that the artist saw little room for good in war.

Plate 11, *The Hanging,* is compositionally and emotionally powerful. It is only 7.2 x 18.5 cm, yet shows much technical skill and complex subject matter. At its centre is the trunk of a tree with numerous bodies hanging from its lower limbs, their necks clearly broken. On a ladder leaning against the trunk, a priest blesses the suspended corpses. Below are various soldiers; one plays a drum underneath the bodies on the right of the tree. An army of soldiers forms an ellipse in the distance; a group of chatting peasants (right foreground) and a soldier (to the left) who points at the tree complete the ellipse. A still life of clothing and weapons (centre foreground) brings the ellipse to a close. A dynamic balance of light and dark areas keeps the detail comprehensible. The dark tree and its human attachments contrast with the white bareness of the circular area below. The white sky on either side of the tree contrasts with the shadowed army below.

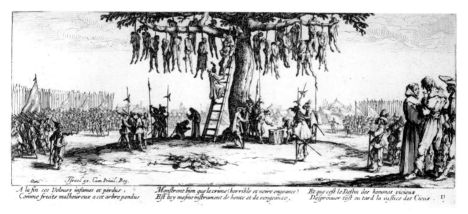

7. Jacques Callot, *The Hanging,* plate 11 from 'The Miseries and Misfortunes of War' (1633).

The seventeenth-century Flemish artist Peter Paul Rubens was also, to all intents and purposes, an anti-war artist living in a period of frequent conflict where the achievements and deeds of war were highly valued. His approach, however, was allegorical and drew on classical and religious symbols. In 1611–1612, he completed *The Massacre of the Innocents,* based on the biblical event in which Herod sent his soldiers to kill infants at Bethlehem in case one of them should be the Messiah.[3] Rubens may have chosen this brutal and emotionally charged subject to reference the 1576 Sack of Antwerp (his home town), in which 7,000 citizens died and many were raped. Nearly two decades

later, this celebrated and influential artist tried to use his art to effect political change: in London, charged with promoting peace, he presented King Charles I with a dramatic painting, *Minerva Protects Pax from Mars* (1629–1630), an allegory of war and peace that argues that peace is good for the economy and war is destructive.[4] In the painting, peace shelters emblematic material that includes gold and jewels, representing the rewards of a life under her care. Seven years later, Rubens returned to this theme in *The Horrors of War* (1637–1638), a far darker allegorical work, in which the benefits of peace now lie shattered at the feet of Mars, the god of war.[5] Picasso's *Guernica* (1937) is in part modelled on this composition (see Chapter 5). The woman cradling her baby in his painting invokes the woman with her baby in Rubens's work.

The seventeenth century produced other artists who married romantic sensibility with neo-classicism. The Frenchman Nicolas Poussin, for example, had trained in Rome and had extensive classical knowledge. *The Rape of the Sabine Women* (1633–1634) introduces violence against civilians into the iconography of art.[6] The subject is a mythological event from just after the founding of Rome. In need of women to populate the city, Roman men abducted a number of nearby Sabine women. This open breach of the rules of hospitality horrified the Sabines, who went home to prepare for war with Rome. When they later returned in arms to take back their women, the Sabine women, who had by now reconciled with their new husbands, prevented the battle by placing themselves between the two armed groups. Ultimately, the two peoples made peace.

Subjects such as this enabled artists to include women, often naked, in their military paintings, frequently to salacious ends, engendering recent debate by art historians as to the hidden purposes of such art. The theme of the Sabine women finds particularly effective treatment in a painting by Jacques-Louis David in 1799, ten years after the French Revolution removed the monarchy and established the new egalitarian republic.[7] Here, the inclusion of women points to the egalitarian society born of revolution to make a political point.

The Eighteenth Century and the Classical/Neoclassical Hero

The eighteenth century saw the battle painting become a document of contemporary history rather than a reminder of classical values. There were two types – either a heroic portrait or a picture of an actual battle. The heroic portrait conferred prestige and in so doing justified military endeavour, which the renderings of battle did also. A battle painting was also educational. It informed the nation of its achievements and fostered national identity, especially through public display and access and/or reproduction. This can be explored in a detailed account of the genesis of one particular British painting and one particular British sculpture. These accounts shed light on the precedents, processes, and contexts for the production of war art in the eighteenth century.

Britain's conquest of New France in 1759–1760, during the Seven Years War (1756–1763), inspired works about two of its victorious generals – Amherst and Wolfe – that reveal a great deal about eighteenth-century war art and about Britain as it stood on the verge of empire. *The Charity of General Amherst* (1761), by the English artist Francis Hayman, is one of two extant studies for a much larger, lost painting.[8] The lost work (4 x 5 metres) decorated one of four walls in the rococo-style Rotunda Saloon at Vauxhall Gardens in London. Hayman executed it after learning of the British capture of Montreal on 8 September 1760. The study in the Canadian War Museum is a fanciful portrayal of the victorious general dispensing bread to the fearful but grateful French inhabitants of Montreal. In its final form, the composition was an instant and immense success. In our own time, both studies, and what we know of the final painting, tell us much about popular expectations and public understanding of the British conquest of North America.

In 1760, the British Prime Minister, William Pitt, Earl of Chatham, had ordered the capture of Montreal as 'the great and essential object'.[9] As commander-in-chief in North America, Jeffery Amherst made typically careful plans, amassing by midsummer a large and well-provisioned force at Oswego (now in New York state). The siege of Montreal followed in August, the city finally surrendering in early September. With French forces by now much smaller, Amherst's success essentially concluded the war in North America.

Britain's overseas exploits had captured the country's imagination, and the portrayal of so recent and crucial an event fed the public's craving for visual images of British imperial successes. People wanted a feeling of involvement and being *au courant* more than they wanted accurate information. The painter and his patron, the owner of Vauxhall Gardens, were for commercial reasons happy to oblige – a situation that finds parallels in our television age.

Vauxhall Gardens was a pleasure garden from the mid seventeenth century until 1859 – in many ways a precursor to the theme park and museum. The public paid to stroll, by day or night, along brightly lit, tree-lined promenades, to eat overpriced food, to listen to the latest compositions by Handel, and to view paintings by Gainsborough, Hayman, and Hogarth. As a business, it depended on people, and the customers had to hear and see what they wanted if they were to come back.

Over some twenty years, Hayman executed many commissions for Vauxhall Gardens. His early subjects reflected the frivolous, light-hearted tastes of the rococo era. But, once Britain was at war, the public demanded more substantial narrative images, involving recent heroes and their noble deeds, which demonstrated British humanity and consideration to the defeated. The change in taste affected Hayman's four compositions for the Rotunda Saloon. Along with the Amherst painting, the artist's subjects included Clive at Plassey, Hawke at Quiberon Bay, and an allegorical scene of Britannia distributing laurels.

The starting point for the four massive works lay in classical history painting – the accepted format for recording major national events, adding the appropriate grandeur and gravitas. In the Amherst composition and its studies, the inspiration comes from the recorded exploits of the classical heroes Scipio and Alexander the Great, well known for their magnanimity after battle. Moreover, there is a direct compositional link to French artist Charles Le Brun's *The Family of Darius before Alexander* (1660–1661), in Versailles, where Alexander treats the defeated Persians kindly.

However, Hayman took history painting closer to the viewer by clothing his figures in contemporary dress and eschewing allegorical figures in favour of actual people. (A decade later, Benjamin West followed the same route with his famous *The Death of General Wolfe*.) While the events in *The Charity of General Amherst*, for example, never happened, and the landscape, tent, and column of the Canadian War Museum study belong to classical Rome, the use of a vernacular vocabulary for the figures presents a reality that washes over the rest of the work. This approach allowed the artist to suspend the disbelief of his audience, which wanted to believe what it saw as truth. As an account of viewers' responses records, the public thought 'that clemency is the genius of the British nation'.[10]

Hayman depicts an elegant Amherst, instructions in his right hand, greeting grateful Montrealers, kneeling and bowing in obeisance. French soldiers are notably absent from the group of women, children, priests, the elderly, and the weak. At the rear, an English soldier protects them from a group of armed and naked 'savages'. Behind Amherst, a servant brings in a large basket of bread for distribution. We know that words on the column were to read, 'Power exerted, conquest obtained, mercy shewn! MDCCLX [1760]', as they appeared in the final painting. As imperialist propaganda, the final version seems to have been a tour de force. Painted to please the public, it presented the war in North America with British victors humane and generous to the vanquished. In so doing it must have helped garner support for Britain's further overseas ambitions.

The death of General James Wolfe a year earlier proved, however, to have richer, longer-lasting significance and propaganda appeal. On 13 September 1759, French musket fire killed the thirty-two-year-old general on the Plains of Abraham, outside the walls of Quebec, in the battle that ultimately ended French rule in northern North America. From relative obscurity, Wolfe rose to be one of Britain's greatest military heroes. As British portraiture scholar J. F. Kerslake noted in 1977, he 'became famous only in death'. The English responded rapturously to news of Quebec's capture, and a Wolfe industry emerged, placing the hero's image everywhere: in prints, on mugs, on tobacco jars, and in needlepoint.

There were few sources, however, for the early renderings of Wolfe after his death – a few portraits, reconstructions from memory, and conjecture. Virtually no one had depicted the mature man in portraits. Written accounts varied widely: the French found him ugly, the British manly. To allow serious memorials, Wolfe's friends sought an

immediate likeness in death to fix his appearance for future use.

Soon after his return to England in the autumn of 1759, Wolfe's protégé, the Duke of Richmond, commissioned Sir Joseph Wilton to model Wolfe's likeness from the dead man's face. The army had shipped Wolfe's corpse in a stone casket to England, where it arrived on 16 November, at Spithead off the Isle of Wight. Wilton went immediately to record his features but found the face so badly decomposed that he could make no impressions from it. According to novelist Horace Walpole, Wilton needed some other model. A local servant deemed to resemble Wolfe very closely was found. A long-standing acquaintance of the general's then corrected the details. Wilton also had access to a portrait sketched at Quebec by an aide-de-camp, Hervey Smyth, shortly before the hero's death.

Wilton, an Italian-trained London sculptor, worked in the neoclassical style that was captivating Britain and admired the portrait tradition of the Roman bust. The Wolfe commission made his career. In 1764, he became sculptor to King George III, and later, using his earlier studies, he won the competition to execute Wolfe's monument (1772) in Westminster Abbey. Wilton's initial plaster portrait has disappeared, but he soon made three secondary plaster sculptures from it.[11] In their surviving forms, as art all are superb examples of the work of one of Britain's finest eighteenth-century neoclassicists. As history, they are probably as close as we can ever get to Wolfe's appearance at the time of his death. Nonetheless, they are clearly a product of their time, depicting Wolfe as the hero, the epitome of the type of character whose self-sacrifice supposedly forged the British Empire. A record of the period's sensibility, they have long both informed and determined the general's image.

The American Benjamin West's subsequent heroic portrayal of Wolfe's death is romantic and historically dubious despite its attention to detail, as in the native Canadian dress, for example. In the century that soon saw Britain's loss of the American colonies, the nation needed heroes when remaining territories – in this case, Canada – were restless and increasingly talking about independence. Wolfe's colleagues found him somewhat aggressive and unpleasant, but public relations and the imperial propaganda detailed above raised him posthumously to near sainthood. In *The Death of General Wolfe* (1770), West presents the soldier as Christ taken down from the Cross.[12] As in many Renaissance scenes of the Deposition, mourners surround the body, the furled flag behind it acting as the Cross. The painting also owes a great deal to classical precedent – seventeenth-century French military paintings – and see Jacques-Louis David's *Oath of the Horatii* (1784).[13] West, however, presents Wolfe in everyday clothes, whereas the seventeenth-century French canvases culled subjects from Roman history, leaving the viewer to figure out any contemporary allusions. Fellow American (but British-based) artist John Singleton Copley's *The Death of Major Peirson, 6 January 1781* (1783) is in a similar vein and leaves no doubt as to these painters' pro-British sympathies.[14]

The Nineteenth Century: Napoleon and After

It is Francisco de Goya y Lucientes who returns us to the world of Callot, onlooker and observer of war, not practitioner. After the execution of the French King Louis XVI in 1793, Spain declared war on the young French Republic. The years 1793–1808 saw uninterrupted warfare. Napoleon Bonaparte, who had become emperor of France in 1804, invaded Spain in 1808 and put his brother Joseph on the throne. A popular uprising against French troops in Madrid in May 1808 and subsequent revenge executions sparked a national struggle for freedom.

The terrible fighting led Goya in 1808 to begin a series of eighty-two prints known as *The Disasters of War*, the title a tribute to Callot and his *Miseries and Misfortunes of War* and the work an homage to the Spanish resistance. Goya's planned title, *Fatal Consequences of the Bloody War in Spain with Bonaparte*, was very courageous: Goya knew that partiality could compromise his position as court painter. Even the post-war Bourbon monarchy, reinstated after British troops under the Duke of Wellington had helped drive out the French, would not have tolerated the prints' publication. As a result, in the artist's lifetime they went only to proofs for his own use; the completed published edition appeared only in 1863 after his death, with further editions in the early twentieth century.

8. Fransisco de Goya y Lucientes, *And There's Nothing One Can Do About It* (c.1810-1813).

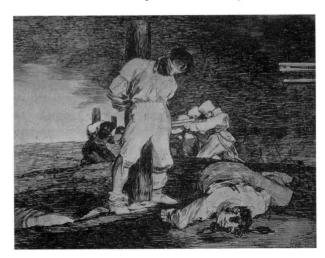

Macabre, horrific, disgusting, and unutterably bleak, these prints speak to a humanity fallen into a hell of the sort sculpted by Gislebertus, the medieval sculptor of the west portal of the cathedral at Autun in France. Goya's technique is rough and coarse, in keeping with the subject matter, and distant from the grace and prettiness of his and others' earlier work. The prints fall roughly into three categories: scenes of war begun in 1808, the famine in Madrid in 1811–1812, and some added allegorical subjects of similar date. The earliest group contains the most prints. As well, the subjects divide

into groups. The strongest focuses on the treatment of women and their response to horrific acts and events. Others concentrate on brutality itself. Goya uses light and dark almost as stage lighting, and virtuoso foreshortening emphasizes the drama.

One print depicts an execution squad; a dead body lies bleeding on the ground.[15] Other victims, yet to fall, are tied to wooden stakes like so many Christs on the Cross. The executioners at the back align rigidly, completely tense, in contrast to the ruined but relaxed bodies of the dead and dying. To the right, another line of executioners is present only in gun barrels. Here, all humanity is absent. Goya's bleak view of conflict is apparent in his paintings too. He developed the print of the execution into a painting, *The Third of May, 1808* (1814).[16] In it, he allows light to illuminate the victims but casts the executioners in shadow, their backs to the viewer.

Napoleon's military adventures inspired French artists too, but their focus was on the emperor's achievements, not on their consequences. Carle Vernet rose to fame with his drawings of the Italian campaign (1796–1797), and later his vast canvases, such as *The Battle of Marengo* (1804) and *Morning of Austerlitz* (1804), graced the palaces at Versailles, where this genre, celebrating French triumphs, took pride of place.[17] His son, Horace Vernet, became one of the century's most popular military painters, most famous for his decorations of the Constantine Room at Versailles and for *The Gate at Clichy* (1820).[18] Antoine-Jean Gros also created a celebrated portrait of the emperor in action: *Napoleon at the Battle of Eylau* (1808).[19]

Gros's younger colleague Théodore Géricault fused several elements – Gros's classicism, the traditions of English sporting art, contemporary subject matter, and the verve and colour of the Flemish Baroque painter Peter Paul Rubens – to produce *The Charging Chasseur* (1812), an officer astride a rearing horse on a smoky battlefield.[20] He must have drawn inspiration too from David's *Napoleon at the Great St Bernard Pass* (1800).[21] At the Paris Salon of 1814, Géricault's *Wounded Cuirassier* (1814) shocked critics with its serious subject matter and sombre colours.[22] The public expected to see military heroes and their exploits larger than life and definitely not showing the effects of battle.

In the aftermath of Napoleon's final defeat in 1815, artists still sought military-related subjects to depict with the sort of energy and romanticism that they had applied to *his* portraits. Eugène Delacroix, for example, painted a scene from the 1830 revolution and substituted a revolutionary heroine – the allegorical figure of Liberty. *Liberty Leading the People* (1830) combines the drama of a portrait of Napoleon with the female determination of the Sabine women.[23] As others had before him and would do later, Jean-Dominique Ingres turned to the medieval French heroine Joan of Arc for inspiration.[24] In the years around the Franco–Prussian War (1870–1871), some artists sought out less heroic subjects and pondered the harsher consequences of war.

Inspired by Goya's oeuvre is Édouard Manet's *The Execution of the Emperor Maximilian* (1867).[25] Napoleon III had installed the Austrian Archduke Ferdinand Maximilian in

Mexico as a puppet emperor. The new ruler depended on the occupying French army, and when Napoleon withdrew his troops, Mexican forces loyal to the republic captured him. He was executed alongside two of his generals on 19 June 1867. Manet's dramatic scene, like Goya's, contrasts the riflemen's mechanistic stance and attitude with the human tragedy that is the emperor.

In Britain, victory over the first Napoleon ensured survival of the types of battle painting that the emperor (and his successors) championed – but with different heroes. Later in the century, Lady Elizabeth Butler came to dominate English painting in the French military manner. She had first concentrated on religious subjects, but a trip to Paris in 1870 exposed her to battle scenes by Jean-Louis Ernest Meissonier, Alphonse de Neuville, and Édouard Detaille, successors to Delacroix et al., and she switched to war paintings. *Missing* (1873), portraying a battle from the Franco–Prussian War and showing soldiers' suffering and heroism, became her first submission to the Royal Academy.[26] Showing of *The Roll Call* (formally titled *Calling the Roll after an Engagement, Crimea*) at the Academy in 1874 turned her into a celebrity.[27] The event depicted – some time during the Crimean War – is a frieze of exhausted soldiers in winter. But, as artist William Holman Hunt observed, 'It touched the nation's heart as few pictures have ever done.'[28] As the painting toured Europe, along with photos of its artist, she gained notoriety as a woman dealing with war.

Auguste Rodin's sculpture *The Burghers of Calais* (1884–1886), a bronze cast of which stands prominently outside Britain's Houses of Parliament, is not a war memorial or war sculpture. It commemorates the six residents of Calais who offered their lives to the English in 1347, in exchange for an end to the siege of their city, and were spared. Nevertheless, it has influenced numerous figurative portrayals associated with war memorials. Rodin's tragic yet resolute, life-size figures point to an emotive and meaning-laden form of sculpture that reached its apotheosis after the First World War, when noble sacrifice became the preferred visual metaphor for the consequences of brutal killing.

The Second Boer War (1899–1902) used artists as quasi-war correspondents. A leading artist of the day was the jingoistic Richard Caton Woodville. Like the Crimean War, the Second Boer War was not popular; hence the demand for usable artistic records. Improvements in reproduction technology allowed art to illustrate newspapers and weekly magazines. Newspapers such as *The Graphic* and the *Illustrated London News* often touched up pictures from the front. *The Sphere*, in contrast, published sketches as sketches, even if slow mail service dated the events depicted. It was not easy being a war artist in South Africa. British artist Melton Prior reported: 'I was out in the centre of the plain behind some rocks making sketches of what was going on all round me, not realizing the dangerous position I was in. When I found the troops falling back I also retreated from my position in double-quick time.'[29] Many war artists in the next century found themselves in similar situations.

A painting that perhaps best marks the transition from the nineteenth century to the twentieth is *War* (1894) by Henri Rousseau.[30] We do not know why the celebrated French *naïve* painter created this work, which cannot be associated with any particular conflict involving France. The rider on the horse that gallops across the canvas from left to right personifies War. She sits side saddle, a sword in her right hand and a torch in her left. Below her the ground is strewn with the dead, who are naked. The landscape is somewhat barren and the sky is shadowed by red clouds. The work is disturbing in its intensity and, in its dramatic aura, foretells, perhaps, the violent century to come.

Part II

The World Wars

Chapter 3

British Art
and the First World War

Imagine for a moment London in 1914. The metropolis is a ferment of artistic creativity, as exposure to post-impressionist art encourages expressionism, futurism, suprematism, vorticism, and a host of other avant-garde movements alongside more traditional approaches. Some residents have money and time, and the city attracts the cultured and the ambitious from Australia, Canada, and all over the British Empire. It is stimulating to be in London if you love the arts.

War, however, restricted travel and brought military service. Many younger artists found themselves in trenches in France instead of in studios in Paris. However, had people not valued art so highly, perhaps it might not have become a valuable instrument for recording the war experience of Australia, Britain, and Canada, which all had particularly substantial official war art programmes, and of other countries. Without formal programmes, more artists might have died in battle.

This chapter describes British artists' substantial contributions to Britain's and Canada's official war art programmes, some notable portrayals of war's participants, compelling studies of its landscapes, and the Christian symbolism that infused several major British works completed for Canada. The Canadian scheme is given some prominence as it was the first to be established and is notable for its quantity of important British art.

The British Official Scheme

The United Kingdom's Foreign Office initiated the national war art scheme in late August 1914, when it set up a secret department known as Wellington House to manage and disseminate British propaganda; former Liberal politician C. F. G. Masterman was its head. In July 1916, the department created a pictorial section to develop visual propaganda

– from films to postcards. Photography had proved problematic on the western front because heavy equipment and long exposure times precluded action shots; little of it was of use to either the Foreign Office or newspapers. Printing improvements allowed good reproduction of photos *and* paintings in newspapers. However, the Glaswegian printmaker Muirhead Bone recognized that joining the war art programme could help artists avoid conscription – without such official status, the pool of available talent would continue to shrink. By war's end, the government had commissioned 130 artists, including sixteen enlistees released from active service. In February 1917, Wellington House joined the Department of Information but continued to function as it had. By 1920, it had produced some 3,000 paintings, drawings, and sculptures, some of it among the most significant in twentieth-century British art.

What to paint was a consuming issue for most war artists. Generally, they were far from the action and in consequence presented with the much-fought-over landscape of the western front – a mess of mud, broken trees, rusted weaponry, bones, and ruined buildings. Anything in the least bit dramatic that caught the eye became the subject of their brushes. The Cloth Hall at Ypres, Belgium, and the Leaning Madonna on the church at Albert, France, were popular subjects with many. These views used existing skills, unlike details of uniform or weaponry. As the death toll mounted, earlier, more jingoistic images of battle gave way to more searing and meditative compositions, which Wellington House found increasingly hard to accept. Officials asked artists to repaint works and, in C. R. W. Nevinson's case, censored a painting showing dead soldiers by forbidding its London exhibition, as we see below.

In March 1918, the government formed the Ministry of Information, with the Canadian-born Max Aitken, Lord Beaverbrook, as minister. The resulting British War Memorials Committee took over some of the aspects of the Wellington House operation and in effect did away with pictorial propaganda. The new committee was to assemble a collection of war art as a memorial to the conflict. It developed plans for a grand Hall of Remembrance. Artists were to create canvases the size of Paolo Uccello's *Battle of San Romano* in the National Gallery (2 x 3 metres). The Canadians, again led by Beaverbrook, had already decided on a memorial art gallery for works on the scale of Diego Velázquez's *The Surrender of Breda* in the Prado (3 x 3.5 metres).

Under Beaverbrook's stewardship, the British programme identified the topics for paintings: army, navy, air force, merchant marine, land, munitions, clerical and other work by women, and so-called public manifestations. While the intention was to create a legacy of achievement in war, the goal was also to use the most talented people to reflect the best art of the day. The programme offered £300 plus expenses for a single painting intended for the Hall of Remembrance. The earlier scheme had given the same sum as an annual salary in exchange for a person's entire wartime output. In the end, the Canadian programme, which had started earlier, produced more completed oversize canvases. The British generated seventeen large pieces, twelve small ones, and two

sculptural reliefs. The Armistice ended the scheme, and the works produced and most of Britain's official war art from 1914 on became the core art collection at the Imperial War Museum.

Men at War

The earliest British war works emerge – in approach, if not in subject – from the existing artistic environment. Walter Sickert's brief commitment to war art, for example, was intriguing, given that he resolutely opposed war. Fear that his German ancestry might become an issue may have provoked his involvement. He temporarily set aside his previous interest in working everyday urban life as he prepared a massive canvas inspired by the invasion of Belgium. *The Soldiers of King Albert the Ready* (1914) reconstructs an event he did not witness.[1] Yet he expended much effort in studying the component parts, making many drawings and studies of uniform details, for example. As with the war art of so many people, his compositional inspirations are clearly Goya's *Third of May, 1808* (1814) and Manet's *The Execution of the Emperor Maximilian* (1867). His challenge was to transform executioners into heroic figures, fighting on the 'right' side. In this, the work brings to the fore one challenge for war art. Good killing and bad killing are determined only by the perspective that is taken, so how to differentiate them for the viewer? In Sickert's composition it is the detail that clearly delineates where the viewer's sympathies should lie. The soldiers here are identifiably on the Allied side and therefore positioned to be viewed positively by an Allied public.

C. R. W. Nevinson responded strongly to Italian futurism, and his wartime paintings show both his early infatuation and his rejection of it. He experienced the battlefield as an ambulance driver, and what he saw of the human dimension of war made it harder and harder for him to reduce it to purely mechanistic art. In *Returning to the Trenches* (1914), columns of blue- and red-garbed, rifle-toting soldiers march left across the picture plan, echoing Marcel Duchamp's *Nude Descending a Staircase No. 2* (1912) and Umberto Boccioni's *Charge of the Lancers* (1915).[2] Such canvases obtained Nevinson work as a British war artist, but he did not produce what programme officials expected. *Paths of Glory* (1917) was his most controversial piece.[3] The style is distant from futurism and broadly traditional. Two soldiers in British uniform lie dead in a muddy, barbed wire- and stake-laced landscape. The realism of the dead soldiers and the fact that they do not look like heroes seem to have been the main objection. When Nevinson proposed to include the painting in a one-man show at the Leicester Galleries in London, the War Office objected. The artist insisted on including it but he affixed a large piece of brown paper over the canvas reading 'Censored'.

Sir William Orpen also experienced censorship and had to repaint one commission. His experience underlines the difficulties artists had working in any official capacity with its attendant agendas. Though closely associated with the war programme, he was

born and raised in Ireland and returned there regularly. In 1915, he volunteered for the British Army Service Corps; in 1917, the Department of Information appointed him an official war artist. There are seemingly two dimensions to his war work. One group of paintings focuses on ordinary soldiers. The monochromatic *Changing Billets, Picardy* (1918) depicts a soldier embracing a young local woman – presumably in farewell – while a comrade lying on the ground near a flooded crater looks on indifferently.[4] In the background, bright searchlights criss-cross a dark sky. In wartime, the work seems to imply, pleasures are fleeting, and people must take comfort where they can.

Orpen's other subjects were largely official portraits. His final, massive composition – *To the Unknown British Soldier in France* (1921–1928) – presenting a tomb guarded by two dead companions, was incredibly popular, but problematic for officialdom.[5] In order for the Imperial War Museum to add it to its collection, Orpen had to paint out the two somewhat disreputable and accusatory, semi-naked soldiers guarding the flag-draped tomb and the two *putti* fluttering above it. He thereby removed the subtle and ironic commentary on war and made the painting a site of respectable public memory. The removal of the two 'Tommies' excised any realistic depiction of a soldier's life in the Great War and reduced it to romantic memory.

Eric Kennington, invalided out of the Kensingtons' Regiment in 1915, painted a large composition on glass based on his six-month experience. *The Kensingtons at Laventie* (1915) portrays a group of soldiers who have spent time at the front in the bitter cold of winter.[6] The artist depicts himself to the left in a blue balaclava looking as worn out and numbed as his colleagues. The glass exaggerates the harsh tonal contrasts: the soldiers are almost in silhouette against white walls and snow. None looks at the others; each just thinks to himself. One, exhausted, has collapsed in a heap on the cold ground.

9. Eric Kennington, *The Kensingtons at Laventie* (1915).

Henry Tonks took the depiction of the soldier further vis-à-vis the wounded. He had first qualified as a doctor and then turned to art, ending up as principal of the Slade School in London, England. His combined skills allowed him to record in a detached manner soldiers' horrific facial injuries both before and after surgery. The majority of these works are at the Royal College of Surgeons in London and, partly in deference to Tonks's concerns about their content and about subjects' and viewers' sensibilities, remained out of sight for decades – an interesting example of self-censorship, which can be compared, perhaps, to Goya's decision not to publish *The Disasters of War* in his lifetime. In both cases, the artists realized that society would not accept the publicizing of the horrific consequences of war.

The Landscape of War

The paintings of Nevinson, Kennington, Orpen, and Tonks tend to focus on people. Paul Nash turned to the landscape of war, which had made a huge impression on him. In a letter to his wife, Margaret, he described what he saw at the western front:

> Evil and the incarnate fiend alone can be the master of the ceremonies in this war; no glimmer of God's hand is seen. Sunset and sunrise are blasphemous mockeries to man; only the black rain out of the bruised and swollen clouds, or through the bitter black of night, is fit atmosphere in such a land.[7]

His art echoes these nightmarish sentiments with its emotional responses to these landscapes.

Born in 1889, Nash joined up in 1914 but did not see action until 1917. Injured within three months, he was sent back to Britain and later became an official war artist. He returned to the front shortly after the Battle of Passchendaele (autumn 1917), which had left the Belgian battlefield a muddy, waterlogged, treeless cesspool. *We Are Making a New World* (1918) depicts the site's terrible beauty, while the title comments ironically on what the war was doing.[8] *The Menin Road* (1919) details the common experience of battle for the British Tommy.[9] Water-filled craters, limbless trees, dead vegetation, mud, broken pieces of corrugated iron, misshapen blocks of concrete, searchlights, smoke, exploding shells, a copse of dead trees, and a chilly blue sky form the backdrop for two tiny soldiers who seem to be moving quickly across this danger-filled ground.

Stanley Spencer experienced the war at first hand as a medical orderly in Macedonia in 1916–1917. His most important work on the subject, *Travoys arriving with Wounded at a Dressing-Station at Smol, Macedonia* (1919), came long after the Armistice. This first commission flowed from Beaverbrook's involvement in the British War Memorials Committee and his intention to duplicate Canada's planned memorial gallery in London. Spencer's subject drew on his recollections of an event in Macedonia.[10] He remembered

10. Paul Nash, *We Are Making a New World* (1918).

rows of mule-drawn travoys (a form of stretcher) carrying the wounded lined up awaiting access to the brilliantly lit operating theatre (in fact an old Greek church) beyond. The painting observes the scene from above, showing the casualties under their blankets at their most pained and vulnerable. Their helplessness contrasts with the resolute actions of the orderlies, with red crosses on their sleeves. Curiously, we see humanity not in the human presence but in the cocked and attentive ears of the mules that wait patiently at the entrance – perhaps the most famous mule ears in art history.

Like so many post-war artists, writers, and soldiers, Spencer sought to give form to his own war experiences. He found the perfect opportunity in his commission to decorate the Sandham Memorial Chapel in Burghclere (1927–1932). Giotto's Arena Chapel in Padua (1303–1305) was a structural inspiration, as were Beaverbrook's memorial-hall conceptions. Eight arched painted panels, each with a matching predella, line two sides of the sanctuary, which ends in a massive work, *The Resurrection of Soldiers* (1928–1929). Spencer produced a highly autobiographical series of paintings despite the building's dedication to Henry Sandham. In fact, while its structure and the resurrection scene suggest a narrative on the meaning of war, some of the mundane subjects – filling tea urns, scrubbing the floor, washing lockers, reading a map, and making a fire belt – clearly derive from the artist's own experiences. This is perhaps what is so attractive about the work. Grandly conceived perhaps, yet its subject matter speaks to the everyday undertakings of men in war; uniquely the artist strips them of the layers of significance that traditionally accrue to them.

The American but British-based John Singer Sargent found, as had many First World War artists, a challenge in the emptiness of the war landscape. 'The further one goes the more scattered and meagre everything is,' he noted. 'The nearer to danger, the fewer and more hidden the men – the more dramatic the situation the more it becomes an

empty landscape.'[11] Sargent received a commission to paint *Gassed*, a massive frieze in which blindfolded soldiers cling to each other's backs as they move haltingly forward.[12] *Gassed* was the only oversize painting completed for the never-constructed British Hall of Remembrance.

The Canadian Official Scheme

Today, Britain and Canada are regarded as two separate nations and it has been largely forgotten that a majority of the Canadian Corps were British-born and British subjects and that the greater number of the war artists employed by Canada were British. In recent years, new scholarship has recognized the importance of the British work painted for the Canadian scheme. It is a significance that lies in the fact that, of the two memorial art galleries proposed for each country's capital, the Canadian one resulted in considerably more completed commissions. The result was close to forty oversize paintings, the vast majority painted by British and not Canadian artists. For many of these artists, the Canadian commissions are among their finest works. A recent example that highlights the significance of the rediscovery of this body of British work is William Nicholson's *The Canadian Headquarters Staff* (1918), which was exhibited in London for the first time since 1919 in 2004, to widespread appreciation.[13]

Canada's official war art programme remains the visual measure of the country's wartime achievement. The model for the British and Australian schemes in both the First and Second World Wars, it produced nearly 1,000 works by over 100 artists, only a third of them Canadian, most of the balance being British. Not only does it powerfully capture Canada's part in the conflict, but it also helped shape the development of Canadian art. Much of the familiar landscape art of the celebrated Group of Seven, for example, owes its genesis to what members saw and recorded in the mud and trenches of the western front in France and Belgium.

The collection was the brainchild of Sir Max Aitken, later Lord Beaverbrook. Born in Canada in 1879, he made a fortune as a businessman in the country's early years of expansion. After moving to Britain, he acquired an interest in the *Daily Express* in 1911, buying it outright in 1916 and using it as a vehicle for his ideas and to extend his influence. Beaverbrook's genuine nationalist fervour spurred his decision – also in 1916 – to initiate and take responsibility for a project to record the war from Canada's point of view. The result was the Canadian War Records Office to document the conflict in film, photography, and print, an organization not unlike Britain's Wellington House. Beaverbrook's media interests made him ideal for heading such an effort. His experience with a mass-circulation daily paper meant he also knew what engaged people's interests.

The horrific German gas attack on the Canadians during the Second Battle of Ypres in April and May 1915 convinced him of the need to add art to the programme's arsenal:

there were no photos of the gas attack. So, in November 1916, his new Canadian War Memorials Fund commissioned a huge painting, 3.7 x 6 m, from British society artist Richard Jack. The success of this canvas, combined with the prevailing belief that the life-span of large-scale photos was no more than twenty-five years, contributed to Beaverbrook's commissioning of more artists, both British and Canadian, to record Canada's war. He and his art adviser, Paul Konody, art critic at the London *Observer*, thought in terms of large paintings. However, they also felt that artists should spend time on the battlefield making sketches for archival purposes, which they might later turn into bigger works.

While supportive of Beaverbrook's initiative, Sir Edmund Walker, chair of the board of trustees of the National Gallery of Canada, and Eric Brown, the director, sought to ensure that the programme reflected Canada's role in the conflict. They worried that it commissioned too many Britons. Walker's correspondence with Beaverbrook on the subject resulted in the Canadian War Artists Advisory Committee. The committee looked principally to the western front but also at women and the home front. Four future members of the Group of Seven received commissions: A. Y. Jackson, Frank Johnston, Arthur Lismer, and Frederick Varley. In 1917, Beaverbrook hired Jackson, then a soldier recovering from wounds of June 1916, who painted in France and Belgium twice. In 1918, under the committee's aegis, Walker helped ensure a commission for Frederick Varley, who was with the Canadian Corps in August 1918, when it began its advance from Amiens, France, to Mons, Belgium, during the Canadian-led offensives, 'The Hundred Days', that ended the war. Varley created some of the bleakest, most moving, and starkly vivid works to come out of the war on any side. Walker's committee also enabled Arthur Lismer to execute memorable wartime images of Halifax, Nova Scotia, while ensuring that Frank Johnston spent several months documenting pilot training at various bases in Ontario. Commissioned women artists such as Henrietta Mabel May focused on female war workers.

Religious Iconography

Christian iconography is particularly visible in the paintings commissioned for Canada's never-built memorial art gallery. There are two reasons for this subject matter. First, religious practice in general revived in the Great War, conveying meanings understood in a Christian context, which could be effectively translated into art. Second, that so much exists in such massive paintings is because the Canadian plan for a memorial art gallery went further than the British one. And it was British artists who received most of the commissions for the large-scale paintings intended for its decoration. That so many of these works are so unknown in Britain is a consequence of three factors: the influence of modernism, the fact that the memorial was never built, and the ensuing long-term storage that was so many of these canvases' fate.

The revived religious sensibility assisted wartime church and government. It initially allowed them to rationalize a conflict that had undermined many basic Christian tenets and challenged the state's moral authority. Authorities could equate a soldier's death in battle and the resulting grief at home with Christ's agony on the Cross and his mother's sorrow. Some of them argued, especially from the pulpit, that, just as Christ's Crucifixion reflected a larger purpose and demonstrated God's love, so too did the sacrifices of war. Throughout the war, the Cross conveyed the idea that the slaughter was not senseless, but redemptive.

The comparison between the Christian struggle and the soldier's goes back to St Paul's Letter to the Ephesians, chapter 6, verse 11, where Paul calls on the faithful: 'Put on the whole armour of God, that ye may be able to stand against the wiles of the devil.' Dürer's *The Knight, Death, and the Devil* (1513), for example, makes the relationship crystal clear.[14] The subject is an allegory on Christian salvation. Unflustered either by Death, who is standing in front of him with his hourglass, or by the Devil behind him, an armoured knight is riding along a narrow path, accompanied by his loyal hound. This represents the steady route of the faithful, through all of life's injustices, to God, who is symbolized by the castle in the background. In the scene, the dog symbolizes faith, and the lizard, religious zeal. Four hundred years later, the relationship of religion and soldiering took on a new life, as we can see in much of the work completed for the Canadian programme.

Judging by the proportion of modern and traditional commissions, the Canadians clearly favoured a narrative of sacrifice, stalwart endeavour, and recognizable achievement over world-class modern art. The sacrifices of war, couched in quasi-religious terms, called on traditional modes of representation and included emblematic material less challenging to viewers than newer, more avant-garde content. This difference of approach implies that the art of war is as much about viewers' expectations as about the artist's perceptions or feelings. After the war, however, the more modern pieces gained in reputation, while the traditional compositions became virtually unknown. It was not the subject that mattered, but artistic merit, a situation that only recently has begun to be re-examined in the wake of the ongoing deconstruction of the modernist canon.

William Roberts's *The First German Gas Attack at Ypres* (1918) draws on traditional images of the Last Judgement, particularly on Michelangelo's rendition in Rome's Sistine Chapel.[15] The imagery of the Last Judgement employs a widely understood symbolism centred on notions of good and evil and Heaven and Hell. Using this imagery as a visual metaphor for gas warfare lets us grasp instantly one of the conflict's most horrific weapons in all its ghastliness.

David Bomberg's *Sappers at Work: A Canadian Tunnelling Company* (1919) depicts – for Canada's programme – construction of a tunnel at St Eloi on the Ypres salient in the spring of 1916.[16] The sappers burrowed deep under enemy lines, where large mines

could destroy the defences. It was deadly, dangerous work. The subject of this painting is not Christian, but it draws on well-known religious iconography. The tunnel's support structure resembles a veritable forest of Calvary crosses, imbued with a symbolism connected to terrible injury, sacrifice, and painful death, often suffered alone. One of Bomberg's favourite paintings was the Spaniard El Greco's *Christ Driving the Traders from the Temple* (c.1600), which inspired the first, rather abstract version of *Sappers*.[17] He found the commission problematic, and the final version shows the artist in the lower right carrying a heavy beam, like Christ on the road to Calvary.

Charles Sims's *Sacrifice* (c.1918) draws explicitly on Christian imagery.[18] A crucifix splits the vast painting in half; on it we see from behind the dead body of Christ overlooking the corpses, the dying, and the wounded half-buried in the mud and swamp of the western front. Below the Cross the mourners – mothers, children, and the elderly – both grieve and continue their work. Above the arms of the Cross hang the coats of arms of Canada's provinces. The artist's own son died in the war, which adds to the pathos for those who knew or now know.

The theme of mourning at the foot of the Cross is also implicit in John Byam Shaw's *The Flag* (1918).[19] Here, a young, dead Canadian soldier clutches his country's flag as he lies between the vast paws of a sculpted metal lion (clearly from Nelson's Column at Trafalgar Square, London), and his family mourns. However, the dead man is more reminiscent of Christ in the Virgin Mary's arms at the foot of the Cross – the traditional *pietà*. Like Sims's work, the subject acquired additional poignancy when the artist's two sons who served as models died in the Second World War.[20] Nonetheless, its popularity was brief. Surviving loans records at the Canadian War Museum indicate that between 1962 and 1998 the painting had no showings.

Another British work from the Canadian programme quite clearly exploits its Christian iconography. When the Canadian War Memorials' 1919 exhibition moved to New York from London, organizers pulled Derwent Wood's bronze sculpture *Canada's Golgotha* (1918) from the display when the Germans protested that the event depicted had never occurred.[21] It shows a crucified Canadian soldier surrounded by jeering Germans.[22] It appeared again in 1992, in a Canadian War Museum exhibition, *Peace Is the Dream*.[23] Here, in a different, more secular time, there was no outcry.

Chapter 4

Other Nations in the Great War and Later

The First World War catapulted the combatant nations into the brand new situation of total war. Millions of people died, and the conflict touched lives in battle and at home across the globe. The world, some said, would never be the same again. Empires fell, families mourned, boundaries moved or evaporated, and the landscapes of the eastern and western fronts changed beyond recognition. New technology in the form of the machine-gun and the tank wreaked destruction.

Even in an age of modern equipment and avant-garde art movements (cubism, expressionism, futurism, and suprematism, to name a few), traditional patterns of behaviour and practice – particularly religious – also endured. This variety of activity and interest informs the art of the Great War, which we can see as both modern and anachronistic at the same time. Because of the war's reach, this chapter explores a wider geographical sweep than any other. While selective, it may convey some of the flavour and context of the many artistic responses to this first global conflagration. We look first at the official war art schemes of two significant Allies to Britain – Australia and the USA; next at notable war artists in Allied nations; and finally at those in Austria and Germany. The final section considers the Spanish Civil War.

Official Artists: Australia and the USA

Official war art schemes, which provided commissions, tended to reduce the number of independent artists available to challenge official views in the public arena. For Australia, and for Britain and Canada (discussed in Chapter 3), the official programmes helped shape their cultural landscapes during the twentieth century.

From 1917 to 1919, Australia's official war artists created more than 400 pictures.[1] The programme began when Charles Bean, the Australian official war correspondent

and later the country's official historian, proposed an Australian War Records Section to collect papers, photographs, and battlefield relics. The Section also commissioned soldier-artists to sketch the events around them whenever they could. Following the British and Canadian examples, Australia established a programme of war art in London in 1917. The expatriate artist Will Dyson was its first nominee and went to the front. He worked initially in a civilian capacity and without pay but received official status in May 1917. In September, two more Australian artists living in London, Fred Leist and H. Septimus Power, became official war artists. Fred Leist was a well-established graphic artist who worked in a figurative tradition. He produced evocative and richly coloured watercolours of war-ravaged towns and landscapes in Belgium and France. A number of these he painted on grey paper, which intensifies the gloomy subject matter.

Australian artist Arthur Streeton, also dwelling in London, pressed for expansion of the new programme: writing to the Australian high commissioner in London, he argued for employment of the nation's most talented artists. The programme named him, George Bell, Charles Bryant, A. Henry Fullwood, John Longstaff, and James Quinn – all London-based expatriates of some standing – to work on the western front. They became honorary lieutenants but received higher pay than that rank ordinarily allowed. Their appointments were usually for three months and required production of at least twenty-five works, which the artist could exhibit. They were free to depict any subject in any medium within their specialist genre – landscape, still life, or portraiture.

Streeton went to France in May 1918 and worked mostly around the Somme battlefields. Like many Australian war artists, he chose watercolour, so that he could swiftly capture a scene on paper. The war paintings show his continuing interest in the play of light so prominent in his earlier landscapes of the Australian Heidelberg School. In his second stint, November–December 1918, he depicted the ruins around Péronne, France. Fellow artist A. Henry Fullwood had joined him in May 1918. As with many war artists, authorities would not allow Fullwood to go to the front. Many of his landscapes show fighting in the far distance. Yet he was able to capture the mood, as in his late-war depictions of Solrée-le-Chateau and Ypres during his second commission.

Other artists contributed to Australia's visual record of the war. Charles Bryant, the country's leading marine painter, joined up in December 1917 and was to portray naval activities at the English Channel ports in Boulogne and Le Havre, France. He sensitively captured the bustle of the wharves and the range of atmospheric effects; he used a brightly coloured, impressionistic palette for camouflaged hospital ships. George Lambert's evocative Palestinian landscapes changed attitudes to depiction of the Australian outback. Iso Rae was already living in Étaples, France, when she completed pastels of local military scenes while a voluntary aid worker.

As far as the USA was concerned, there were no substantial official art schemes equivalent to the Australian, British, or Canadian programmes to allow artists to visit the front or experience a soldier's life. However, in July 1917, the Committee on Public

Information proposed that the US Army Signal Corps send four artists overseas. Separately, General John Pershing suggested that four artists be sent to the front under the direction of the Army Corps of Engineers. The two concepts were in effect combined and eight men (seven of whom were civilians) were selected and given the rank of captain in the Engineer Reserve Corps and tasked with documenting the war efforts of the American Expeditionary Force. They were William Aylward, Walter Duncan, Harvey Dunn, George Harding, Wallace Morgan, Ernest Peixotto, J. André Smith, and Harry Townsend. They reported for duty in March 1918 and were sent to France. There, they shared two cars, and passes enabled them to move about relatively freely. Generally they made sketches in the field, some of which they worked up into finished paintings after the war. They produced just over 500 works, which the Army turned over to the Smithsonian Institution in 1920. This material is now in the custody of the Museum of American History in Washington, DC.

Given that six of the artists had previously worked as book and magazine illustrators, it is not surprising that their work is illustrative. The initial reaction to it from their superiors was disappointment. The artists themselves were overwhelmed by the subject matter they found, which they did not find particularly compelling in terms of its lack of scenes of action and preponderance of ruins and churned-up landscape. Since the purpose of the commissions was to obtain artwork suitable for propaganda, the lack of available human-interest subjects was initially challenging. An examination of the artists' finished compositions suggests that access to photographs probably ameliorated the situation.

Unofficial Artists: Allied Nations

On the American side, anti-German feeling provoked other forms of artistic expression. US artists designed posters (discussed in Chapter 9) and responded to newspaper reports about the war. Atrocity tales involving their Allies encouraged enlistment and also fired the brushes of American artists. When the country entered the war on 6 April 1917, George Bellows took as his initial subject the murder of British Red Cross nurse Edith Cavell in October 1915.[2] He depicted her just before her death as an angel-like form at the top of a flight of stairs illuminated from below as though on a stage set. In 1918, he responded to the earlier wartime reports of German atrocities in Belgium by creating, in just six weeks, fourteen lithographs – *War (The Tragedies of the War in Belgium)* – that chronicled the horrific acts of the German invaders. The same year, Bellows began five large-scale oils based on images in his lithographic series. *The Barricade* (1919) depicts a group of naked Belgian men, women, and children forming a human shield in front of a group of Germans to protect the latter against Belgian guns.[3] Its gesturing central figure and the position of the German weapons suggest an artist familiar with Goya's *The Third of May, 1808* (1814).

The war also enabled artists, including Americans, to apply new approaches to war art. Inspired by impressionist precedents, Childe Hassam rendered a series of flag-encrusted paintings, emblematic of Allied solidarity. *Red Cross Drive*, for example, depicts a virtual ocean of flags bedecking the sides of a New York street.[4] Thomas Hart Benton enlisted in the US navy right at the end of the war; his task was to sketch at the naval base in Norfolk, Virginia. One assignment permitted him to sketch camouflaged troop ships as they entered the harbour. There is a looseness and expressionist élan in such watercolours as *Impressions, Camouflage: WW1* (1918).[5]

Among independent US artists, only Marsden Hartley could claim any direct experience of military enthusiasm, even militarism. In Berlin in 1913, he responded to the art of Russian Vassily Kandinsky and the German Blaue Reiter group. By 1913, Kandinsky had determined that abstraction was the most effective stylistic means through which to express what he wanted to say about his world and what he wanted by way of viewer response. He believed that this inter-relationship operated at the level of the sub-conscious. Led by Kandinsky and German artist Franz Marc (who was killed in the war), Der Blaue Reiter (The Blue Rider) was a group of expressionist artists, one of whose primary goals was to use art to express spirituality. Hartley's *Portrait of a German Officer* (1914) is in essence a painted collage in a broadly abstract style.[6] The canvas's bright colours and shapes suggest indifference to the approaching war. Hartley later painted more than a dozen emblematic works, his 'War Motifs'. Among these so-called German Officer paintings, the extant fourteen celebrate male comradeship and eulogize Hartley's late friend the officer Karl Von Freyburg, perhaps his lover. Their evocation of German militarism and imperialism was not initially well received in the USA, because the paintings differed so radically from the German stereotypes the American public expected to see.

Russia maintained an official war art programme, but some expatriate artists, the Russian equivalents of Hartley in Berlin, capture the initial national response to the war. These creative people could not know the horrors to follow: mass killings and dislocations, broken homes, shattered families, and ultimately revolution and war combined. Marc Chagall, for example, found himself isolated in his home town of Vitebsk for the war's duration, although Paris was now his home. He observed the conflict's initial impact on his community in a series of moving drawings that focus on themes such as leave-taking. Natalia Goncharova, also unexpectedly back in Russia, responded immediately to events with a print series – *Mystical Images of War* (1914) – a rather medieval view of a crusade, with God's blessing.[7] Kazimir Malevich, clearly influenced by cubism and Picasso, portrayed a new recruit non-figuratively in *Private of the First Division* (1914); an abstracted mixture of collage and drab paint surfaces describes the young man.[8]

The war provided the Italian futurists with the mechanistic subject matter of their dreams. Artists such as Giacomo Balla and Filippo Marinetti incorporated their new,

11. Gino Severini, *Armoured Train in Action* (1915).

modern ideas about what art should be into their paintings. Gino Severini's *Armoured Train in Action* (1915), for example, shows a train passing below the viewer's gaze in the manner of a gun barrel.[9] Soldiers crowd the centre of the train's roof, their faces blank as they shoot at an unseen enemy. In the background the steam and smoke of train and battle become a balletic pattern of curves and lines. The emotional component in the work is expressed in line, colour, and form and not via the traditional means of figurative gesture and expression. Here, the human component is reduced to the same rigidity and metallic construction as the train. Initially, such approaches to the subject of war, which reduced human content to design elements, inspired other western artists, but as the war dragged on and the horrors increased, many painters returned to more traditional approaches as they found that tragedy and grief demanded a familiar and more traditional visual language in order to be understood. To do otherwise was to make light of human devastation, many believed. Furthermore, the few national programmes (the source of commissions) for the most part sheltered older approaches.

The experience of France reminds us that not all soldier-artists painted during the conflict. Thus the nation could not fully explore the possibilities of war art. Georges Braque and André Derain, for example, joined up together in August 1914. Braque, severely wounded in 1915, endured a long convalescence but apparently painted nothing during the war. Derain, demobilized after the Armistice, produced no war pieces that survive. Fernand Léger's treatment of the players in his long-planned *The Card Game* (1917) reduces his figures to mechanical components. Completed after he was gassed and invalided out, it perhaps speaks to a general loss of humanity in war; the artist saw the post-war world in less sombre tones.[10]

Félix Vallotton was one of several French artists who established a documentary magazine called *The Great War by Artists*. His official visit to the front in 1917 led to the searing *Verdun, an Interpreted Picture of War* (1917).[11] In it, brilliantly coloured searchlights illuminate an inferno of a landscape engulfed in black clouds. No humans

are present, only innumerable broken and scarred trunks of trees. Georges Rouault, in contrast, seems to have sought justification for the horrors that he witnessed. In his crucifixion etching, *'Obedient unto Death, even the Death of the Cross'* (1926), he perhaps found hope in the resurrection of Christ, if not explanation for the tragedy of war.[12]

Artists in Austria and Germany

As the conflict dragged on, Austria and Germany and the other opposing countries had less need to commemorate victories and successes in art or memorial art collections, despite having official programmes. Losing affected their monuments too; their cemeteries are simpler than those of the Allies and lack much suggestion that the dead served a good and just cause. Nonetheless, soldier-artists who found their war experiences difficult or shocking discovered later that their pictures of tragedy and brutality touched audiences in the cultured classes of their former enemies. It was all right to oppose war if you were from the losing side – it was tantamount to being on the right side. Most Austrian and German war art that has attracted broad recognition opposes war and, because mostly unofficial, it tends to be avant-garde. Much emerged after the war. The prime exception is Dada, a protest movement that originated in Zurich during the war but rapidly expanded elsewhere in Europe. Its followers mocked the conflict, bourgeois society, and conservative traditional thought. Absurdities and non sequiturs marked the artworks created, which, in sculptures and installations also included random 'found' objects, and which, in performances, defied any intellectual analysis.

The Austrian Oskar Kokoschka enlisted in the Austro-Hungarian cavalry and in 1915 received serious wounds on the eastern front. Back in service by 1916, he suffered shell shock. Just before he joined up he had painted the prophetic *Knight Errant* (1915): a helpless soldier lies on the ground in a desolate landscape.[13] Albin Egger-Lienz rendered the war as a struggle to the death that involved the near-suppression of human feeling. The massive *The Nameless Ones, 1914* (1916) reveals a denuded landscape of brown earth over which soldiers relentlessly struggle forward, bent double, bleeding onto the soil, and looking like Van Gogh's *Reaper (after Millet)* (1889) repeated ad nauseam.[14] Austrian expressionist Egon Schiele attempted to become an official war artist but found himself assigned instead to prisoner-of-war duty, where he painted sympathetic portraits of his Russian charges, whom he came to admire. These are gentle in comparison to the jagged lines that typify his self-portraits and erotic compositions.

Otto Dix dominates the German war record. He is perhaps the conflict's most powerful artist. Dix joined the German army in 1916 and stayed with it to the end, winning the Iron Cross, second class. Throughout his service, he drew – sometimes on the back of postcards – using charcoal or a soft black pencil. Inspired by the Italian futurists, he looked for dynamic scenes of fighting, shellfire, and destruction. His post-war prints

draw instead on anti-establishment Berlin Dada and on social-realism. After Callot and Goya, he is the greatest of all anti-war printmakers. As Goya paid homage to Callot, so too did Dix to the Spaniard in his fifty-print series, *War* (1924).

Dix's prints grew from his wartime experiences and combine etching and aquatint. Some subjects receive sparse treatment, while others are rich in tone and texture. Many capitalize on Dix's interest in the grotesque and the absurd. The prints vary in size, but all dwell on the experience of ordinary soldiers. We see them moving forward, wearing gas masks, frightened, resigned, dead, even drunk. At no point do we see them as heroes. When they are dead, maggots gnaw at their entrails; when alive, they are unkempt, unhealthy, poorly equipped, and wallowing in horrific trench conditions. Like Callot and Goya, Dix often intensifies the drama and emotion by starkly contrasting an image's dark and light areas. Often the scene is night, and only the light of an unseen moon gives shape to the churned-up stretches of no man's land and the skulls of the slain.

12. Otto Dix, 'Wounded Soldier (Autumn 1916, Bapaume)' (1924).

In Plate 6 of *War*, 'Wounded Soldier (Autumn 1916, Bapaume)', a face right out of a horror movie, with wide, staring eyes, a gaping mouth, and dishevelled hair, clutches his jacket across his shoulder.[15] Sticking out of the jacket is an arm, but with the hand turned the wrong way round: perhaps completely detached from the soldier's body. The man's figure consists of short, sharp staccato lines, while the aquatint softens the background by way of contrast. Splotches of revealed white paper suggest explosions in the background; perhaps one caused his terrible wound.

In 1934, and coinciding with the rise of Nazi militarism, Dix began his crucial *Flanders* (1934–1936).[16] In a panoramic view of no man's land, only small, glittering patches of water and the occasional shattered tree enliven the relentless brown of the beaten-up ground. The soldiers are almost at one with the mud in which they sit. The artist wanted them to remain somewhat visible to reinforce the message that war is traumatic. On the

stump behind the central soldier, a small twig suggests Christ's crown of thorns at his Crucifixion. The painting owes much to Henri Barbusse's famous anti-war novel, *Le Feu* (1916), in its rejection of any heroic portrayal that might justify the war. At the same time it pays homage to German history and culture, even in its bleakest moments, as its bright and possibly optimistic background echoes that of Albrecht Altdorfer's *The Battle of Alexander at Issus* (1529), discussed in Chapter 1.

Max Beckmann found nothing redemptive in war. *Resurrection* (1918), a vast canvas intersected by groups of people in various stages of despair, is a bleak and complex meditation on the unattainability of salvation.[17] War achieves nothing but death, it argues. Ernst Ludwig Kirchner, a central figure in the German expressionist group *Die Brücke* ('the Bridge'), would have agreed: war service brought about his complete breakdown, from which he never entirely recovered. Erich Heckel, another group member, might have begged to differ. While his work as a medical orderly put him face to face with numerous men who had suffered terribly, he was able to portray sympathetically what he witnessed.

Max Ernst, in contrast, saw the machinery of war as a continuing threat. *Celebes* (1921), with its massive green metallic monster at the centre, presents the danger as ongoing and substantial.[18] Even Max Slevogt, an official war artist, had misgivings about the war's conduct. The fate of his twenty-one lithographs – *Visions* – hints at why official war art has a low reputation in Germany. Clearly influenced by Goya's *The Disasters of War*, Slevogt condemned the conflict in his prints, which the government confiscated. In *The Answerable (The Unknown, Masked, Wades with Innumerable Corpses on His Back through a Sea of Blood)* (1917), he presents a future for the war of more bloodshed, suffering, and death.[19]

War changed Dix and many fellow artists, and the war pieces of some of them. Grosz and Beckmann, for example, evince a late maturity. George Grosz's *Punishment* (1934) is an apocalyptic vision of conflagration, portraying attacking aircraft, fire and smoke, and destruction.[20] We can speculate that it not only reflects on the past war but also offers a warning about the war to come.

The Swiss artist Paul Klee was working in Germany when he was called up by the German Army in 1916 but he did not go to the front. His war work reflects the tenets of Dada but introduces a lyrical, childlike element, whose appeal belies the serious commentary contained within it. *'Once Emerged from the Gray of Night'* (1918) is a patchwork quilt of colour and delicate lines that together resemble a stained glass window.[21] Above the painting, Klee has attached a poem that speaks to the inability of the artist to truly capture the nature of the war except through abstraction. In this work, Klee addresses a central debate of twentieth-century war art: whether it is realism or abstraction that can best convey war's fundamental truths.

The Spanish Civil War

While close to twenty years separates the 1918 armistice from the start of the Spanish Civil War, only a year separates completion of Dix's *Flanders* from the Spaniard Pablo Picasso's *Guernica* (1937). War and its art do not run their courses together. Picasso painted his celebrated war image in response to the bombing of Guernica in northern Spain on 27 April 1937, but it is a direct successor to Dix's composition.

As in the rest of Europe, so in Spain the 1930s was an intensely ideological era, with political radicalization and growing social disorder. The Civil War began on 17 July 1936, when a group of right-wing officers staged a coup against the constitutional Republic. The event immediately cast half of Spain against the other. The rebellion initially succeeded in about one-third of the country, but the rest resisted, including most major cities – Barcelona, Madrid, and Valencia. The resistance found its leaders in popular militias organized by radical trade unions that armed for the occasion. As a result of their role, communists and especially anarchists and revolutionary socialist organizations became the de facto power in the main centres of Republican Spain. With comparatively few military professionals at its disposal, the Republic called on common people to enlist in its defence. Along with press and radio, posters were a principal means of seeking support. In the midst of a barely controlled and often-dangerous revolutionary euphoria, trade unions and political parties also promoted themselves, issuing numerous posters calling for backing.

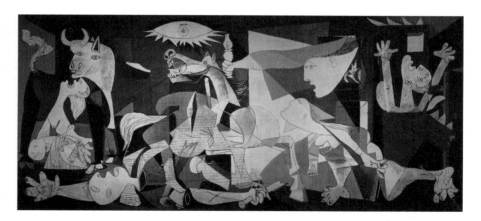

13. Pablo Picasso, *Guernica* (1937).

Guernica is a work of protest.[22] Picasso painted it for the Spanish Pavilion at the Paris International Exposition in 1937. However, he forbade its return to Spain until democracy returned, which it did only after the death in 1975 of the fascist dictator Francisco Franco. *Guernica* owes much to poster art. The posters for the two sides in

mid-1930s Spain are blunt and forceful in their art and iconography. Elements of these appear in the shapes in Picasso's piece. *Guernica* also evokes newspapers – through the areas that resemble newsprint and in the overall use of black-and-white imagery, much of it immediate and shocking, which resembles newspaper photography.

While the meaning of some of the motifs is not immediately obvious, other aspects of the composition are less ambivalent. On the ground lies a dead warrior, still clasping his broken sword in his right hand. On the viewer's left, a mother mourns her dead baby while, on the right, flames engulf a screaming figure, arms upraised. In the centre, a horse shrieks in agony, with a lance-like pole rammed into its body, while another figure attempts to flee. Here also, an arm thrusts a torch over the scene as if seeking physical and metaphorical illumination in a world succumbing to the dark.

The year 1937 is critical in the history of war art. In two different countries two events initiate future creative paths for the genre: Picasso's *Guernica*, likely the most famous anti-war painting of all time, is completed and exhibited in Paris; in Munich, the exhibition, *Degenerate Art*, opens and temporarily buries the reputations of many leading German artists, including Otto Dix. Both events speak to the political power of art in a time of conflict. Both make art an instrument of propaganda. For the balance of the twentieth century, the division between official war art and unofficial, often anti-war art, is not ambiguous.

Chapter 5

The Second World War

Four Allied National Programmes

The Second World War (1939–1945) brought total war to the world. The unimaginable conflagration that had been the First World War seemed doomed to be repeated. The media, in the form of radio, film, photography, and newspapers and magazines, brought it relentlessly into people's homes and lives. Not only were the war casualties high, but the number of civilian deaths also was shocking. Nonetheless, this conflict was not a surprise for many observers, and authorities had to some extent anticipated its consequences. The plans for war art reflected this attitude. Those countries that valued their First World War art established well-thought-out programmes with need and goals similar to those in the previous conflict. Many of these goals related to national identity and the record of history, while others, perhaps less laudatory, had to do with keeping artists alive.

Australia, Britain, and Canada, inspired by their First World War successes, adopted and adapted many elements of their successful art programmes from the Great War. As a result, official schemes dominate the Allied war art of the Second World War. The US programme, in contrast, operated officially only intermittently and obtained most of its support from *Life* magazine and Abbott Laboratories. This chapter examines the war art of all four nations – Australia, Britain, Canada, and the USA.

Most combatant nations recorded their involvement in the conflict in paint, ink, and pencil or crayon during and after the war. Germany's substantial official programme resembled its Allied equivalents. Its collection is in the custody of the Bavarian Army Museum in Ingolstadt, near Munich. The French also had a programme; so did Italy and New Zealand. There is also a collection of Japanese war art in Tokyo, some of it very much reflective of Asian art traditions. A great deal of the official war art is illustrative rather than innovative, although there are exceptions. Much of the official Soviet war art was finished after the war and tends to the heroic. The British programme generated

a number of interesting compositions, perhaps because of the involvement of Kenneth Clark, who sought the very best artists.

Britain: Clark, the WAAC, and the Works

Soon after war broke out in 1939, Kenneth Clark, director of England's National Gallery and the dominant figure of British art, persuaded the Ministry of Information to establish a small committee to consider the employment of official war artists. The goal of the resulting War Artists Advisory Committee (WAAC) was 'to draw up a list of artists qualified to record the war at home and abroad ... [and] to advise on the selection of artists from this list for war purposes and on the arrangements for their employment'.[1] The first part of this section explores Clark's efforts at the WAAC, which helped transform British art; the second, artists on the home front; the third, overseas work.

Clark had found inspiration in Lord Beaverbrook's First World War Canadian scheme and its one hundred or more artists. He also learned from the US government's Depression-era Public Works of Art Project, under the auspices of the Works Progress Administration, which had hired thousands of artists to decorate civic buildings.

Government circles in Britain grasped the need for and potential scale of such a project: 'The camera cannot interpret, and a war so epic in its scope by land, sea and air, and so detailed and complex in its mechanism, requires interpreting [by artists] as well as recording'.[2] Clark marshalled his political skills and influence to hatch the scheme at the outbreak of hostilities, cleverly selecting committee members from a variety of interested parties – the London art schools, the Royal Academy, the armed forces, government ministries, and the Imperial War Museum.

The scheme's overall intention was to create a historical and artistic record of Britain's involvement in war and to bolster morale through exhibitions and publications. Clark hoped also to support and enable the production and purchase of high quality art that expressed Britain's liberal cultural values, as opposed to the Nazis' controlled and centralized aesthetic. Clark aimed his vision primarily at an educated art audience that, following the First World War, would reject overt propaganda. The committee avoided commissioning or accepting anything overtly didactic or obviously morale-raising. In addition, throughout the war, it prepared and toured exhibitions overseas, notably to North and South America, to influence that hemisphere and build support for Britain and, by default, the Allies' struggle.

Clark's vision and the overall goal shaped what emerged: a somewhat sentimental view of Britain at war. Most of the artists employed supported the war, and so their paintings are not generally confrontational, critical, or violent. A further, subtle objective of the programme was to keep artists from risking death or dismemberment, although three died on active duty.

Clark's long-term agenda to develop and exploit growing interest in the visual arts included a programme of wartime exhibitions that transformed British visual culture. The WAAC programme, as intended, both appealed to its audience, when other forms of popular entertainment largely avoided the subject of the war, and broadened it by cultivating a new public for gallery visiting. The National Gallery, its valuable historic collections safely stored outside London, provided an ideal space to show new paintings. Public interest resulted in media coverage that made the war art and artists quite well known. By 1945, the programme had employed 300 of the 2,000 artists who had applied, and completed works exceeded 6,000 by 1946.

As we saw above, Clark had chosen influential people in art, government, and the armed forces for the WAAC. The Treasury provided artists with materials, places to work, transportation, and some income. The Ministry of Information organized operations and ensured necessary permits to allow participants to sketch Britain at war. Its War Artists Section even looked after artists' bureaucratic problems vis-à-vis income tax or exemption from military service. Some artists went on salary for up to six months at a time, transferring everything they produced in that time to the crown. The committee commissioned other artists to produce specific works on certain topics. It also looked at paintings that artists submitted and occasionally purchased them, and acquired work from other artists, many in active service, and gave out permits to enable them to work in restricted areas. As with the First World War programme, artists employed a variety of styles, from traditional to more modern. Their contracts or commissions required them to produce specific types of works – canvases or works on paper, for example – but they chose style, quantity, and subject matter. They included many high-profile artists, but abstract painting did not fit into the programme, thus excluding even Ben Nicholson.

The WAAC wanted eyewitness works and frowned on reconstructions of scenes that the artist had not viewed or experienced. The fact that British art was relatively traditional furthered this objective and helped ensure the programme's success as a record. Most compositions adhered pretty much to the representational.

The programme effectively encapsulates contemporary artistic practice in the United Kingdom. Stanley Spencer's dramatic, teeming shipyards vie with the empty desolation of Graham Sutherland's neo-romantic cityscapes and landscapes. Paul Nash's carefully constructed imagery, which sought to embody British resistance, contrasts with Edward Ardizzone's intimate scenes of daily life. Other artists recorded aspects of economic and domestic life, revealing complex new wartime arrangements and values. They resolutely looked behind the scenes at every dimension of a modern industrial nation attempting to exploit its resources to the full. The subjects of their portraits are also new – not the higher ranks, but dispatch riders, auxiliary fire fighters, and air raid wardens.

Distant and dangerous terrains also challenged their compositional abilities. Edward Ardizzone, Henry Carr, Leslie Cole, Anthony Gross, Eric Ravilious, Leonard Rosoman, and Carel Weight all started the war at home but then travelled to such places as North

Africa, Italy, Greece, northern Europe, Norway, and the Far East. They explored places and ideas that were less certain, or entirely unfamiliar. Their compositions reveal their struggle to combine national priorities with artistic vision; to balance duty to record and interpret with military security and individual dignity; to weigh technological developments against the resulting widespread destruction and chaos; and to judge new industrial practice by its impact on society.

The collection surveys the experience of civilian and military life and captures the national mood and responses to the war, as well as shaping the collective memory of it. Individuals appear at their most vulnerable and courageous. The collection illustrates the reality of modern war, the displays of force, the fear and the tedium, how the familiar could juxtapose with the utterly strange and new, and how extreme needs and everyday routines shaped lives. Total war ordered lives completely: an economy and an entire population endured all its consequences.

Total war produced a new iconography. In Britain, depictions of industrial sites and workers took on urgency: the public wanted to be sure about the capacity to produce armaments and their effective use. These images reveal working environments, relationships between buildings and their functions, and connections between individuals and technology. They also show new roles for women, from menial tasks with the Auxiliary Territorial Service to complex factory work, while their children explored the new nurseries – temporary support structures that would not threaten established social roles when peace returned.

The home front attracted major artists and significant commissions. Paul Nash, an acclaimed artist during the First World War and a pioneering force afterwards, worked on Royal Air Force subjects and produced some of the finest paintings of the war. Nash, like many artists, grasped the importance of the events he witnessed: his *Battle of Britain* (1941) majestically reveals the possibilities of art engaged with history.[3] His huge, contemporaneous canvas of the English Channel and France grabs the viewer and encapsulates the battle's scale and crucial role. It also restates the value of art and the urgent need to defeat Nazism. Nash, a fierce critic of the conduct of fighting on the western front in the Great War, steadfastly abhorred Nazi Germany and its culture. In this painting, light-hued Allied fighter planes break and defeat the regimented patterns of the dark-toned Luftwaffe.

Nash's *Totes Meer* (Dead Sea) (1940–1941) is of a different order.[4] Here, the shoreline on the right holds back waves composed of aircraft wings and fuselage. The icy-green metallic sea stretches back to low, dark red hills over which hangs a waning moon. Nash described it thus:

> The thing looked to me, suddenly like a great inundating sea. You might feel
> – under certain circumstances – a moonlit night for instance, this is a vast tide
> moving across the fields, the breakers rearing up and crashing on the plain.

And then, no; nothing moves, it is not water or even ice, it is something static and dead. It is metal piled up, wreckage.[5]

Compared to some of Nash's later, cartoon-like aircraft in watercolour, this visionary work is a serious and compelling update on his First World War compositions. His 1944 *Battle of Germany* combines the abstraction of *Totes Meer* with the drama of *Battle of Britain*.[6] A full moon hangs over a barely recognizable landscape surrounding an area of water profoundly agitated by explosions and smoking, downed aircraft. It was a measure of Nash's belief in the propaganda value of his images that he wanted them produced as postcards and dropped over Germany to demonstrate the fate of anyone who attempted to attack British shores.

Another artist re-commissioned for another world war was Stanley Spencer. Between 1940 and 1946, he completed his massive sequence of eight mural paintings depicting the shipyards on the Clyde at Port Glasgow.[7] While the approach is characteristically his, with its exaggerated gestures, attention to detail, and slightly caricature-like figures, his varied viewpoints on work and the graceful link between figures and tasks are elegant. Spencer responded to the community he found there and respected the complexity of shipbuilding. The resulting detail is highly revealing, yet his technical and imaginative virtuosity so successfully melds the detail that the viewer can grasp and feel the shipyard experience.

Henry Moore's two wartime series of drawings – of shelter and of coal mining – established his reputation. During the Blitz (1940–1942), up to 100,000 people were sheltering down below in London's Underground on any given night. In this subject Moore found a match with his figurative sculptural forms. Using wax crayons, watercolour, and ink, he developed an immediately recognizable graphic style. *Pink and Green Sleepers* (1941), for example, shows two sleeping figures covered in blankets.[8] The figure on the viewer's right gently rests a hand on the other's chest. The drawing has a very graphic feeling, as Moore delineates the arms with bracelets of line rather then by contour.

Edward Ardizzone also painted underground. *In the Shelter* (1940), a view inside a blockhouse shelter during the London Blitz, exemplifies the government's anxiety to show how civilians coped under fire and how it had provided for their defence.[9] Ardizzone preferred to depict scenes such as this. 'I feel strongly about the illustration of violence. Often suggestion is enough.'[10] His painting is typically humorous and tender; in uncomfortable conditions two adults, asleep standing, balance precariously above a child, while the figure behind them snores.

The wartime vulnerability of children is a focus of artists' interests. In *A Nursery-School for War Workers' Children* (1942), Elsie Hewland shows a cloakroom at a nursery school, with children putting on their uniforms and exploring their environment.[11] The painting hints at the changes not just for the youngsters but also for their mothers,

called into unfamiliar duties. Nursery schools were a new, essential, but temporary support for women conscripted into full-time employment, with over 1,300 of them established by 1943. In *A Child Bomb-Victim Receiving Penicillin Treatment* (1944), Ethel Gabain's image of the child's treatment shows her isolated, amid weights and levers and drips that balance and sustain her.[12]

Some female artists painted women at work. While Dame Laura Knight portrayed the war crimes tribunal at Nuremberg, her most celebrated commission is *Ruby Loftus Screwing a Breech-Ring* (1941).[13] Loftus was an outstanding factory worker who had mastered complex engineering skills very quickly, and Knight, who had never depicted industrial machinery, received praise for her technical accuracy.

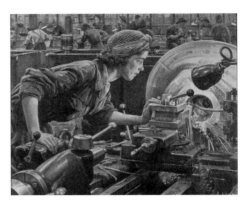

14. Laura Knight, *Ruby Loftus Screwing a Breech-Ring* (1941).

The artist and writer Mervyn Peake, invalided out of military service, joined the Design, Poster and Visualising Group of the Ministry of Information in 1942. During the war, his first two volumes of poetry appeared. He also illustrated a number of books and started writing the first book of the *Gormenghast* trilogy, *Titus Groan*. The WAAC commissioned him to paint in a glass factory. *Glass-Blowers 'Gathering' from the Furnace* (1943) shows part of the production of cathode-ray oscillation tubes.[14] The manufacturing process, and workers' balletic skills, fascinated Peake.

Graham Sutherland was one of the century's major British artists. His wide range of wartime commissions included drawing blitzed cities and tin mines. After peace came, he designed the tapestry *Christ in Glory* for the new Coventry Cathedral. Responding to suffering and loss through art could be difficult for him – even drawing his own possessions damaged by bombs in the East End. Thus his 1941 image of a twisted lift (or elevator) shaft, painted just north of St Paul's Cathedral, suggests something positive emerging from the area's devastation.[15] He has animated the twisted structure, creating a presence that both threatens new life and implies its possibility. He explored the deserted, foul-smelling area with growing confidence during the Blitz.

Duncan Grant was part of the Bloomsbury Group of artists, critics, and writers that included Virginia Woolf. He was a conscientious objector during the First World War. In the Second, the WAAC gave him two commissions, one a painting of St Paul's.[16] Surrounding Blitz damage opened up new and dramatic views of the cathedral. Kenneth Clark wrote to Grant:

I know you have painted St. Paul's a great many times but I hope you will not mind painting it once more because I don't think it has ever looked more beautiful than it does rising out of this sort of Pompeii in the foreground and the Pompeii has all the elements of colour which I think you enjoy painting.[17]

Many people believed that the Blitz was allowing artists to see something new, something worth painting, but so unfamiliar that they struggled to know where to begin. Grant's emphasis on the aesthetic gives the painting a strange slant. Yes, it makes the cathedral look impressive so strangely exposed, but its symbolic values and its evocation of a ruined city impress the viewer just as much, if not more.

Before going overseas, Henry Carr painted scenes in the capital throughout the blackout, including such public spaces as St Clement Danes, St Pancras Station, and the Underground. He was desperate to see that war artists recorded the everyday toil of servicemen and women, believing the subject of great public interest. In *Incendiaries in a Suburb* (1941), workers surround a fallen tree, civilians put out street fires, and distant industrial sites burn.[18] This is a jarring image, as ordered life is under threat – street lighting has given way to fires, and quiet living to rapid action – while the city that sustains them faces destruction. Carr's rapid brush strokes and scratching of the paint surface heighten the sense of urgency.

Overseas, life as a war artist was not always easy. Edward Bawden was an official artist with the British Expeditionary Force before the army sent him to the Middle East. The ship on which he was returning to England in 1942 was torpedoed, and he spent two months in a camp outside Casablanca, Morocco, before the Americans liberated it. He returned to the Middle East in 1943, travelling from Iraq to Kurdistan, Iran, Saudi Arabia, and Italy. In *Refugees at Udine* (1945), an Italian scene, refugees – former slave labourers – gather uneasily in the compound, some around a Catholic priest, who is giving instructions.[19] The Polish prisoners of war (POW) still wear their striped clothing. The refugees are behind wire fences and under armed guard, perhaps to prevent their escape or to protect them.

Paul Bullard served in the Royal Artillery and was a POW in Italy. *British Prisoners of War, Italy* (1946) shows the interior of a POW hut filled with framed wooden bunk beds.[20] The composition conveys stubborn coping and restless waiting in a constrained life. Disrupting, even subverting the apparently endless, machine-like structure of the bunk beds are draped laundry and flailing arms; the steep perspective offers a vanishing point, an illusion of escape.

Leslie Cole was a salaried war artist with an honorary commission as a captain in the Royal Marines. He travelled widely, recording the aftermath of the war in Malta, France, Greece, Germany, and the Far East. He did not return to Britain until the spring of 1946, having seen Bergen-Belsen concentration camp and Japanese POW camps in Singapore. *British Women and Children Interned in a Japanese Prison Camp, Syme Road,*

Singapore (1945) shows the interior of a wooden hut, with skeletal figures carrying out daily domestic activities.[21] The Japanese interned British civilians in Syme Road when Singapore fell to them in 1942. After liberation, inmates remained there, having nowhere else to go. The painting has a motif of cleansing; a bath filled with water, swaths of white sheets, and draped washing suggest quiet redemption from the dark days of imprisonment. However, it is the familiar gestures and activities of the stick-thin women and children that unsettle the viewer.

Anthony Gross received several proposals for commissions before becoming an official artist in the Middle East, India, and north-west Europe. *Battle of Arakan, 1943: Men of the 7th Rajput Regiment Resting on South Hill with a Parasol Captured near the Mayu River on the Rathedaung Front* (1943) is an example of his work in Burma illustrating British and Indian commitment to the area.[22] The parasols of a geisha who had been entertaining Japanese troops holding a nearby village were booty from a night raid on a nearby enemy camp. Their prominence signifies the success of the soldiers' skill and daring.

In 1944, the WAAC offered Leonard Rosoman a commission as an artist attached to the British Pacific Fleet, sailing for Sydney and Japanese waters before visiting Hong Kong. Rosoman travelled with the fleet to Australia and from there visited Hong Kong, where the landscape and post-liberation mood caught his eye. *A Crater in the Naval Dockyard, Hong Kong* (1945) exposes the wooden structure underneath the dock and the metal cables within the concrete.[23] The destruction looks like a tentacled sea creature, which contrasts with the calm, restored order of the junk boats in the harbour.

Two war artists died on assignment. Eric Ravilious was an official war artist, with the Royal Navy and then the RAF, until a flying accident killed him off Iceland in 1942. His *HMS* Ark Royal *in Action* (1940) is a cunning design that plays with the light and sound of gunfire, and it also captures the terror invoked by the weapons' awesome firepower.[24] This work has a sublime beauty: the ship has frightening strength, and the bright explosion conceals the crew's precarious position, utterly dependent on the metal ship.

Albert Richards enlisted early and, before becoming an official war artist, was three years a sapper and one an engineer parachutist. His compelling works on parachute training use innovative techniques. He would rub a wax candle into the paper in a wax-resist method to animate the composition and to suggest the surface of a glider canopy or a vehicle. Along with many other artists, he discovered that a black background helped unify a composition and prevent the intense war colours – the yellows and oranges of fire and active destruction – from obscuring its meaning. Looking for subjects, in 1945, Richards drove into a minefield near the Maas River in the Netherlands and died instantly. He was twenty-six.

Carel Weight's experiences give some sense of the WAAC's control. He received a number of separate commissions throughout the war, including the series of four paintings entitled *Recruit's Progress*, before becoming an official artist in 1945. In

Recruit's Progress: Medical Inspection (1942), where the new recruit, painfully uncomfortable in his situation, attempts to talk his way out of the procedure, the humour made the imagery acceptable to the WAAC.[25] The committee had rejected an earlier painting of a London trolley bus attacked in broad daylight by a German fighter; it feared the work might lower morale.

Australia: The Australian War Memorial

During the war, the Australian programme expanded to thirty-five artists, including three women. The Department of the Interior originally ran the scheme, but control, including the appointment of artists, passed to the Australian War Memorial in 1941. The key managers and shapers of the project were veterans of the Great War; all had experience in collecting relics and records and had been active in the memorial's development. The Memorial's art committee had three members: Charles Bean (the nation's official war historian); General Sir Harry Chauvel (the Australian commander in Egypt and Palestine during the First World War); and Louis McCubbin (an artist and director of the Art Gallery of South Australia).

With the assistance of the conservative Commonwealth Art Advisory Board, the art committee created lists of potential artists. McCubbin had firm views: younger artists rather than previous appointees, and art that was emotional as well as documentary. Bean supported shorter stints, to involve more artists and a number of categories: portraits, figures, genre, industry, landscape, and marine subjects. The early choices tested the programme and raised many issues: relations with the military, status of artists, working conditions, length of employment, availability of art materials, transport and accommodation, rates of pay, access to the front line, traditional versus contemporary artists, and uncertainty about results.

The Memorial's Military History Section seconded artists from the army, navy, or air force. Works also entered the Memorial's collection through schemes initiated by the Royal Australian Air Force War History Section, the Royal Australian Navy Historical Records Section, and the Allied Works Council. The Memorial has continued to acquire non-commissioned art for the Second World War collection, resulting in a portrayal reflecting many views of war.

Some of Australia's finest artists served in the war. Sidney Nolan worked as a labourer and a guard in Australia. His notable *Dream of the Latrine Sitter* (1942) reveals him sitting on a toilet lost in contemplation.[26] Defective eyesight kept Russell Drysdale from serving, but his compelling images of the home front include his iconic portrait of a weary soldier and his kitbag.[27] The figure is lean, uniformed, and somewhat heroic. A contrasting icon is William Dobell's *The Billy Boy* (1943) – a Glaswegian Irishman who enjoyed political arguments far more than making tea.[28] The man is rotund and sports a tattoo and casual dress. Overseas, Murray Griffin, after capture, sketched harrowing

scenes in the notorious Changi prisoner-of-war camp in Singapore, while Alan Moore painted the horror of Bergen-Belsen after its liberation by the British.

Women artists also covered the war experience officially and unofficially. In England, Stella Bowen struggled to complete a painting of a bomber crew killed during the course of the commission.[29] In Sydney, Margaret Preston depicted the city's new defence structures. In New Guinea and Australia, Nora Heysen produced memorable portraits of working servicewomen. "The conditions were tough and your paintings almost went mildewed overnight up in that climate," she recalled in 1994.[30]

Canada: Learning from the Great War

Canada's Second World War art programme differed greatly from that of the Great War. There are no huge memorial compositions focusing on destruction, tragedy, and misery. Instead, over 5,000 small paintings emphasize locations, events, machinery, and personnel on all fronts. Like the earlier scheme, however, the new plan depended on a committed few. The central player was Vincent Massey, Canada's high commissioner to Britain. When London's National Gallery exhibited some of its initial Second World War works in December 1939, Massey suggested that Canada should institute its own project. The Department of National Defence responded with indifference. Meanwhile, H. O. McCurry, Eric Brown's successor as director of the National Gallery of Canada, began lobbying.

Yet Massey and McCurry did make progress, and Canadians were soon producing war paintings. A number of artists had enlisted in the armed forces and, inspired by the First World War programme, contacted McCurry about becoming artists in uniform. McCurry passed their offers to National Defence Headquarters. There, Colonel A. F. Duguid, director of the historical section of the general staff, employed Private E. J. Hughes and Sapper O. N. Fisher to depict activities in the army. In England, Massey arranged for Trooper W. A. Ogilvie's attachment to Canadian military headquarters as an artist.

Major C. P. Stacey became the Canadian army's historical officer in London in late 1940 – and a valuable ally for Massey and McCurry. One of Stacey's first tasks was to coordinate the work of the notable English artist Henry Lamb, who, as part of the British art programme, agreed in 1941 to paint the Canadian army in England. Convinced of the project's historical value, Stacey helped formalize the employment as war artists of Hughes, Fisher, and Ogilvie in early 1942, and of Lawren P. Harris later, all as second lieutenants. Nonetheless, and despite support from the Canadian art establishment, the war's first three years saw little recording activity.

Late in 1942, the indefatigable Massey again tried to organize a programme. His request reached the desk of his old friend Prime Minister William Lyon Mackenzie King, who finally approved it. The government set up the programme in January 1943, with a committee – McCurry and senior military personnel from the three services – to

run it from Canada. In Britain, Massey was the guiding light; officers in the services administered the programme. Stacey, for example, continued to direct the army's official art programme. It was a huge endeavour, generating archival records in the form of hundreds of letters from service personnel, units, and newspapers requesting work or information; innumerable notes from staff officers regarding movements of war artists; and file after file of war art listings, photographic records, and requests for loans.

The official war artists – all officers and eventually numbering thirty-two – received rank, pay, supplies, and instructions; they came almost evenly from the three services and served in all the western theatres of war, including Britain, Italy, north-west Europe, and the Atlantic Ocean. The army started with the most artists in the field, followed by the air force. The navy programme was the last one up and running. The only woman artist, twenty-three-year-old Molly Lamb, formerly a private in the Canadian Women's Army Corps, went overseas only after the war in Europe ended in May 1945. The programme initially neglected the home front and, in particular, the women's military services – with nearly 46,000 female personnel by the end of the war. McCurry recognized this oversight but only in 1944 hired artists such as Pegi Nicol MacLeod, who painted the women's services in Ottawa.

The artists' work assignments closely resembled those of their Great War predecessors; their instructions specified size of works, quantity, and subjects and left little room for interpretation. Most artists, steeped in landscape, had little preparation for this subject matter. Accuracy was paramount, and participants prepared thousands of small, detailed sketches of equipment, vehicles, and uniforms. Their finished oil compositions reveal how well they adapted; creativity and record combine in images sensitive to both history and art.

Official army artist O. N. Fisher was unusually innovative. In preparation for the D-Day invasion on 6 June 1944, he strapped tiny waterproof pads of paper to his wrist. After racing up the beach from his landing craft, Fisher made rapid, on-the-spot sketches, using perfectly dry materials, of the battle unfolding around him. Later, he created larger watercolour paintings, carefully noting on their backs the time, date, location, event, and names of units. Historical officers for the same units would assess such works for accuracy and any breach of censorship before forwarding them to London.

After May 1945, the artists returned to Canada, where the military provided them studio space to complete canvases based on their earlier work. Despite restrictive instructions, new subject matter, and dangerous surroundings, the war artists produced a visual record that documents the experiences shared by many of the 1.1 million Canadians who served, including the more than 42,000 of their comrades who died.

The USA: Public and Corporate Programmes

The Depression and the resulting federal sponsorship of public art had stimulated the

notion that artists could serve in times of crisis. The Second World War fused the ideas of artists' public service and federal (military) backing with corporate sponsorship in the national interest. In 1941, *Life* magazine commissioned artists including Floyd Davis, Tom Lea, Fletcher Martin, Paul Sample, and Byron Thomas to present their nation preparing for war. Artists Griffith Baily Coale, a well-known muralist, and Barse Miller also made contributions. *Life* was in for the conflict's duration, joined by (at times) the War Department, the services, and Abbott Laboratories.

In fact, the Navy Combat Art Program started in 1941 through Griffith Baily Coale's insight and persistence. Believing US involvement in the war to be imminent and pleading to have competent artists available, he convinced the navy to send artists into the field, including Coale, William F. Draper, Mitchell Jamieson, Albert K. Murray, and Dwight C. Shepler. The navy eventually had eight active-duty artists. From their experiences, they created an invaluable, if traditional and somewhat illustrative, record of all phases of the war and all major naval operations.

In November 1941, the army compiled a list of artists. The programme was under the umbrella of the War Department Art Advisory Committee (WDAAC), which included established artists such as George Biddle and even a writer, John Steinbeck. The committee hired twenty-three serving artists and nineteen civilians, who served in a number of theatres until Congress cut funding in August 1943. By that time participants had produced 2,000 works that sympathetically portrayed the events of war from an American perspective.

Yet work continued, inside and outside the army. *Life* picked up the cancelled programme and again commissioned artists. It sent George Biddle to Sicily and seventeen artists to other theatres. The magazine worked with the army, which provided transportation and accommodation to the artists. Other army artists continued to paint, even without any formal programmes. These included Jack Levine (Ascension Island), Edward Reep (North Africa and Italy), Sidney Simon (Pacific), Manuel Bromberg, Olin Dows, Albert Gold, and Frede Vidar. When Congress reauthorized the programme in 1944, many of these army artists simply continued work under the new umbrella.

Concurrent with these events, in February 1942, the Office of Emergency Management opened an exhibit of war art at the National Gallery in Washington, DC. Over 1,000 artists submitted 2,582 pieces. The venture's success encouraged *Life* to hold a competition in April 1942, which solicited entries from artists with field experience. *Life* remained a catalyst vis-à-vis war art. Its earlier commissioned paintings – 125 in all – went on view at the Metropolitan Museum of Art in New York in July 1943. This show inspired a competition called 'America in the War' organized by Artists for Victory; the winning entries toured to twenty-four cities beginning in the autumn of 1943.

Abbott Laboratories also commissioned some of the most popular US artists to document the work of the army's medical staff and navy. Participants included Howard Baer, Robert Benney, and Joseph Hirsch. Navy subjects included naval aviation,

medicine, submarine service, and the US Marines. Abbott worked with the Associated American Artists and the military services, which ensured artistic competence and access to combat subjects. The collections of the various US services now include the *Life* and Abbott commissions. *Life*'s contribution was 1,058 paintings by twenty-seven artists. In total, the US Army Art Collection has over 6,000 works, and the navy 8,000. The air force and the Marine Corps also have substantial paintings collections. Together they portray the US experience of the Second Word War in a generally positive and, if occasionally negative, certainly a heroic light.

'Total war' is a term used in connection with the Second World War. In the twentieth century, it can be defined as warfare in which vast human, material, and emotional resources are marshalled to support military effort. Industrialization, technological innovation, and organizational capacity make it possible. The war art projects of the 1939–1945 conflict, as we have seen, reflected many of the elements that define total war. The official programmes were complex operations involving hundreds of artists and support staff operating in intricate logistical webs that directed where the artists went, what they did, and what happened to what they produced. That there is no developed alternative to these extensive activities in the form of anti-war art shows the degree to which artists, as a community, committed themselves to the war.

Given what was accomplished, it was natural for Allied countries that established war art programmes during the two world wars to re-establish them in later conflicts. However, by the end of the twentieth century, as we shall see in the next two chapters, the British programme stood alone in its commitment to contemporary art. Other nations, such as Australia, ran relatively conservative programmes, which were somewhat balanced by the purchase of works from more avant-garde artists. For other nations, however, war art was independently produced in a majority of cases. Germany's, for example, emerged in a national climate that was challenged by its memory of the war. Interesting work that has been very little studied also appeared in Eastern Europe – for example, in Macedonian artist Vasko Taskovski's dramatic *Riders of the Apocalypse* (1971).[31] Here the machinery of war and the dead meet in an inferno of colour and light.

Part III

War Art since 1945

Chapter 6

British and American War Art

1945-1989

'Now I have become death, destroyer of worlds,' observed J. Robert Oppenheimer when he saw the first nuclear explosion. He was paraphrasing the sacred Hindu text, the *Bhagavad-Gita*, and commenting ironically on the belief of many scientists in the Manhattan Project that they were creating a safer world. Certainly this was what the governments involved wanted the public to think, although it seems clearer over time that the scientists understood the impact of what they were doing.

The possibility of a nuclear holocaust has dominated the world since 1945. The bombing of Hiroshima and Nagasaki in August 1945 had demonstrated what a nuclear bomb could do. Politicians of all persuasions in the West argued that nuclear armaments in the hands of an opposing power would lead to another world war and untold loss of human life. Deterrence was the only answer, many governments argued, as they stockpiled supplies and ringed their territories with defensive missiles. In the wars in Korea (1950–1953) and Vietnam (1957–1973), a different issue faced the western nations – the containment of Communist expansion. After the collapse of the Soviet bloc beginning in 1989, a new threat to western security emerged in Afghanistan and Iraq. Except for Afghanistan, concern again centred largely on nuclear capability. The USA, Britain, and thirty-three other countries participated in the first Gulf War (1991). The destruction of the World Trade Center in New York on 11 September 2001 led to the invasion of Afghanistan and was subsequently used as part of the justification for the invasion of Iraq in 2003 under the command of American and British forces. The various conflicts, interventions, and new domestic security arrangements since then have gained a collective name, the war on terror.

The following two chapters examine artistic responses to the post-1945 conflicts. War art differs radically between the UK and the USA in this period. Much contemporary British work has emerged under the lead of the Imperial War Museum in terms of com-

missions and acquisition. US work operates largely on two fronts: official war art, under commission by the various services, and anti-war, which many art institutions collect. Both chapters touch on the underlying politics – for example, the military's ongoing and often blatant attempts to ensure that commissions reflect its viewpoints. We also question war art's veracity as historical record and ask ourselves to consider its value as an eyewitness account and the degree to which such work fictionalizes events.

The Holocaust

Although the Holocaust is an event of the Second World War, knowledge of the extent of its atrocities belongs to the post-war period. In Germany, a degree of guilt continues to drive its people's ongoing involvement in this national legacy. Georg Baselitz, for example, reduced the issue of how to paint it to whether the artist should paint figures at all. In the face of this mass annihilation, which had seen millions killed and then reduced to ash, how could the figure, in his opinion, ever carry the weight of history and culture again. Baselitz introduced the concept of the patched-up hero who, for him, represented the German people's ambition to recover by acknowledging and understanding how they had knowingly destroyed their culture and millions of people in the first place.

The Holocaust is a subject that artists such as Anselm Kiefer have returned to over many decades but from the point of view of the perpetrator rather than the victim. Born just months after Germany's defeat, Kiefer grew up in a country divided between the prosperous West and the Communist East that struggled after 1989 to reunite itself. In exploring the interwoven patterns of German mythology and history and the way they spurred the rise of fascism, Kiefer violated aesthetic taboos and resurrected sublimated icons. In his 1969 photographic series *Occupations*, reflecting his participation in the 1960s protest culture, he photographed himself in different locations striking the Nazi 'Sieg Heil' pose. His aim, however, was to ridicule. The gesturing figure lacks the usual accompanying pomp and ceremony and instead looks rather foolish. Later paintings – immense landscapes and architectural interiors, often encrusted with sand and straw – invoke Germany's literary and political heritage and include references to Wagner's music, Albert Speer's architecture, and Adolf Hitler.

In *Shulamite* (1983), Kiefer transforms Wilhelm Kreis's design for the Funeral Hall for the Great German Soldier into a death camp oven.[1] *Seraphim* (1983–1984) is part of Kiefer's *Angel* series, which treats of spiritual salvation by fire, an ancient belief that the Nazis perverted into death-camp ovens in their quest for an exclusively Aryan nation.[2] In this painting, a ladder connects a landscape to the sky. At its base, a serpent – symbolizing a fallen angel – refers to the prevalence of evil on earth. According to the Doctrine of Celestial Hierarchy, a fifth-century text, the seraphim 'purify through fire and burnt offering'. Kiefer used fire to create the surface of *Seraphim*, and this and

many other works associate fire with the redemptive powers of art. Here, the association is with the Holocaust and its original historical meaning for the Jewish people of burning a sacrificial offering.

Kiefer's *Poppy and Memory: The Angel of History* (1989) is more of a warning shot than a meditation on history. Here, books hold down the wings of a grounded aircraft and ooze dried poppies – a potent symbol of remembrance. War carries an immense burden in the future, the piece implies, in terms of the memory of what it has involved both militarily and humanly.[3]

American responses have been different. Canadian-born Philip Guston became well known after 1945 in the USA as a founder of abstract expressionism. He had earlier produced work that reflected his personal responses to war. *Bombardment* (1937–1938), for example, addresses the atrocities of the Spanish Civil War and reflects his knowledge of Picasso's *Guernica* (1937) and the politically charged Mexican muralists of the 1930s such as Diego Rivera, whose work he knew well.[4] *Bombardment* depicts civilian panic and horror at the moment of a bomb explosion. Later works respond to events of the Second World War, particularly the Holocaust (he was Jewish), and become progressively more abstract as he treats participants in mock battle or silent witnesses or victims. The 1950s, his period of success as an abstract expressionist, saw no war images. In the late 1960s, the Vietnam War returned him abruptly to figurative approaches using a gritty, almost cartoon-like style. He apparently felt that the world no longer deserved art of beauty and tranquillity.

Some of American Morris Louis's lesser-known work also relates to the Holocaust. *Charred Journal: Firewritten* (1951) is a series of seven small acrylic-on-canvas abstract paintings, each approximately one metre by three-quarters of a metre, reflecting on the Shoah.[5] Louis was Jewish, and the paintings refer to the book burnings by the Nazis. A related piece, *Untitled (Jewish Star)* (1951), clarifies their link to the Holocaust.[6] The works' style owes much to Jackson Pollock, whose first famous gestural abstracts date to the late 1940s. In *Untitled*, a series of crude but energetic lines suggesting graffiti partly erase and obscure the outline of a six-pointed Star of David.

In 1954, a Jewish friend of Jasper Johns commissioned a mixed-media piece on a similar subject from the artist that he entitled *Star* (1954).[7] Its surface also hints at Pollock's free-flowing gestural line. Its subject, however, is unambivalently a Star of David. Its arrangement of one triangle over another to create the star suggests both hiding and revelation.

The Vietnam War (1957-1973)

The beginnings of American unofficial, mostly anti-war art lie in the Spanish Civil War and the Second World War, but the 1960s and the Vietnam War marked its flowering and, beginning with the first Gulf War in 1991, there has been a new efflorescence.

After the Second World War and the prosperity of the 1950s, the USA found itself socially divided not only by the Civil Rights movement but also by the Vietnam War. Public disquiet about war continued, as successive overseas military actions became part of US life. Artists increasingly protested against war rather than accepting commissions lauding the successes of conflict – a trend that started in 1964 with the War Artists and Writers Protest Group opposing the Vietnam War. Many artists participated, and the resulting art is remarkably rich and provocative. One of the features of American war art since 1945 is the presence of many women practitioners.

The US army established the Vietnam Combat Art Program in June 1966 to create a pictorial record of the war. The initiator was a committee drawn from the Army Arts and Crafts Program, the Adjutant General's Office, the Office of the Chief, Military History Center, and the Office of the Chief of Information. The programme asked artists to apply with curriculum vitae and samples of work to the nearest facility of the Army Arts and Crafts programme. A civilian committee led by Eugenia Nowlin, head of the World Wide Army Arts and Crafts programme, and Marion McNaughton, curator of the US Army Art Collection, made selections. The first nine teams of artists spent sixty days each in Vietnam making sketches before transferring to Hawaii for sixty or seventy-five days to work up sketches into more finished compositions.

The navy's Combat Art Program from the Second World War had resurfaced to appoint two military artists in the Korean War (1950–1953), and in the Vietnam War era it employed civilian artists in cooperation with the Salmagundi Club.[8] The navy also began sending artists to cover non-combat activities. During the Vietnam War, North Vietnamese official artists, including Quang Tho, Do Hoai Nam, and Nguyen Toan Thi, worked in representative styles similar to the Americans'. Following the merger of the navy's Combat Art Program with the Naval Historical Center, military artists have gone to US conflicts beginning with the first Gulf War. The air force and the Marine Corps have also continued to employ artists, all focusing on documentary and traditional approaches.

One of the most significant American artists to address the Vietnam War is Nancy Spero. As we see below, she has also dealt with other US incursions abroad and with the Holocaust, as has her husband, Leon Golub.

In an interview she recalled:

> For five years from 1966 to 1970, I painted (gouache and ink on paper) *The War Series: Bombs and Helicopters*. These works were intended as manifestos against our [the US] incursion into Vietnam, a personal attempt at exorcism. The bombs are phallic and nasty, exaggerated sexual representations of the penis: heads with tongues sticking out, violent depictions of the human (mostly male body). The clouds of the bombs are filled with screaming heads vomiting poison onto the victims below, etc. The helicopter becomes

anthropomorphic – a primeval (prime-evil) bird or bug wreaking destruction. I imagined that Vietnamese peasants saw it as a giant monster. I viewed the helicopter as the symbol of this war – the omnipresent image of the chopper hovering, transporting soldiers, napalming villages, gunning fleeing peasants or picking up wounded and dead US soldiers.[9]

As Robert Storr writes in his introductory essay to *The War Series*, 'The Weapon and the Wound', Spero's 150 drawings, like Goya's etchings, fall into the category 'of moral witness'.[10] Her subjects are direct and accusatory, and she makes her point in language that is universal and easy to understand. She expresses her disillusionment cogently and eloquently. In its use of gentle, translucent washes, her technique is delicate. But it is also hard, with its jagged and uncompleted lines like poorly healed scars. Storr suggests that the work of Japanese survivors of Hiroshima and Nagasaki influenced her.[11] She herself has cited the medieval *Beatus Apocalypse of Gerona*, about wars between angels and demons and the terrible fate befalling non-believers.[12] While her subjects are close to Goya's – but clearly of a different age and time – she did not witness first-hand what she depicts as did Goya. Second-hand images bombarded her from the media – newspapers, magazines, and the relatively new television.

Issues of power drive Spero's output, and she sees power as resting with men. By the 1970s, she had excluded images of men from her art. Instead, her gendered work sexualizes the conduct of war; her bombs look like penises. In *The Male Bomb* (1966), an erect penis ejaculates blood and an army of blood-spitting sperm.[13] In *Gunship* (1966), a bird-like blue and grey-white anthropomorphized helicopter spews blood-red corpses from its mouth and ejects skulls and bones from its rear.[14]

The facts that Spero is Jewish and was working as greater understanding of the Holocaust was emerging have also shaped her compositions. The notable trials of concentration-camp planners such as Adolf Eichmann were a feature of the early 1960s. *Victims, Holocaust* (1968) features a Star of David on whose points are screaming heads with pointed tongues.[15] *Crematorium Chimney* (1967) makes a phallic symbol of this icon of genocide.[16] From its base emerge heads with tongues that lick it. Spero commented in a 1994 interview: 'These creatures are the victims coming around and licking the chimney. I think this had to do with the idea of the oppressor and the victim and the terrible symbiosis of that relationship.'[17] To help explain the Holocaust, she combines the image of the male bomb with the Nazi swastika in *Male Bomb/Swastika* (1968).[18] The artist lived in Paris from 1959 to 1964, when memories of the war were still fresh and France was fighting in its (former) colony Algeria. Vietnam was also a former French colony. The Cold War was on, and the great fear was nuclear annihilation.

Spero's *Christ and the Bomb* (1967) refers to the Crucifixion in the bleeding Christ figure that emerges from the pink mushroom cloud at the piece's centre.[19] Her work is unequivocally political: it is a wake-up cry to the USA to beware the consequences

of militarization. Some of her subject matter reduces the terrifying to an insect, a nightmare category of life for many people. *The Bug, Helicopter, Victim* (1966) shows a green, many-legged bug falling into a green mess peppered with broken bodies under a rain of red blobs.[20] Spero wanted to suggest what the war was like for the Vietnamese.[21] But there is also gentleness in some works, as in *Peace* (1968), where a naked male figure, perched on top of a white helicopter, holds aloft in each hand two winged cupids. Beside him on the right, in white paint, is the word 'peace'.[22]

15. Nancy Spero,
Peace (1968).

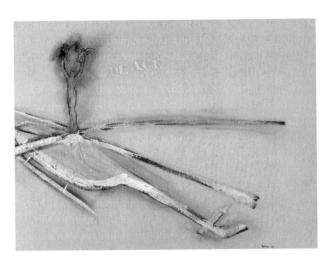

Spero revisited war in a mid-1980s series about American involvement in El Salvador and Nicaragua, but it does not have the urgency and passion of the Vietnam works.[23] Also war-related is the series of installations and related pieces based on Bertolt Brecht's poem *The Ballad of Marie Sanders*, which ran into the early 1990s.[24] The Nazis had tortured the woman for sleeping with a Jew. The photo that inspired Spero's installations came from the body of a dead Gestapo officer. The dead woman's body is bound, naked, and clearly has suffered torture.

The Jewish Museum in Vienna commissioned Spero's 1996 installation, *Remembrance/ Renewal*. It consists of found and reworked photos of a 1938 raid by the Gestapo on Vienna's Jewish community. The artist also alludes to what the city's cultural and social life lost by including images of musicians, dancers, and athletes.

Leon Golub was Nancy Spero's husband, and he had similar concerns to hers. Picasso's *Guernica* has influenced him too.[25] He was fifteen when he saw it at the Chicago Arts Club in 1937. During the Second World War, he was a cartographer with the US Army in Europe. In 1946, he painted a number of works about the Holocaust and the death camps. Like his wife, he produced anti-Vietnam War work following their return to the

USA after spending 1959–1964 in Paris.[26] In *Mercenaries IV* (1980)[27] and *Interrogation III* (1981),[28] Golub continued to protest against war. He was one of the first signatories to a June 2002 petition condemning the Bush administration's policy towards Iraq. He also further explored male domination and power. In a 1994 interview he stated, 'I try to get at male aggression, at how men posture and so on. This is not a theater of the absurd, but the theater of reality, this is the way the world runs, the world as it is.'[29]

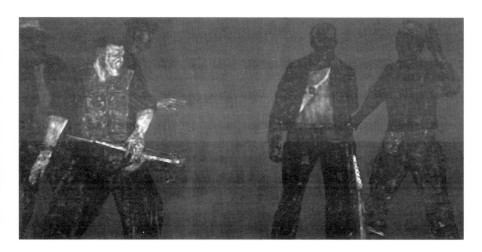

16. Leon Golub, *Mercenaries IV* (1980).

He called his first massive 1960s works on men and war the *Gigantomachy*. In an interview, he explained his sources:

> I began to emphasize ancient sources and started to configure male nudes, warriors or philosophers, partially classical, primitivized, fragmented and eroded, like ancient sculpture. I've never been able to envision a world without stress. I don't see a proleptic vision by which our existence can be redeemed. The *Gigantomachies* are the most irredeemable of all my work, the most difficult to finally acknowledge because they are totally fatalistic. The one positive aspect is that these figures demonstrate energy and endurance.[30]

Gigantomachy II (1966) draws from a long tradition of painting conflict – Greek battle friezes, such as the Pergamon altarpiece, Pollaiuolo's *The Battle of the Naked Men*, the *Gigantomachies* of Giulio Romano in the Palazzo del Te, Nicolas Poussin's *The Rape of the Sabine Women*, Jacques-Louis David's painting of the same subject, and the war art of painters such as Géricault and Delacroix.[31] Works in the 1960s on the Vietnam War

he entitled the *Napalms* after the fiery and destructive chemical fuel. *Napalm III* (1969) is a colour-intensive, emotion-laden narrative on atrocity.[32] *Vietnam 111* (1973) includes even more colour but is less classical and contains elements of theatre.[33]

'In the 80s, with the *Mercenaries* [a subsequent series] I tried to work along the borders, the peripheries – how official power becomes ferocious indirect power,' Golub recalled. 'These paintings state that you cannot see America without seeing the Contras, and everything else that has gone on.'[34] Golub was commenting on US support for opponents of the legal government in Nicaragua. The compositional tension and raw, rough texture of this series emerge slowly. Golub commented cogently:

> I orient the figures as the painting develops, adjusting gestures, leers and grins etc. Original intentions often change considerably. I begin by projecting draw- ings or parts of photographs onto the canvas – each figure is a synthesis of different sources. The drawing is evolved to precise details of dress, weapons, intention and so on. I want each figure to be both the reconstruction of a generic type and to possess an idiosyncratic singular existence. The figures are first outlined and shaded in black. The second coat emphasizes three dimen- sionality and designated highlights. I apply local colour to define skin, wood, metal, cloth. The canvas is put on the floor and paint areas are dissolved with solvent and scraped. The main scraping tool is a meat cleaver. Once the can- vas has been scraped down, eroded – a process which frequently takes two weeks – I reconstruct the figures. I go on doing this, making adjustments. The paintings have a raw, porous appearance. The figures are activated against the surface. There is surprisingly little paint on the canvas; the forms and colours smashed into the tooth of the canvas but, paradoxically, aggressively active on the surface. The final adjustments involve glances, all kinds of acknowledg- ments between these guys, to what extent I take them at face value, to what extent I parody gestures and looks.[35]

Golub's compositions expose the vulgar and gross in human activity. As he said, 'On another level, they can be considered celebratory of these kinds of macho strutting attitudes.'[36] For him, while he refers to past masterpieces, his subjects are typically American. They show the prevalence of violence in American society and that it is a military and paramilitary violence that people learn and act out. 'These paintings could be seen as an inversion of a heroic tradition,' he noted.[37]

Martha Rosler's work falls between photography and art. *Bringing the War Home* is a series of photomontages made between 1967 and 1972. Her pieces set images of Vietnamese atrocities into American dream interiors and draw attention to the jarring contradictions offered by the post-Second World War affluent American lifestyle and its conduct of the war overseas. In one image, a figure cradles a baby-corpse on a shag-

pile carpet. The grafting process of such propaganda recalls its ancestry in the cut and paste of Berlin Dada photomontage and, in particular, the extraordinary work of John Heartfield, born Helmut Herzfeld in 1891, who had, unusually, anglicized his name in response to German Anglophobia during the First World War. He combined whole or parts of photos with text to communicate new messages as a political weapon. One of his celebrated images, *The Meaning of the Hitler Salute: Little Man Asks for Big Gifts. Motto: Millions Stand Behind Me* (1932), shows the yet-to-become powerful Hitler literally receiving banknotes from big business, represented by a huge, unidentified figure standing behind him.[38] Dada was born in a Europe devastated by the First World War and its iconoclastic, ironic, and provocative couplings of objects and images found fertile ground in a similarly distraught and distressed America four decades later.

The Cold War (1947-1991)

The Cold War is a term used to describe the long period in global history in which actual conflict was remarkably absent (hence 'cold'). In essence it was the political and economic struggle between the capitalist, democratic western powers and the Soviet Union (and later other Communist nations) after the Second World War. It was marked by massive military build-ups (including nuclear weaponry) on each side, intensive economic competition, and strained, hostile diplomatic relations. Like the Vietnam War, the Cold War produced a considerable amount of anti-war art, but on both sides of the Atlantic. Much of its expression parallels that of the anti-Vietnam War era. Several artists revived the mocking photomontage techniques that had characterized aspects of post-First World War anti-war art. Artists such as the American Barbara Kruger used text and imagery in the Rosler manner, as in *We Don't Need Another Hero* (1987), which juxtaposes the words with a young boy flexing his arm muscles in front of an admiring girl.[39] Many artists also expressed their objections to both conflicts utilizing the tools of the new abstract movements that had taken root in the western world in the aftermath of the Second World War. A

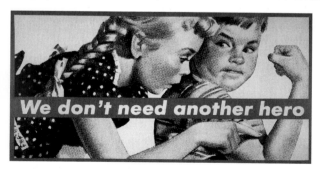

17. Barbara Kruger, *Untitled (We Don't Need Another Hero)* (1987).

group called Fluxus, whose international membership included the influential Joseph Beuys, challenged the new American consumer society though performance, using as

their props and tools its products and culture. In many respects they are the direct heirs to Dada.

In terms of immediate post-war Western European responses, it is difficult to place Pablo Picasso's other massive painting on the subject of conflict, *War* (1952).[40] Its symbolic elements include a horned devil, an armoured warrior, a battle scene, and a chariot set against a threatening landscape and sky. It has been argued that the composition is connected to the Korean War since it followed on a painting specifically responding to this event entitled *Massacre in Korea* (1951).[41] If so, Picasso's Korean compositions are rare examples of any art from this conflict.

Roy Lichtenstein was an American pop art painter whose works, in a style derived from comic strips, portray the trivialization of culture endemic in contemporary American life. Using bright, strident colours and printing techniques, *Whaam!* (1963) renders the anticipated shock and horror of an aircraft under attack and damaged, banal and familiar.[42] Forty years ago, this treatment of a subject so well-known to many viewers familiar with the air battles of the Second World War may have been awkward yet, in the era of the Cold War and the Cuban Missile Crisis (1962), the painting, while pointed, removed real fears to a world of fantasy.

American Robert Arneson's *General Nuke* (1984) addresses the escalating US and Soviet nuclear arms build-ups.[43] Anticipating Britain's Chapman brothers (see Chapter 7), it features a grimacing, helmeted head with an MX (Missile Experimental) 'peacekeeper' missile as a phallic nose. Above a military map of the globe incised on the helmet are acronyms for several kinds of nuclear weapon. Their lethal capacity is also clear in words such as 'mutually assured destruction' and 'Armageddon'. The bloody, fanged head sits atop a pillar made up of miniature, charred corpses supported by a granite base of the sort used in traditional memorials.

British artist Colin Self worked on the theme of war in the 1960s (and returned to it in 2001 in a series of intaglio prints showing flying instruments of war).[44] In 1966, he conveyed an apocalyptic vision of nuclear annihilation in *Guard Dog on Missile Site*.[45] Here, a desolate-looking landscape, punctuated by a few posts, surrounds an approaching, menacing hound – shades of the Baskervilles' pet in Sir Arthur Conan Doyle's famous story. *Beach Girl: Nuclear Victim* (1966) goes further. Modelled on his wife, the one-armed, one-legged victim of a nuclear attack could in another context be sunbathing.[46] Layers of cinders and black paint cover the life-size body and represent burned flesh, as at Hiroshima and Nagasaki. The piece reflects wide anxiety about the growing nuclear threat and the hardening of the Cold War.

Like Rosler and Heartfield before him, British artist Peter Kennard comments on war through photomontage. His earliest politically motivated works date from the Vietnam War era of the late 1960s and early 1970s.[47] From the beginning, he wanted his efforts to be reproducible on placards, posters, postcards, and T-shirts. His notorious *The Haywain, Constable (1821) Cruise Missiles, USA* (1983–1988) incorporates deadly

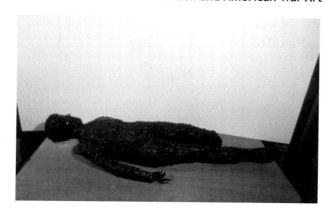

18. Colin Self, *Beach Girl: Nuclear Victim* (1966).

weapons into a famous British pastoral painting, John Constable's *The Haywain.*[48] In front of three missiles in the wagon that point aggressively upwards, a gas-masked figure waves a welcoming hand in the direction of the bucolic countryside. As part of US-led Cold War defence, Britain's Conservative government had agreed in 1980 to install missiles in silos around the country. An added irony: there were US bases close to Flatford Mill, setting of Constable's painting. The opposition Labour Party quickly had posters made of the photomontage. Later, many tens of thousands of copies appeared as protest continued. In 1981, to draw attention to the nuclear submarine base on the Clyde at Faslane in Scotland, Kennard inserted an image of a nuclear submarine into a postcard entitled *The Firth of Clyde*. The Campaign for Nuclear Disarmament (CND) later reproduced it as an actual postcard.[49]

In other pieces, Kennard attempted to empower protestors. In a statement for the exhibition *Images for the End of the Century*, he noted, 'The point of my work is to use recognizable iconic images, but to render them unacceptable.'[50] In 1980, for example, he created a photomontage of images of a missile and the CND logo with the missile broken but the logo intact. *Broken Missile* appeared in posters taped to the fence of the Cruise missile base at Greenham Common, Berkshire, in 1982.[51] The site was home to a US military base until 1997; at its peak it housed ninety-six ground-launch missiles. From 1983 to 1991, it saw sustained protest by the women's peace movement.

The Gulf War of 1991 led Kennard, amongst other artists, once again to produce striking photomontages. Kennard's *New World Order* (1991) depicts a gas-masked skeleton standing on a partially blown-up and smoking globe over which bombs are raining. The skeleton waves a placard with the words 'The New World Order', evoking US President George H. W. Bush's famous call. The Committee to Stop War in the Gulf later used the image as a poster.[52]

Other British artists, perhaps better known in different contexts, have addressed the Cold War. The endlessly prolific Gilbert and George have worked extensively with

historic postcards for three decades. *Victory March* (1980) and *Battle* (1980) are collages of old postcards on the titles' themes.[53] Susan Hiller's lurid colour and macho imagery in *Happy Days* (1985) challenge perceptions of war.[54] This work reflects her anthropological studies and uses lengths of children's bedroom wallpaper covered with images of war. The artist has painted a black panel over part of the patterned area; the shapes of her 'automatic writing' pierce the panel as if in a screen. This panel, with its personal and internalized meaning, scrambles the wallpaper's war imagery – here a confusion of parachute soldiers and jeeps, helicopters and tanks, and beach and sky.

English Eccentrics, a clothing design and manufacturing company owned partly by the artist Helen Littman, used women's traditional work, but with untypical decoration, to make Littman's intriguing *Women's Peace Movement Scarf* (1986).[55]

Towards the end of the Cold War, the Imperial War Museum's Artistic Records Committee sent Jock McFadyen to Berlin after the fall of the Berlin Wall in 1989. This social satirist, or critical realist, mixed fine art with cartoon and caricature. The resulting physiological types derived from German First World War artist George Grosz's physiological explorations and the socially committed work of the Artists International Association in the 1930s.[56] He portrayed the people and the detritus in the streets and around the graffiti-encrusted Wall in gritty, gestural, graffiti-like sculptures, paintings, gouaches, and prints. Photography, too, captured recognizable symbols of the city's eastern neighbourhoods. The painting *Kurfürstendamm* (1991) shows one of Berlin's most fashionable shopping streets.[57] In it, a one-legged youth plays the accordion, his broken body and music making denoting a damaged but celebrating city.

The late Scottish artist Ian Hamilton Finlay's attitude to the end of the Cold War is perhaps more cynical. Finlay gained recognition in the early 1960s as a concrete poet. His poem-objects express their meaning through both words and physical form and have extended poetry into the realm of sculpture. In *A Wartime Garden* (1989), with John Andrew, he juxtaposes images of modern warfare with words evoking pastoral themes and texts by the classical philosopher Plotinus and the nineteenth-century writers Hegel, Feuerbach, and Novalis.[58] A typical quotation is: 'The animals devour each other: men attack each other: all is war without rest, without truce.' These references to different stages of civilization create a cultural continuum, while the disparities between image and text invest the objects with new and surprising connotations.

The Conflict in Northern Ireland (1960s-)

After the end of the Irish civil war in 1923, the Irish Republican Army (IRA) began an on-off guerrilla war against the British in Northern Ireland, since 1949 a part of the United Kingdom. In 1969, civil rights demonstrations by the Catholic minority in Ulster, one of the six Northern Ireland counties, led to the outbreak of hostilities between Catholics and Protestants. This period, commonly referred to as 'the Troubles', was

characterized by an IRA campaign of urban guerrilla warfare against British forces, the bombing of economic centres in northern cities and towns, and terrorist attacks in Britain. This pattern of resistance continued at varying levels of intensity for the next two decades. Since 1994, a process leading toward peace has been under negotiation and the country has calmed down since the Good Friday Agreement of 1998 was reached.

Irish artist John Kindness's *Sectarian Armour* (1994) draws on the tradition of medieval and Renaissance decorated metal armour.[59] A hybrid piece, it combines a contemporary denim jacket with a coat of medieval armour. The jacket is the 'uniform' of the Belfast 'hard man' – a tough guy probably active in the paramilitary. The armour's decoration is complex. On the front, British loyalist imagery appears on one side and Irish Republican Army (IRA) on the other. The British imagery includes Queen Elizabeth II, a bulldog, and English roses, while the IRA is represented by a Madonna and Child, an Ulster hog, and shamrocks. Two political leaders (Ian Paisley and Gerry Adams) are trying to pull the jacket apart in a parody of the famous Levi jeans logo. Much of the piece is subtle – differences are often small – as if to show how close the two sides may be. On the back, two funeral scenes – one IRA, one loyalist – surround a single coffin. The Ulster policeman angel has a crown surmounting his harp, unlike the IRA angel. Two skeletons holding guns lie supine at the bottom, much as in the lower panels of medieval altarpieces. Both sets of mourners, however, are united in the funeral scene. The jacket's materials are etched and gilded steel and brass.

Irish artist Willie Doherty's photo-text works and video installations explore the raw side of sectarian politics in the province of Derry. For more than twenty years he has lived and worked in Derry and documented 'the Troubles'. *Unapproved Road II* (1995) is an example of his seemingly simple photo-based compositions.[60] Two large rectangular stones – one yellow, one grey – lie in the middle of a small, scruffy country lane. There are three round black holes in the yellow stone. The two stones may denote the two sides in the conflict, a permeable border, a broken barrier, and the traditional war iconography of ruins symbolizing conflict's human cost. The viewer must complete

19. Willie Doherty, *Unapproved Road II* (1995).

the narrative – a metaphor for the political parties' inability to end the cycle of sectarian violence. Doherty's use of familiar imagery in unusual juxtapositions challenges the

viewer to make sense of what he shows and, in perhaps acknowledging fallible memory, to understand the story's uncertainty. We reshape history to suit present needs, and this doubtful process Doherty highlights in his compositions.

The Falklands War (1982)

Argentina has long claimed sovereignty over what it calls the Malvinas, which have been in British hands since 1833 and known to them as the Falkland Islands. The Argentine government's 1982 invasion of the islands sparked a war in which 255 Britons died.

The Imperial War Museum commissioned Linda Kitson as its only official war artist to depict this conflict in April 1982. She sailed with the troops on the *Queen Elizabeth 2* to San Carlos in the Falkland Islands. She followed the British forces' advance across the island to Port Stanley and returned to Britain in July. Her over 400 swiftly executed conté-crayon drawings record the soldiers' behind-the-front experiences, from basic training in the UK to briefing, disembarking, and operating behind the lines.[61] She was usually three or four days behind the action and saw little of the fighting or its consequences.

When the Museum exhibited her sketches shortly after her return, the media criticized the absence of finished canvases. The results of her commission, in the form of sketches on paper, seemed slight for a major campaign that had resulted in a significant loss of life. The criticism led to a public debate about what war art should be, which widened public appreciation for its variety. The consequences of this debate, in the United Kingdom at least, had profound implications for the quality of the art produced.

Jock McFadyen, for example, painted *With Singing Hearts and Throaty Roarings* ... (1983), which shows a dockyard scene on the return home of the British forces.[62] The assembled group consists of ugly, bull-necked nationalists. The picture indicts the media celebration of victory. War art as we have seen in this chapter and will see in Chapter 7, flourishes in culture of debate, interest, and relevance.

20. Jock McFadyen, *With Singing Hearts and Throaty Roarings ...* (1983).

As a whole, the post-Second World War conflicts that involved Britain and the USA produced widely differing bodies of artwork that engendered debate. The variety was, in part, because none of the conflicts resulted in national art programmes on the scale of those of the First and Second World Wars, which might have effected some homogenization of approach and results. Instead, what was clearly an established need to respond to war through art became a far more independent exercise that has encompassed a wide range of approaches reflective of developments in art as a whole. In this period, furthermore, there are far fewer artists of a contemporary 'turn' to whom one can append the title 'war artist' as part of a particular stage in their careers. Instead, many address the subject of war only at the times in their professional lives that they are inspired to do so. In such cases, it is clearly a politically directed activity for many. Artists like Spero and Golub continued and continue to paint war because they are active in anti-war movements. A further significant factor in the production of war art centres on the ability of artists to be accommodated in theatres of conflict that are unpredictable and increasingly dangerous. It is an aspect of war art-making that has led and continues to lead war artists into a reliance on media other than battlefield experience for the content that inspires their work.

Chapter 7

War Art
Internationally

1990-2005

By the end of the Vietnam War, war had become regular television fodder and the atrocities and tragedies of conflict had become everyday viewing for many people across the world. Conflict was spectacle. In terms of war art this has resulted in two largely distinct bodies of work. The first panders to war art's troubling kinship with aspects of pornographic imagery by emphasizing war's brutality and presenting it as performance. The other evinces moral outrage that such things should be allowed to happen. Both these approaches are countered by reflective and at times elegiac pieces that have grief and mourning as their centres. The range of materials used is wide and encompasses painting, installation, and photomontage.

As we have seen in Chapter 6, most contemporary British war artists work through the Imperial War Museum's Artistic Records Committee (founded in 1972 and renamed the Art Commissions Committee in 2001) or find their pieces purchased sometimes by the museum and other collecting institutions such as the Tate Gallery. When Angela Weight was keeper of art at the Museum (1982–2005), her involvement in contemporary art practice in Britain made any such division porous. Commissioned artists might go to any military theatre where British forces were participating, from bases in England to South America. They have generally experienced direct engagement with their subjects, having obtained the necessary permissions.

In the USA, there have been two principal kinds of war art since 1945: official and anti-war. The division was clearest during the Vietnam War.

> My ability was self taught, I never took more than one art class in college ...
> My artwork was spontaneous because I didn't have any hangups brought on
> by any earlier (training). I just looked over [the other combat artists'] shoulders
> a lot and learned how to work with all types of medium.[1]

So wrote Augie Acuna, one of the young and inexperienced soldier-artists employed in the US army's Combat Art Program during the Vietnam War. Yet the well-trained and highly regarded Leon Golub observed:

> And the guys I portray, one could say I was celebrating rather than exposing them. For example, if the Pentagon had wanted, they could have displayed one of [my] huge *Vietnam* paintings and claimed it as a victory painting. It shows our boys vertical and the gooks down. That's a victory painting. Just like the Romans and the Greeks showed off their victories, the winners and the losers. So why is this an anti-war painting?[2]

Acceptance or not of these two forms of art as art centres on the notion of the eyewitness. The military community, and not only in the USA, values art by military personnel simply because they were on the ground. Whether this art can move beyond the descriptive or even say anything about conflict is less significant than its eyewitness status. If eyewitness artists present events in the most laudatory or heroic of lights – often because of their own subjective interests vis-à-vis the military – the fact of their field experience overwhelms any (lack of) critical assessment and analysis. The art-interested public, however, sees the concept of eyewitness as more elastic, including even works based on responses to issues of the time and to information in the media. During the Vietnam War, television took the conflict into people's living rooms and provided what was broadly understood as being the next best thing to being there. There was arguably a suspension of belief regarding the presence of bias. The issue is therefore really about power. The US military employs and thus controls its combat artists and can censor works or request specific subjects but because the artist was there we want to believe that they are recording exactly what they saw. Similarly, broadcasters can filter what they show but because of the nature of the photographic medium we tend to equate what we see with the eyewitness experience.

A further aspect centres on what can actually be witnessed in the field regardless of issues of power. During the second Gulf War (2003), the US military introduced embedded journalists, a controlled version of the traditional position of war correspondent. US communications personnel informed non-embedded journalists that their security could not be guaranteed, which discouraged their participation. Combat artists during previous US conflicts were in similar situations. Like the journalists of today, they had little freedom to move, and so their field sketches record only what they saw – a very limited slice of a much greater subject. Can paintings completed away from the action and with more knowledge, reflection, and understanding more fully convey the meaning and implication of war than eyewitness accounts? The evidence suggests that the long view, complemented by a wider contextual standpoint, is the more valuable testimony of events. With this in mind, this chapter considers the art that emerged

in response to the wars of the 1990s and early twenty-first century. The final section brings the war art of Australia and Canada up to date.

The First Gulf War (1991)

During the first Gulf War in 1991, a coalition of thirty-three countries, including Britain and led by the USA, destroyed much of the military capability of Iraq and drove the Iraqi army out of Kuwait, which it had invaded. The significant role of the USA was not lost on officially appointed British artist John Keane, who earned notoriety from his pictorial references to American cartoon-icon Mickey Mouse.

21. John Keane, *Mickey Mouse at the Front* (1991).

Attuned to war zones, Keane had in 1987 been the guest of the Sandanista Association of Cultural Workers in Nicaragua. He had also spent time in Ulster – at times with the British army – in 1989. However, *Mickey Mouse at the Front* (1991) proved extremely provocative.[3] While oil fires blaze on the horizon, the grinning Disney symbol sits on a toilet on the sand, with a shattered palm tree to his left and a shopping trolley of anti-tank missiles to his right. 'Outrage at war artist's view of tragedy in the Gulf,' trumpeted the London *Daily Mail* on 14 January 1992. Angela Weight defended the work in the catalogue for an exhibit of Keane's work in 1992:

> *Mickey Mouse at the Front* is the quintessential Keane painting, a
> transmogrification of culture and topography, an allegory of a city that has
> been raped, abused, shat upon and abandoned. The irony of finding the
> shopping trolley with its load of anti-tank rockets was not lost on Keane,
> who has frequently used the ubiquitous trolley in his work as a symbol of

consumerism. (He added the Kuwaiti flag under its wheels.) The Mickey Mouse figure was a child's amusement ride from a marina, in a room that had been used as a lavatory by the Iraqis. The palm trees along the brick-paved promenade were dead or dying and the beach defences barricaded Kuwait's empty hotels against an attack from the sea that never came. There is no glory, still less a cathartic sense of tragedy, in this painting; rather it conveys shame and degradation, feelings that humble rather than inspire. *Mickey Mouse at the Front* is an image that epitomizes the end of all wars – the sheer bloody mess that is left behind when it is all over, with the added reminder from the weeping palm tree that a terrible environmental crime has taken place.[4]

Despite the reactions, Keane was well aware of other war artists' work. *We Are Making a New World Order*, in the same show, evokes Paul Nash's great First World War piece, *We Are Making a New World.*[5]

American-born Mary Kelly worked extensively in England on activist paintings that focused on women. The first Gulf War inspired a major work. *Gloria Patri* (1992), which consisted of five text-laden shields.[6] As she notes:

The whole question of power seemed to involve thinking about the construction of masculinity rather than femininity for the woman. I also felt it had been altogether too easy to say that men have a less difficult role in the oedipal scenario. I mean, it might also be appropriate to think about the man's relation to the feminine term. So this was on the agenda when I started working on *Gloria Patri*.

But the Gulf War put everything in place:

This is what I think of as the ethnographic material; events observed and recorded – not literally recorded – but noted in my sketchbook for about two or three years before I even start a project. So during the war, it was mostly what I heard on television. There was a very interesting but eerie kind of distance involved in watching that spectacle ... watching the commentators, watching the soldiers making their comments on it. I just kept track of those comments and thought about it. Now I can see the pathological structuring of masculinity that this specific condition – the Gulf war – provoked.[7]

Mea Culpa (1999), meaning the acknowledgment of fault or error, took her thinking further.[8] It consists of four white rectangular supports, 0.5 x 6 metres, attached to walls that carry curved strips of flecked grey lint collected from a dryer. Letters, seemingly cut in the lint, reveal the white support beneath. In fact, Kelly attached vinyl letters

in Helvetica typeface to the filter of the clothes dryer in her garage. While drying thousands of pounds of black and white cotton clothing, she slowly created texts on the lint trapped against the screen. The words derive from media accounts of politically motivated atrocities before the International War Crimes Tribunal. These are Phnom Penh (1975), Beirut (1982), Sarajevo (1992), and Johannesburg (1997). Kelly's accounts feature an unidentified female protagonist who acts as a witness, seeing events through particularly female eyes and referencing, for example, children and kitchen and bathroom paraphernalia. Women are war's victims, the piece proposes, and men its perpetrators, but the media involve and traumatize everyone. This thinking, she acknowledges, derives from Jacques Lacan's theory that trauma is a missed encounter with the real.[9]

22. Mary Kelly, *Mea Culpa (Johannesburg 1997)* (1999).

Gentle, too, in its material, but not in its criticism, is the work of Welsh artist Rozanne Hawksley, whose beautiful wreath of white gloves, *Pale Armistice* (1991), also includes bone fragments and lilies to remind us about what we remember on 11 November.[10] The white gloves allude to flesh and youth but also to burial (the hiding of flesh), flesh itself (the leather), cleanliness, purity, and saintliness. The bone fragments refer to the remains of dead soldiers. The three plastic lilies too bespeak purity but also the Trinity of God, Christ, and the Holy Ghost. The artist states in her notes on the piece that the pale colour is 'to remind one of the fragile quality of peace and hope'.[11]

The work of San Francisco-born Nicola Lane is brutal and insensitive by comparison because it invokes disinterest and ignorance. *The Three Graces* (1991) and *Sunbathing Sergeants* (1991) reconceptualize the first Gulf War.[12] In the latter canvas, the sergeants are virtually naked women, one sunbathing and the other smoking a cigarette in the desert. Behind them oil fires burn, and in the left foreground a gun rests on a pile of military gear. In this work, Lane is making a point about being a soldier being a job and not a vocation. When you are not clocked in to fight, so to speak, a regular life of leisure continues, even if the world is on fire.

Londoner Rasheed Araeen was visiting Pakistan at the time of the first Gulf War in 1991 and watched the first few weeks of the conflict on CNN. He also learned that two million copies of a poster of Saddam Hussein astride a white horse sold in Pakistan during the conflict. The poster's image has powerful significance for Muslims, for it was on a white horse that Saddam's namesake Hussein – the Prophet's grandson – fought against the tyrant Yazid in the seventh century. In *White Stallion* (1991), Araeen took a copy of the poster and cut out the image of Saddam on horseback. He then superimposed the image on a photo taken from the television screen of the American field commander General Schwartzkopf giving a press conference on a podium draped with the US flag on one side and the Saudi flag on the other.[13] Thus Saddam appears to be defying his enemies, while TV images of AWAC (Airborne Warning and Control System) planes come to punish him for his hubris. The colour green, significant in Islam, dominates the Saudi flag; it also refers to nature, youth, and immaturity. As often in war art, this piece has art-historical precedents. The image of Saddam on horseback derives from Jacques-Louis David's *Napoleon at the Great St Bernard Pass* (1800), which in turn refers to the Arab Hannibal crossing the Alps en route to the near-conquest of Europe in 218 BC.[14] As Paul Overy notes in his essay on Araeen, this work

> does not celebrate, nor does it glorify either 'side', but rather problematises the complex dynamics of the war and its representation through different media by drawing attention to the essentially racist origins of the war and the way in which it is represented through images and language.[15]

The art that emerged during the first Gulf War shows the degree to which war artists no longer only recorded the events of conflict but how their work also reflects commonly held values and attitudes of the time. Keane's compositions show how war 'brands' nations, the USA being encapsulated in the image of Mickey Mouse. Lane's pieces illustrate how being a soldier is now a job like any other and, perhaps, less than heroic. Kelly and Araeen draw our attention to the other voices of war, in Kelly's case, women, and in Araeen's, the Arab diaspora. Together, the artists discussed in this section address the multifaceted nature of conflict and show that war is not only about fighting but about how the fight is perceived.

The Yugoslav Wars (1991-2001)

The Yugoslav wars were a series of violent conflicts in the territory of the former Yugoslavia that took place between 1991 and 2001. They comprised two sets of successive ethnic wars affecting all of the six former Yugoslav republics, Bosnia and Herzegovina, Croatia, Kosovo, Macedonia, Serbia and Montenegro, and Slovenia. Ultimately, NATO (the North Atlantic Treaty Organization) became involved in securing peace, an endeavour that has

involved a majority of its member states. Many of the perpetrators of what has been termed 'ethnic cleansing' or genocide remain at large.

Theatre by Scottish artist Graham Fagen was the result of a commission from the Imperial War Museum in 1999.[16] A multi-media work that incorporates video, sculpture, and photography, it explores the inter-communal conflict between the Serb and Kosovan Albanians, two peoples with historically little in common. Unlike Howson (discussed below), however, Fagen remained detached. 'The last thing you want is to go somewhere like Kosovo and be destroyed yourself,' he noted in an interview.[17] The resulting installation approached what he observed in both actual and metaphorical terms. Set up as a briefing room, it included a video that showed two different-looking groups of people arguing and gesticulating but unable to communicate. Their bafflement found echoes in that of visitors. Although the words came from Shakespeare's familiar *Henry V*, the rearranged sentences and phrases made only intermittent sense. In the adjacent entrance were photos of Kosovo and thirteen mounted, stuffed rooks – an allusion to three historical elements: the famous Turkish–Serbian battle in 1389 on the so-called Field of Black Birds; Kosovo's name, from 'kos', or crow; and Chaucer's argumentative assembly of birds in *Parliament of Fowls* (c.1380).

The brutality associated with the Yugoslav Wars has resulted in several works by British and American artists that explore humanity's relationship with violence. In 1993, two years into the conflict, the Imperial War Museum commissioned Scottish artist Peter Howson, who had military experience, as an official war artist. He went to Bosnia twice and found the experience difficult but addictive. 'Life is strange,' he told Robert Crampton of *The Times* in 1993, 'if you actually want to go back to a place where you could be killed.'[18] 'The sixteen days I was there was the most intense time of my life,' he said.[19] War artists often owe much to their predecessors. Howson's work shows the influence of Francisco de Goya, Stanley Spencer, and German artists of the Great War such as Max Beckmann and Otto Dix.

Although he diligently recorded what he saw, back in Britain Howson began to paint rumoured atrocities – rape and castration – as opposed to what he had seen. Public debate ensued. The concept of war artists as eyewitnesses is strong, and people expect their work, like journalists' reports, to be in some degree truthful. Thus they tend to reject overly imaginative reconstructions, even if such pieces derive from a profound belief or knowledge that terrible things do take place in war (see Goya) and do matter. Howson defended his approach to *The Times* (19 September 1993): at least half of the Imperial War Museum's paintings, he claimed, did not come from events the artists had actually seen.[20]

Croatian and Muslim (1994) is probably the best known of his compositions on such themes.[21] It owes something to Otto Dix and his portrayals of wartime bestiality and speaks to the addictive element of violence.[22] In it, a Croatian man holds a Muslim woman's head down a toilet in her own home while another rapes her from behind. One

man's hand reaches to the left of the painting to obscure a family picture. It is a brutal image of the highest order. The artist applied the paint in thick, jagged areas of violent green and red. Light harshly illuminates the scene; there is no escape for victim or viewer. As Howson had not actually witnessed what he was painting, we have to wonder what his motivation was beyond his acknowledged liking for the terrain of war. Was it simply a desire to depict what was known but not witnessed perhaps? Or was it a wish to bring home the almost unimaginable brutality of war by transforming that same level of horror to the imaginable? If the latter is the case, then this work follows in the tradition of Callot and Goya, who also sought to place the grossness of conflict in the realm of the conceivable.

23. Peter Howson, *Croatian and Muslim* (1994).

In light of the 2006 public release of amateur photographs and video of horrific acts of cruelty and bestiality on the part of British and American troops in Iraq, acts of war such as this are now being increasingly normalized and, as such, will continue to form part of the visual language and record of war.

Plum Grove (1994) brings Goya's vision even more clearly to mind.[23] Here, a naked and castrated Croatian man hangs from a tree branch as if in a crucifixion scene, while two children play nearby in the bucolic and seemingly unsullied farmland. One, seemingly unaware of the horror, also hangs from the branch, while the other, more aware, stares intensely at the horrific scene. Frenzied brushwork and vibrant greens and yellows only emphasize the terrible nature of the evil act depicted.

The brutality of war, but more sensitively addressed, also informs the work of American Jenny Holzer. Her earlier pieces were textual in the tradition of Heartfield and Rosler, discussed in Chapter 6 – for example, a T-shirt bearing the words 'Abuse of power comes as no surprise' (c.1984).[24] In the face of the brutality that characterized the conflict in the former Yugoslavia she, like Howson, turned to a different media, in both senses of the word. In *Lustmord* (1993–1994), a mixed-media installation, she comments on the rape of women in wartime from three different perspectives (the Observer, the Perpetrator and the Victim). One element, the photographic images of

the text written on human skin, appeared in the magazine of the German newspaper *Suddeutsche Zeitung*. The ink used on the cover of this magazine, which reached five hundred thousand readers, contained women's blood. This was a statement of complicity: that the rape of a woman, symbolized by the blood (the victim), is an act not only committed by a human being against another human being (her utilization of blood in her piece), but is also watched by other human beings (the blood's presence in the newspaper). Such art, with its focus on our involvement as observers, makes us question whether depictions of the human body at war contribute to its waging.

A further element of *Lustmord*, when it was exhibited in 1994, was an installation in which an immense, dark, and claustrophobic shape, neither sculpture nor architecture, was illuminated from within by a warm, red pulsating glow that, with closer attention, transformed into words which described the rape referenced in the newspaper.[25] Like the newspaper, this element comments on the permeable border between attraction and violence.

'Lustmord', loosely translated, means 'sex murder'. Holzer views violence as a problematic given and, without judgement, seeks to understand its presence in the human condition for good or ill. This was made clear in another component of the original installation. On display in a room of their own were human bones, each bearing an engraved silver band. Viewers were encouraged to pick up the bones and imagine that, in holding the bones, they were familiarizing themselves with their own deaths, perhaps violent ones. In doing this, Holzer was again attempting to break down the barrier between our understanding of life and death. As with the newspaper cover and the other part of the installation, she was removing the psychological walls that shelter our awareness and knowledge of brutality. In positioning the viewer as a participant in the moment of understanding horror and death, she was underlining humanity's complicity in acts of physical cruelty. Clearly a more sensitive and complex approach to the subject of rape than Howson's, Holzer's goal is no different. If we can bear to look at evil then we are evil.

Brothers Jake and Dinos Chapman's war art emerged following the first Gulf War and the Yugoslav Wars. The artists turned for inspiration to the past – specifically the prints of Goya and accounts of Nazi atrocities. In May 2004, a fire ripped through a London fine art warehouse and destroyed, among other contemporary pieces, the brothers' war sculpture, *Hell* (1998–2000).[26] Only photographs of the work remain. *Hell*, according to the Chapmans, is a fantasy of our own visual imagining and knowledge and, as such, it references popular culture (film, games, and models) and art history and contemporary art (John Martin's nineteenth-century apocalyptic scenes mixed with the homoerotic skinhead and Nazi images of Canadian Attila Richard Lukacs, for example). Moving on from Holzer and Howson's works described above, it seems we can not only imagine and depict, but also physically make what we imagine thus ensuring a greater complicity in acts of evil. It is therefore not surprising that the Chapmans' hell includes

scenes of Nazi brutality, pits of bodies reminiscent of Bergen-Belsen, and bloody dismemberments and disfigurations of unbelievable brutality and sadism. This is war art because the protagonists wear uniforms and perform the deeds expected of war but it is a completely cynical piece. There are no acts of courage or heroism, no gentleness anywhere in this massive, swastika-shaped sculpture. It is a kind of three-dimensional contour landscape seemingly overrun by *Warhammer* figurines and miniature shop-window models that have then participated in a massacre. This, the Chapmans would have us believe, is us.

In 1999–2000, the Chapmans interpreted Goya's art by drawing on the collective memory of German horrors during the Second World War. Their version of Goya's series *The Disasters of War* (2000) follows its predecessor in medium and dimensions.[27] Unlike the Spaniard's realism, however, they filter their images through comic strips, children's drawings, and caricatures. They also equate the cruelty of war with sexual exploitation, seeing pleasure writ large in acts of war as well as in the sexual act but perhaps with rather less sensitivity and more cynicism than Holzer. The Chapmans, leading figures among the Young British Artists (YBA), had already drawn on Goya's series for two works. In a 1993 diorama, toy soldiers like a hobbyist's model soldiers acted out each of the *Disasters*' scenes.[28] *Great Deeds against the Dead* (1994) is a life-size re-creation of one of the series' more macabre scenes, with two figures – one deprived of head and arms, and both with their genitals hacked off – tied to a tree stump.[29]

In 2003, the Chapmans reworked an original set of Goya's *The Disasters of War* and called it *Insult to Injury*.[30] They added clowns' heads to certain figures, thus mocking

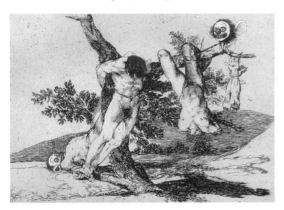

24. Jake and Dinos Chapman, *Insult to Injury* (2003).

the seriousness of Goya's purpose by both desecrating and trivializing his work. If you equate this with graffiti, which can be viewed from the point of view of the victim as desecration and from that of the artist as a mark of ownership, what is going on in these prints makes more , sense. As long as Goya's prints are from a different time, a different war, and by a long dead artist, they are not part of our human condition now. By desecrating the prints, the Chapmans took ownership of the acts depicted in their own time and thus acknowledged that as humans they are complicit in such tragedies of the past today. By adding

elements of humour, they went further than complicity and, rather, normalized the horrific actions Goya so passionately recorded. This work is profoundly disturbing if you accept that by understanding it you therefore 'know' that what is depicted is part of you. Again, the parallels with Holzer's *Lustmord* are compelling, although the approach is so very different.

Wars of Terror: Lebanon, Rwanda, Afghanistan

The powerful machinery of mass propaganda is the unfortunate legacy of the twentieth century's world wars. This has made possible unimaginable degrees of confrontation between incompatible and passion-laden ideologies that resemble the crusades of the long-distant past. Often religious, these confrontations are also based on tribal and ethnic differences, as evinced in the Yugoslav Wars. The current war on terror is directed at the religious extremists who threaten the security of the western allies, in particular the USA. But the late twentieth- and early twenty-first-century civil wars in Rwanda, Lebanon, and Afghanistan, the examples cited here among the many, many possible examples, are, in their own right, wars of terror and, in the case of the latter country, linked to the larger crusade, the US-led war on terror. Experience of these wars of terror on the part of observers and participants has resulted in a range of art that has been both officially commissioned and personally motivated, as we see below.

Through his organization the Atlas Group, American-based Lebanese artist Walid Raad 'documents' daily life during the Lebanese Civil War (1975–1991). He chooses to work from the perspective of those who live in war-torn environments as opposed to those who observe conflict from afar. However, neither the Atlas Group nor the people whose lives he documents are real. Instead, Raad uses fiction to impart an intimate experience of the war through a series of real and false collections of documents. Raad's creation Yussef Nassar's collection of 100 pictures of the aftermath of car bombs, for example, shows military and civilian bystanders hovering over mangled car engines in futile attempts to glean information about the bombers. In the midst of the ongoing urban carnage, and in minute detail, Raad's fictional historian Dr Fadl Fakouri records regular trips with fellow historians to a racetrack and the results of the races. In this project, Raad shows how an artist can be in a war situation and in everyday life simultaneously, separately, obsessively, and impotently.[31]

Mona Hatoum, a London-based artist of Palestinian origins, works in a related area but with a focus on the war-induced exile brought about by the ongoing Arab-Israeli conflict. Her art seeks out wider political meanings beyond her personal experiences. *The Light at the End* (1989) consists of an iron metal frame and five electric elements.[32] Visually it looks like a dark tunnel with red, orange, and yellow lights at the end. This coloured light appears warm and appealing, in contrast to the hostile darkness of the tunnel. However, the seductive colour is a trap. Only when the spectator moves

closer does the coloured light reveal its true character as dangerous electric wiring. The warmness of red is transformed into the violent redness of blood. The installation reflects both Hatoum's personal experience of the conflict and the more universal experience of living in exile. Her parents had been forced to live in exile by the conflict and, in 1975, when war broke out in Lebanon, she found herself exiled in the United Kingdom, unable to return to her home country. In its colours, *The Light at the End* speaks to the reality of the violence that has transformed her former home and to its warmth as a place that still appeals.

The Rwandan genocide can be described as the organized murder of nearly one million Rwandans in 1994. Militias of the Hutu ethnic majority, with the connivance of the Hutu-dominated government, attempted to carry out an ethnic cleansing against the minority Tutsis, and against Hutu moderates who opposed the genocide. The genocide was notable for the role of political elites in mobilizing and arming supporters. American Alfredo Jaar is not Rwandan but he produced a work that speaks loudly of his empathy for the murdered and dispossessed of the genocide. The word 'genocide' appears regularly in the chronicles of the twentieth century. The Nazi death camps, the killing fields of Cambodia, the Rwanda massacres conjure up chilling images. Jaar's provocative works – *The Rwanda Project* (1994–1998) – give evidence of such recent evils and show how art can depict the virtually unimaginable, the elimination of large groups of human beings.[33] The project was a combination of installations, site-specific interventions, and premeditated actions. From Africa, Jaar sent thousands of postcards announcing that named Rwandans were still alive. He put up posters at bus stops in a Swedish town that starkly repeated the word 'Rwanda'. He made a number of installations in museums and galleries in Europe and North America, such as outsized light-tables bearing vast piles of thirty-five-millimetre slides each bearing the same image of a pair of African eyes, to evoke the innumerable deaths. His installations do not show dead bodies. Instead they infer the dead, much as a fleeting image, a relic, or even a smell can trigger a memory.

25. Alfredo Jaar, 'Eyes of Gutete Emerita', from *The Rwanda Project* (1994-1998).

US forces invaded Afghanistan in October 2001, soon after the 11 September attacks that resulted in the destruction of the World Trade Center in New York. The invasion marked the beginning of the war on terror. The goal was to oust the Taliban government and find al-Qaeda leader Osama bin Laden, who had masterminded the attacks. Operation Enduring Freedom, which is ongoing, was supported by the Afghan Northern Alliance and a number of western powers, including Great Britain, Canada, and Australia. In 2002, the Imperial War Museum commissioned Ben Langlands and Nikki Bell to create a conceptual piece in Afghanistan. During a two-week visit, and using a still and a digital video camera, they recorded a number of sites of military and popular interest. These included the partly destroyed, massive statues of Buddha at Bamiyan and the former dwelling place of Bin Laden at Daruntah, where he lived briefly in the late 1990s. The resulting virtual installation – *The House of Osama bin Laden* – allowed visitors to explore his home and gardens, by then a base for a local Pashtun militia. The vacant structure acted as a metaphor for Bin Laden's continued existence but non-presence, while the virtual exhibit symbolized his virtual reality in the form of videotaped messages. In 2004, this commission was on the short list for Britain's Turner Prize.

The fact that this work was considered for a prestigious prize is not irrelevant. As this brief survey has shown, conflict looms large in artistic practices and in the public imagination. War art is now a legitimate and well-regarded subject no longer primarily associated with the bolstering of official positions but part of the global debate on war and peace. Artists who sought meaningful roles in society before the Second World War have found in the past fifteen years that war art has an important role to play in the public's understanding of conflict. The mass movement of peoples in the aftermath of wars has contributed artists who have experienced war from the inside, but as civilians not soldiers, and who can reflect on these experiences from the relative security of their new homes. In complete contrast, the mass media now make it possible for artists to comment on world events without having been there. On the other hand, traditional commissioning opportunities continue as we have seen.

Australia, and Canada

Many war artists across the world use historical wars to make points about today's wars. Some base what they do on their own experiences and others make reference to experiences that they have not personally known save through photography. Television, newspapers, magazines and, now, the Internet provide other resources. In the context of official and unofficial art in Australia and Canada, this section examines a somewhat eclectic grouping of art and artists who have put a variety of resources to work to compile visual records of conflict.

Australia has employed war artists in an official capacity since 1945, having been

a participant in most of the major twentieth-century conflicts as a US ally. As with all official programmes, the Australian practice ensures a visual record to facilitate remembering – a record that increasingly reflects contemporary artistic practice. Ivor Hele was a war artist during the Second World War but also sketched figures in action in his Rubenesque manner during the Korean War. Clifton Pugh joined the peace movement in 1966, and his horror at the unnecessary killing of civilians finds expression in his Francis Bacon-like *The Vietnam Body Count* of the same year.[34] Trevor Lyons was a landmine casualty in Vietnam. His *Journeys in My Head* (1987), a series of twenty-two states of an etching, gradually strips away his features until only the skull remains.[35] Artists such as Jan Senbergs have produced nightmarish pictures of the first Gulf War. His *News 1991* depicts a totally mechanized world in the form of a monster war machine next to a cameraman with a camera for a head.[36] In 2002, Gordon Bennett painted *Notes to Basquiat (Pink)*, which combined his shock at the destruction of the World Trade Center and his fascination with the graffiti art of the New Yorker Jean-Michel Basquiat.[37]

26. Trevor Lyons, *Journeys in My Head* (1987).

Some of the more celebrated Australian artists have depicted war from the observer's perspective. Arthur Boyd filled his landscapes with stick-like people, the physically challenged, and mad dogs to convey the Second World War's effects. In 1959, Boyd moved to Britain, where, in response to an anti-war demonstration on London's Hampstead Heath, he produced the Nebuchadnezzar series (1957–1971). Boyd's mad Assyrian despot, once a fabled King of Babylon and the creator of its celebrated hanging gardens, wanders a wasted, nightmarish landscape. *Nebuchadnezzar on Fire Falling over a Waterfall* (1966–1968) shoots the protagonist like a flaming comet over the Australian bush.[38]

In 1968, the National Gallery of Canada and the Department of National Defence (DND) initiated a new scheme to have war artists record the country's post-1945 military endeavours. The Canadian Armed Forces Civilian Artist Program (CAFCAP) commissioned nearly 300 works that capture the military experience in bases across Canada and in locations ranging from Cyprus and Israel to Somalia and Croatia. A 1995

government budget cut eliminated the programme. Since 2001, DND has operated a smaller Canadian Forces Artists Program. Several participants have produced interesting work, but, by and large, the most stimulating contemporary war art in Canada has emerged outside of any official programme.

Gertrude Kearns is notable on several counts; she has painted both officially and unofficially in recent years. In 1995, she began a series of canvases about a 1993 event that had led to the disbanding of the country's airborne unit in 1995. In 1993, during Operation Deliverance in Somalia, two aboriginal Canadian members of the airborne regiment had tortured and killed a Somali teenager named Shidane Arone. Kearns based her paintings on media accounts in Toronto.[39] The pieces created no problems until two of the three that the Canadian War Museum had acquired went on display when its new facility opened in May 2005. Former members of the airborne unit and aboriginal veterans launched a public campaign to remove the paintings as unrepresentative of either the airborne unit or aboriginal soldiers. The debate raised important issues about the ownership of remembrance.

The official war artist in Somalia, Allan Harding MacKay, discovered that, even though he was in the right place at the right time, he too had to rely on media accounts back in Canada to understand what had been happening in front of him. He was actually working in the camp at the time of Shidane Arone's capture. MacKay's works shed light on an interesting conundrum for war artists. In Somalia, he chose as his subject the contrast between the highly technological military force and the traditional Somali way of life.[40] Did this in fact blind him to what was actually happening? And what does this have to say about the value of the eyewitness war artist?

27. Gertrude Kearns, *Somalia I: With Conscience* (1996).

Part IV

Rendering and Remembering

Chapter 8

Other Types
of War Art

A dirt road with scrubby vegetation on each side leads the eye into the distance. In the foreground is a pile of dead bodies – maybe twenty – some of them naked babies, their skin pink and unprotected. At the top run the words: 'Q. And babies?' Below, the words: 'A. And babies.' This is a description of one of the most famous posters produced in the USA during the Vietnam War. Five factors help explain its power as a visual image. First and foremost, it is based on a photograph, which gives it legitimacy as a truthful portrayal of what happened. Second, the overprinted words resemble typewriting and suggest journalism, another legitimating tool. Third, technology made it cheap and easy to distribute and therefore highly visible. Fourth, the developments in art involving dramatic text and image usage that began in the First World War with artists such as John Heartfield enhance its effectiveness as a visual image. Fifth, and perhaps most important, is the fact that the image is horrific. Marc Chaimowicz, a member of the Art Workers' Coalition designed the poster in 1969–1970.[1]

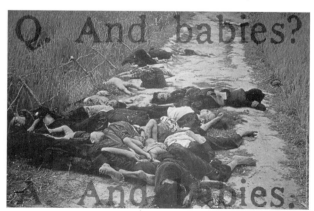

28. Marc Chaimowicz, *Q. And babies? A. And babies* (1969-1970).

This chapter examines visual expressions other than fine art that comment on war and its consequences. It touches on the intense relationship between war and art visible, for example, in editorial cartoons in newspapers and magazines. The First World War Dutch illustrator Louis Raemaekers represents one end of the spectrum, and today's cartoonists Jeff Danziger of the *New York Times* and Steve Bell of Britain's *Guardian* the other. This chapter also looks at unique creations, such as the American Art Spiegelman's cartoon-strip account of Holocaust memory, *Maus* (1977–), and at the broadsides, posters, and ephemera of current anti-war art. It also explores war art's relationship to technology and, more recently, to the digital revolution. It shows how war art has used technology to further specific messages – as in protest art on the Internet. We will look especially at five forms of, or formats for, war art: photographs, (official) posters, cartoons, the Internet, and military magazines.

War Photography

Historic War Photography

War art and photography link inextricably. First World War artists relied on photography, but they had access only to what the authorities allowed them to see. William Nicholson's *The Canadian Headquarters Staff* (1918), for example, depends not only on an aerial reconnaissance photograph for its background but also on a group photo of the generals for its main subject matter.[2]

Photography and the horrors of war also connect, as we saw above, in the Vietnam War poster. For British-born Canadian artist Jack Shadbolt, cataloguing photos of Bergen-Belsen for the Canadian army was so traumatic that the subject dominated his art for a decade. Even today the world relies on photography, in its still, moving, and digitized formats, to bring home the horrors of conflict. It is this attribute that has led many artists to include photography in their war art vocabulary. Especially after the First World War, when wartime censorship lifted and the propaganda machines withered, photography was hugely influential, and it has remained so. There are, however, issues with photography, which need to be borne in mind. It can be physically manipulated, cropped, and faked and its meaning can be controlled by its context, presentation, use, and reception. A photograph of Hitler, for example, can be understood as a portrayal of a hero or of a villain, depending on the person viewing it and the circumstances and time period in which it is viewed.

Nonetheless, our visual view of war has emerged in conjunction with photographic images that are generally accepted a being truthful records, ranging from napalmed victims of the Vietnam War to bloodied survivors of 9/11. In Canada, as we saw in the art of Gertrude Kearns and Allan Harding MacKay (Chapter 7), photography shaped the art inspired by the difficult mission to Somalia in 1993. Protest groups also rely on

photography to justify their objections to war, while appreciating the view on war that the medium provides. 'Thank God that's not happening to us,' we shudder. Perhaps one of the most compelling recent links between war, photography, and spectacle were the shocking pictures from Abu Ghraib showing Iraqi prisoners in US-run prisons – printed straight off the Internet and exhibited at the International Center of Photography in New York in October and November 2004. Photos of the returning American dead or soldiers' hideous injuries do not receive exhibition like this, although that may yet come. The former action compounds victims' humiliation, the non-action of the latter lessens our anger, and the photographer is complicit in both reactions.

The invention and development of photography in the early nineteenth century, combined with the unpopularity of the conflict itself, made possible Englishman Roger Fenton's photographic record of the Crimean War (1854–1856), between Russia and an alliance of Britain, France, and Ottoman Empire. Photographic equipment was bulky and required long exposures, and Fenton was never near any action. In consequence, many of his images show camp and harbour scenes near Sebastopol on the Black Sea or the landscape of battle in its aftermath.

His best-known image, *The Valley of the Shadow of Death* (1855) – the gully through which the celebrated Light Brigade had earlier charged to its slaughter – is an invented 'site of memory' rather than a historical document, as the men galloped elsewhere.[3] Barren of humanity, this constructed scene is a desolate Mars-like landscape that acknowledges, perhaps more powerfully than reality, the harsh conditions of the battle and the great loss of life that resulted.

Two years after Fenton left the Crimea, Italian-born Felice Beato was photographing the consequences of slaughter in India, Sudan, and China. His 1857 photo of Secundrabagh Palace near Lucknow, India, after the British took the city, its forecourt littered with skulls and bones, possibly rearranged, is still compelling.[4] Six years after Fenton left the Crimea, Mathew Brady's studio employees were photographing the brutal consequences of the American Civil War (1861–1865) from the Union perspective. Their subjects (also possibly rearranged) present a far harsher view of war than Fenton's. Bodies lie around the battlefields, and flies almost visibly hover and land on them. Brady's studio went bankrupt in 1872; Americans did not want to remember what they had done to each other so recently. Yet all the questioning of the actual reality of what Fenton, Beato, and Brady photographed is a recent development. When the pictures became available, people accepted them as truth, and the images helped form attitudes towards the various military endeavours at the time.

By the First World War, photography was ubiquitous but more open to challenge as a record of reality. It was not only dangerous but also difficult to set up weighty and complex equipment near any action. Like Fenton, Beato, and Brady before them, some official photographers – often anonymous – arranged men and equipment in order to create images that showed more than endless, featureless no man's land. In this

period, photography was also subject to military censorship. Thus artists rather than photographers initially exposed the consequences of war. It was not until 1924 that the German conscientious objector Ernst Friedrich published *War against War! (Krieg dem Kriege!)* – an album of more than 180 of his unpublished photos, equalling in their horror the prints of Otto Dix. It had gone through ten editions by 1930.

By the time of the well-documented Spanish Civil War, equipment was lighter and more efficient. Scenes of battle rather than its aftermath became possible. Robert Capa's celebrated 1936 photo of the republican soldier at the (now-questioned) moment of his death by gunshot is still the archetypal image of the conflict.[5] The photos of the inmates of the liberated concentration camps in May 1945, charred bodies in Hiroshima and Nagasaki in Japan in August 1945, and the napalmed victims of the Vietnam War in the late 1960s and early 1970s tell us that war is horrific and that all too often civilians are its casualties. While we would like to believe that war photography since then has not been victim to reinterpretation, set up, cropping, and other manipulative techniques that photographers such as Brady, Beato, and Fenton used, such techniques have become more sophisticated and accessible. As historians and art historians continually inform us, a picture of any kind is all about meaning and reception, and the person holding the camera is not an automaton; nor is the viewer of the camera's product.

Contemporary War Photography

The boundaries between art and photography are increasingly facing challenges. British and American photojournalists today remind us of this fact: they have names and appear on websites and in museums. The American Susan Meiselas, to cite one example, works for the internationally renowned Magnum photo agency co-founded by Robert Capa. She is most famous for her dramatic and graphic images of the insurrection in Nicaragua that overthrew the dictator Anastasio Somoza and brought the Sandinistas to power in 1979. A later commission took her to Kurdistan, where she photographed the devastation of Kurdish villages by Iraqi forces and the mass graves that resulted. She also took photos of the devastation after 9/11 at 'Ground Zero', site of New York's former World Trade Center. Yet, her work appears widely in coffee-table books. In some respects, this rather strange phenomenon speaks to the seeming commodification of war, earlier addressed in the photomontages of Martha Rosler (see Chapter 6). It also reflects the issue that concerns artists such as Jenny Holzer (discussed in Chapter 7), that by wanting to view tragedy and horror we are complicit in its continuance.

Don McCullin is a well-known British war photographer who, throughout the 1960s and 1970s, covered events across the globe, including the Vietnam War, for the *Sunday Times Magazine*. His work proved so painful and memorable that in 1982 the British government forbade him from covering the Falklands War. He is on record as questioning the relationship of art and photography:

We have a problem now, because [photography's] been looked upon in a different vein now, it's actually looked upon as art, which disturbs me greatly. I think every man and woman and child in the world can take a photograph now. They can't put claim to being artists. And I don't see photography as an art. I mean, a lot of photographers, myself included, goes without saying, are very influenced by art, and I can't help admitting that when I take photographs I try to compose my pictures, even in the moment of battle and the moment of crisis, I try to compose them, not so much in an artistic way, but to make them seem right, to make them come across structurally. So there is a confusion and I myself try not to associate myself with art, really.[6]

While artists and photographers have both used photography since the invention of the medium, some photographers are artists more than photojournalists, although they may make photos that fall into both camps. French artist-photographer Sophie Ristelhueber's extraordinarily beautiful photos of the desert following the first Gulf War appeared in a book entitled *Aftermath: Kuwait, 1991*. The photo series itself she called *Fait*. In keeping with previous work, she approached a damaged world that she found haunting, provocative, and tellingly lyrical. 'I was obsessed by the notion of a desert that had ceased to be a desert,' she later said.[7] *Fait* consists of seventy-one colour images, each 101.6 x 127 cm, most of which she took from a helicopter, and showed at Le Magasin at the Centre National d'Art Contemporain in Grenoble, France. The images, placed so as to approximate Ristelhueber's own experience of the desert, enveloped visitors. As Brutvan notes:

Fait is as much a physical experience as an intellectual and emotional one. Surrounded by the shifting planes, confused by the absence of recognizable scale and loss of perspective in these intentionally abstract details, the viewer is left to his own conclusions, and even with a sense of vertigo.

A typical image could be the desert taken from a great distance, its features reduced to pattern, or a close-up of a dried and pebble-strewn riverbed.

Ristelhueber followed *Fait* with *Everyone* (1994). Ostensibly about the hostilities in the former Yugoslavia, the images were actually of anonymous scarred bodies taken in Paris hospitals. When the images – hugely blown-up – exhibited in Utrecht at the Centraal Museum, visitors assumed that the pictures were from the former Yugoslavia. The accompanying book of fourteen black-and-white images included an excerpt from the first written document to describe war as one man inflicting violence against another rather than avenging the gods. The source was Thucydides' *History of the Peloponnesian War*, written in the fifth century BC. 'In their struggle for ascendancy,' wrote the historian, 'nothing was barred.'[8] The question Ristelhueber arguably is

identifying in this work is whether, when the significance of war's horrors has to be conveyed, does it actually matter if what you are presenting is truthful? Is the intent of the image more important than its source in reality? Furthermore, if what you do is art, how important is the documentary record in the creation of art? In 2005, Ristelhueber published her photographs of the Israeli-occupied West Bank.[9]

The Canadian Jeff Wall's *Dead Troops Talk (A Vision after an Ambush of a Red Army Patrol, near Moqor, Afghanistan, Winter 1986)* (1992) is an extraordinary essay on photography.[10] The massive image uses the scale and compositional techniques of a First World War canvas. The photographer was never on site but has the necessary elements, much as artists had models, accoutrements, still-life elements, and photos to reconstruct events. But here the tables turn: Wall looks back to history painting for inspiration to create a photographic image of an event that he never witnessed and only imagined. Dead men do not talk, but the thirteen– sometimes severely wounded – Soviet soldiers are lounging around a shell-crater, chatting and relaxing. Here, war becomes normal, but Wall, in undertaking the exercise, shows us how abnormal it really is.

Krzysztof Wodiczco has spent half his life in Poland and half in Canada and the USA. He projects carefully selected photographic images onto national sites to make points about power and repression. Just days after the outbreak of the first Gulf War, in January 1991, he projected a pair of death hands, one grasping an M-16 machine gun, the other a gas-pump nozzle, onto the triumphal arch in Madrid celebrating fascist Generalissimo Francisco Franco's victory in the Spanish Civil War. At the top of the arch he beamed the question, '¿Cuantos? (How much?)'. He builds on the work of Jenny Holzer and Barbara Kruger (see Chapter 7), challengingly combining visuals and text. In this case, he replaces photos with real buildings.

The British artist John Kippin is primarily a landscape photographer. In several works, however, he foregrounds the tools of war in order to allude to the military's potentially destructive presence in the most innocent of surroundings. In 1997, West Berkshire Council gave Kippin a commission in the form of a year's residency at Greenham Common, a massive US airbase near London that housed ninety-six ground-launch Cruise missiles and Europe's longest runway. Sustained and powerful protest by the women's peace movement had gained the site an international profile. The council acquired it from the Ministry of Defence in 1997 and embarked on a major programme to reclaim the area for recreation and wildlife conservation. The artist was to document the transformation and to develop work in response to the site. Kippin photographed potent details of the women's connection with the site – for example, a patch of 'darned' perimeter fence. Here, a traditional female pursuit kept women out.[11]

In 2002, the Imperial War Museum commissioned Paul Seawright as a photographer in Afghanistan. His large-format washed-out colour images of the war-torn landscape there quietly described remote beauty and extensive devastation. *Valley* unequivocally

echoes Roger Fenton's Crimean War classic *The Valley of the Shadow of Death*.[12] In Seawright's piece, a similarly flattened dry path winds into the distance towards the crest of a hill with only sky beyond. In Fenton's photo, cannonballs – perhaps placed there by the photographer – litter the path. Seawright replaces (perhaps manually) cannonballs with spent shells. In both photos, the depleted weaponry seems out of place in an ancient landscape that will endure again.

Official War Posters

Posters were not the unique creation of any warring government. The first coloured posters appeared in the 1860s, and the ensuing years saw more sophisticated printing presses and lithographic methods. The publicity aspect of war posters had its origin in pre-twentieth-century broadsides – posted, official announcements developed using letterpress, a derivative of the oldest mechanical printing method. Early twentieth-century war posters were also often textual but increasingly included a prominent visual image. The captions were short, to produce an immediate and lasting response. By 1914, posters were a common advertising medium used to promote all aspects of any war effort.

Between 1914 and 1918, warring governments used war posters to solicit recruits, to secure war loans, to urge conservation, to announce and make acceptable national policies, and to demonize the enemy. Charitable and civic groups also employed them. For charities such as the Red Cross, the Royal Society for the Prevention of Cruelty to Animals (RSPCA), the Young Men's Christian Association (YMCA), and relief groups, posters made appeals for volunteers, donations, civilian relief, and universal compassion. For civilian groups, posters announced programmes, broadcast appeals, and urged emotional involvement in the war or related causes.

The US government, to cite just one nation, enlisted the talents of an army of artists to publicize various causes. Edward Hopper, for example, won the United States Shipping Board's competition with his somewhat aggressive but dynamic poster design of a working man juxtaposed with bayonets – *Smash the Hun* (1918).[13] In this era, before television and radio, the poster was the quickest and most effective means of sending a message to a large population. In wartime such an undertaking required an official body of artists. The voluntary organization producing these official posters was the Division of Pictorial Publicity launched by a group of New York artists, with Charles Dana Gibson as chair. From 1917, after the USA had entered the war, the group met weekly at Keene's Chop House in New York to discuss the government's requests. It named a 'captain' to ensure designing of the week's required posters. He would select an appropriate artist, approve the sketch, and pass it to committee headquarters in Washington, DC. On approval of the design, the artist would complete the poster. In nineteen months, Gibson's group executed 1,484 designs.

Posters were similarly important during the Second World War. As early as 1940, the Society of Illustrators and Writers Guild of New York had formed a National Defense Committee to determine what artists could do in case of US entry into the war in Europe. In June 1941, a group of radical artists and writers convened a congress in New York in defence of art against fascism. In late 1941, the National Art Council for Defense and the Artists Societies for Defense formed in New York. Representatives from twenty-one major US art groups joined the two bodies. Complying with a federal request for one central wartime organization of artists, they merged in January 1942 as Artists for Victory. Similarly, in late December 1941, the Division of Information of the federal Office of Emergency Management announced a competition for defence and war pictures. The Graphics Division of the Office of Facts and Figures in Washington soon started sponsoring war-related art projects, as did the Works Progress Administration (WPA) until its demise and the US Treasury Department's Section of Painting and Sculpture.

After the Second World War, with the development of television in particular, posters were no longer the propaganda weapon of choice in the western world.

War Cartoons

In 2006, cartoons reached a new level of notoriety. When editorial cartoons depicting the Islamic prophet Muhammad were published in the Danish newspaper *Jyllands-Posten* on 30 September 2005, Danish Muslim organizations staged protests. The controversy grew to global proportions in 2006, with news of their publication spreading across the world, and the cartoons were reprinted in more then fifty countries. Violent protests resulted in hundreds of deaths. The debate centres on whether the cartoons should not have been published because they are culturally insensitive and humiliating or whether the Danish newspaper and others were exercising the right of free speech in printing them.

Cartoons form part of the history of war art. In Britain, the three-month Falklands War in 1982 provided a rich theme in the pre-Internet era.[14] Many cartoons – Ralph Steadman's famous cover drawing 'Flies on Meat' for the *New Statesman*; Peter Brookes's cartoons for *The Times*, several of which comment on the treatment of the media during the conflict; Les Gibbard's powerful satires on the politicians of left and right; Michael Cummings's punchy attacks on the war's critics; and examples of Steve Bell's 'IF ...' comic strip in *The Guardian* and the more scatological 'Maggie's Farm', which appeared weekly in *City Limits* – notably captured the controversial and jingoistic aspects of the conflict.[15] Nicholas Garland, Stanley Franklin, and social satirists Giles, Mel Calman, and Michael Heath also contributed to the war's cartoon record. Heath's 'Well I really enjoyed that war, it was better than the one last week,' which depicts a clearly middle-class couple with their television set, highlights the prevalence of war as

a popular television programme.[16] Ken Mahood's 'A Bigger Splash Somewhat Outside the Total Exclusion Zone', about the sinking of the Argentinean vessel the *Belgrano*, also refers to British artist David Hockney's famous 'California lifestyle' painting, *A Bigger Splash* (1967).[17]

In the USA, in more recent times, cartoon strips and comic books have been immensely popular and influential war art-related genres. The children of Holocaust survivors depend on archival and artefactual material to reconstruct their parents' experience. Art Spiegelman's Pulitzer Prize-winning comic books *Maus I* and *11* (1986 and 1991), while seemingly distinct from this sort of material evidence, could not exist without it, and this is what makes them resonate. They have a basis in reality. The two volumes introduce readers to Vladek Spiegelman, a Jewish survivor of Hitler's Europe, and his son, a cartoonist trying to come to terms with his father, his father's terrifying story, and history itself. Its form – the cartoon (the Nazis are cats, the Jews mice) – shocks us out of any lingering sense of familiarity with the events described, approaching the unspeakable through the diminutive. Tragic and comic by turns, it attains a complexity of theme and a precision of thought new to comics and rare in any medium. The two volumes tie together two powerful stories: Vladek's harrowing tale of survival against all odds, delineating the paradox of daily life in the death camps, and the author's account of his tortured relationship with his ageing father. The drawing style is direct and effective, relying on black and white contrasts and the dynamism of Spiegelman's line to support the narrative. In 2003, Spiegelman published *In the Shadow of No Towers*, his equally personal response to the destruction of New York's World Trade Center in September 2001.

Joe Sacco combines his comic-book skills and eyewitness reportage with the political and philosophical perspectives of the people he meets. He recovers stories about the experiences, memories, and histories of those who do not make it to the mainstream news. He was in Palestine for two months in late 1991 and early 1992. In 1996, he won the American Book Award for his groundbreaking two-volume *Palestine* – a first-person, journalistic account of the situation in the occupied territories, which he tells in comic-book form and that appeared first as a series of nine comic books (1993–1996). Sacco spent four months in Bosnia in 1995–1996. *Safe Area Gorazde: The War in Eastern Bosnia, 1992–95* tells about the wars in the former Yugoslavia in relatively realistic and complex, Bruegel-inspired, thick-lined drawings. The book focuses on the Muslim enclave of Gorazde, which Bosnian Serbs besieged and where Sacco stayed five weeks.

War Art and the Internet

The Internet has become a site for war art, particularly protest art.[18] Images – many ephemeral – that appeared on the Internet during the second Gulf War of 2003 hark

back to Peter Kennard's photomontages of the 1980s (see Chapter 6). Using the familiar, these works question and criticize political decisions by reworking propaganda and advertising tools of the past. The famous First World War recruiting poster centred on an image of a beckoning 'Uncle Sam' adds George W. Bush's face and the words, 'I want you for my war.'[19] Another, similar, states: 'To those responsible. We're coming for you.'[20] Yet another shouts abruptly: 'I want you dead.'[21] One particularly ironic variation replaces Uncle Sam with Osama bin Laden, who states: 'I want you to invade Iraq.'[22] 'Uncle Sam' images surface in other contexts. One tells viewers: 'I want you to die for Israel.'[23] British Prime Minister Tony Blair is not immune either. A smiling Blair appears in a poster: 'I want you to kill women and kids so western capitalism can have cheap Gulf oil.'[24] In the USA, artist Richard Serra has begun to use the Internet as a site for artwork. *Please Vote* from www. pleasevote.com appeared on the back cover of *The Nation* on 5 July 2004. It depicts George W. Bush devouring a naked body and was based on Goya's painting *Saturn Devouring One of His Sons* (1821–1823).[25]

Familiar products inspire some Internet protest art vis-à-vis the war on terror that followed al-Qaeda's destruction of the World Trade Center. A particularly resonant image invokes the famous Second World War memorial at Iwo Jima in the Pacific and McDonald's golden arches logo: 'Did somebody say McArabia?'[26] An Italian site presents a new hamburger – the McLaden – topped with appropriate headgear and sporting a wispy beard.[27] Other images slightly rework famous film posters. 'Usama Bin Laden in Ben-Hur' is a typical example.[28] This same site – 'Bin Laden's greatest hits' – also offers a poster of the World Trade Center entitled 'Puzzle: 1000000000000 pieces.' Another image from this site sports a familiar message window: 'Are you sure you want to delete both towers?' Albeit flippant, these are horrific and compelling images. What are they doing as images? Are they normalizing horror or are they reducing its impact through a kind of twisted humour? Do images such as these confirm humanity's dark side and echo the concerns of Jenny Holzer and the Chapman brothers that we are what we create when it comes to war?

Military Magazines

Innumerable military magazines such as *Battlefields Review*, *Military History*, and *Military Illustrated* call on a veritable army of artists whose names will rarely grace the pages of an art-history book. Wanting accurate historical reconstructions of military events, their art illustrates magazine articles and books and appears as limited-edition prints. Websites such as www.military-art.com, www.naval-art.com, and www. aviationartprints.com present their work for sale.

Such art is not so distant from the more politically motivated expressions that fill this book. Much as Goya's viewers find confirmation of their own views about war, so too do those who participate in re-enactments or paint armies of toy soldiers. The latter find

visual support for their dedication – to remembering history factually and accurately, stripped perhaps of any judgment call – in military magazines and web pages.

Chapter 9

War Art as Memorial, War Art as Memory

James Young, a keen observer of monuments, explains their changing roles in the twentieth century:

> Like other cultural and aesthetic forms in Europe and America, the monument
> – in both idea and practice – has undergone a radical transformation over the
> course of the twentieth century. As an intersection of public art and political
> memory, the monument has necessarily reflected the aesthetic and political
> revolutions, as well as the wider crises of representation, following all of this
> century's major upheavals – including both the First and Second World wars,
> the Vietnam War, and the rise and fall of Communist regimes in the former
> Soviet Union and its Eastern European satellites. In every case, the monument
> reflects both its socio-historical and its aesthetic context: artists working
> in eras of cubism, expressionism, social realism, earthworks, minimalism, or
> conceptual art remain answerable both to official history and to the needs of
> art. The result has been a metamorphosis of the monument from the heroic,
> self-aggrandizing figurative icons of the late nineteenth century, celebrating
> national ideals and triumphs, to the anti-heroic, often ironic and self-effacing
> conceptual installations marking the national ambivalence and uncertainty of
> late-twentieth-century postmodernism.[1]

This chapter explores memory and war art in the twentieth century with reference to memorials in art; to memorials in sculpture and architecture; and finally to counter-memorials. It looks at structures such as Maya Lin's Vietnam Veterans Memorial (1982) in Washington, DC, and Daniel Libeskind's Jewish Museum in Berlin (2001) as art. It leaves out some more traditional monuments, such as the new American Second World War

Memorial in Washington, DC which, one journalist reported, has 'the emotional impact of a slab of granite'.[2] Yet both Maya Lin's Vietnam memorial and Rachel Whiteread's Holocaust Memorial in Vienna contain traditional elements – in the former, a group of bronze American service personnel, and in the latter, the names of the Viennese Jews whom the Nazis killed.

Susan Sontag argues in the *New Yorker* in 2002 that photography is the most powerful form of memory. 'The problem is not that people remember through photographs but that they remember only the photographs,' she writes.[3] 'This remembering through photographs eclipses other forms of understanding – and remembering.' She continues: 'To remember is, more and more, not to recall a story but to be able to call up a picture.' The same may be true about art. We cannot remember our pasts second by second. We can recall only bits and must rely on other's recollections or on visual and aural stimuli to piece our pasts together. Often, because we are all relying on similar sources or stimuli, we all tend to remember much the same things. In other words, we 'remember' things that we have never seen or experienced directly, but that have affected us. This is 'collective memory'.

Collective memory manifests itself in many ways. With war art it enables a single painting – Alex Colville's *Infantry near Nijmegen*, for example – to resonate for many of the thousands of Canadians who served in the Netherlands during the Second World War.[4] The canvas is a tapestry of still-life elements – the material of soldiers' lives interwoven into the fabric of the artist's imagination. The result *looks* historically true – the cold, the wet, the burdensome Bren gun, the webbing, the pale watery sun of winter – and therefore *could* have been lived, but it is really a reconstruction that the artist based on his own memories and the sketches that he retained. People who served in the Netherlands *can* find something of their own remembered experience there. They can build on that memory by incorporating the painting's missing bits into their own recollections. This forms the sort of collective memory that grants Colville's painting a status equivalent to that of history. But it is an ever-changing vision of the past. All those viewers who respond to that work and share their reactions to it change its meaning, both for themselves and for others. We can call this painting a site of memory.

The traditional site of memory for war, however, in western nations is the war memorial, for the memory of war is mostly local. Young, the author of the commentary above, discounts monuments' role in formulating memory.[5] He finds them 'of little value' by themselves.[6] 'But as part of a nation's rites or the objects of a people's national pilgrimage, they are invested with national soul and memory.' In his view, a state-sponsored memory is not a concretized memory. 'Once created, memorials take on lives of their own, often stubbornly resistant to the state's original intentions,' he notes.[7] Citing the French sociologist Maurice Halbwachs on collective memory, Young argues further that citizens and state always socially mandate this process: 'For a society's

memory cannot exist outside of those people who do the remembering – even if such memory happens to be at the society's bidding, in its name.'[8]

For historian Daniel J. Sherman, memory is ultimately a politicized interaction of individual and group memory with site. In his 1999 study of war memorials in interwar France, he writes of commemoration, in particular, as representing a power struggle between interests.[9] Nonetheless, his emphasis on external forces providing meaning to monuments constructed to enshrine memory, rather than finding their value in formal aesthetic analysis, resembles Young's approach.

The literature presents national memory as a fluid phenomenon that can both exist and evolve at the same time. What people make and understand exists within an often-contested dynamic that involves many interests, including power. This dynamic gives shape and meaning to the rituals and objects associated with the ever-changing memory. Furthermore, in art, it is not so much a work's aesthetic qualities that ensure its significance in the making of memory as the particular meaning that interacting political and social groups impose on the piece or derive from it. Within this informing context, we can grasp how memorial art has moved in and out of the shadows of history, art history, identity, and memory in a manner beyond the strictly narrative.

Memorials in Art

The various anniversaries of the First and Second World wars at the end of the twentieth century gave rise to what can only be described a culture of remembrance. Fuelled by veterans' groups, the rituals of remembrance loom large in the public imagination. War art in the form of memorials and exhibitions has supplied 'sites of memory' for a public eager to reflect on war. Here we will briefly explore aspects of remembrance first in some two-dimensional works and then in sculpture and architecture.

American Cy Twombly's memorial goes very far back in history to the Battle of Lepanto in 1571. *Lepanto* (2001) was the artist's response to the fiery sea battle that rescued Europe from the Ottoman Empire. It was there, off the coast of Turkey, that European forces led by the Venetians destroyed the Turkish fleet. Twombly's composition consists of a series of twelve large panels and begins and ends with a conflagration. The work is colourful yet opaque; in some respects it resembles Monet's water-lily paintings as New York's Museum of Modern Art exhibited them before its renovation. Ghostly vessels drift across giant canvases whose dripped paint evokes the narrative of history and the stuff that makes up the paintings. The scratches, marks, and fine cracks are emblematic of wounds from fighting.[10]

The Anglo-American artist John Walker's work encompasses history, biography, and poetry in a dialogue with the First World War that began in the late 1950s. He lost eleven uncles in one day during the battle of the Somme in 1916, and his father survived the war. The German First World War artists George Grosz and Otto Dix influenced many of

his early prints, and his more recent works echo Goya as well as Dix. Two British poets, Wilfred Owen and David Jones, also influenced him. He scrawls their words over many of his paintings. In a number of his compositions, a sheep-skulled figure loosely refers to his father, the sheep suggesting the lambs going into the slaughter of war.[11]

Walker has expressed a debt to Paul Fussell's *The Great War and Modern Memory* (1975), which problematizes his work. Walker's work is a postmodern expression of war, with its references to past poetry, art, history, recollection, and commentary, but this usage perhaps dilutes its impact. To be good war art – to say something – and to connect with the viewer, war art has to be more than the sum of its parts, even in a postmodern world.

Other artists have explored their nation's past involvement in war. Raymond Arnold is an Australian artist whose work owes much to the memories of his own great-grandfather and compatriots-in-arms during the First World War. The literature of memory and war is notable in his country, where war still looms large and art continues to address similar themes. In 1998, Arnold made a pilgrimage to the Somme in France. 'As the artist mirrored the paths of his soldier-forbears,' Katherine McDonald writes, 'he also reflected on his own life, his role in the family lineage with mixed notions of history and memory, masculinity and duty, war and dislocation.'[12] In '*Je me rapelle*' – *le Coquelicot*, he plays with the emblem of remembrance, the poppy.[13] In this delicate etching, images of a skull, a skull-like face, and the blood red of the printing ink intermingle.

Many years after 1945, Sidney Nolan, a war artist during the Second World War (see Chapter 5), was living on the Mediterranean coast. The setting inspired him to paint about the Australians' ill-fated 1915 landing at Gallipoli in Turkey. Over more than twenty years, he produced landscapes, portraits, and figure studies. His *Gallipoli Landscape with Steep Cliffs* (1961) honours the memory of a searing national event.[14]

Inspired perhaps by the fiftieth anniversaries of the Second World War in the mid-1990s, Anglo-Irish artist Hughie O'Donoghue focuses on his father's war experiences: evacuation through Cherbourg in June 1940 and the Italian campaign of 1944, specifically the Battle of Monte Cassino.[15] He casts his father, however, as 'everyman,' believing that only pursuit of the particular can reveal the universal.[16] His very beautiful meditative compositions – most completed since the mid 1990s – take the form of a narrative and address many traditional themes of war art. Death justified as redemption, for instance, invokes First World War myths, while ruins – in this case, antique sculpture – stand in for war's destruction. The works' peculiar power, however, rests on their personal content – details of family experiences of battle, gained from letters, diaries, photos, and mementos. They also draw on the artist's Irish background, the old masters, and archaeological excavation of both antique sculpture and preserved bodies.

Like so many war artists, O'Donoghue uses photography, even though many of them feel that it does not adequately explicate the subject. Most of them are silent about

using the medium, but O'Donoghue lets it inform his compositions and is frank about that. He sees photos 'as a fundamental part of the story'. 'When the work is complete,' he states, 'there won't be any kind of jump between the photograph and the painted image.'[17] The way he integrates the two media facilitates his goal. He prints photo images on Japanese paper and attaches them to the canvas with paint. In places the image is virtually invisible behind layers of paint or disappears completely in a textured, layered surface of elegiac beauty.

In *Painting Caserta Red (Crossing the Rapido VI)* (2003), the artist includes much of his personal material.[18] The slightly opaque image of the flayed Marsyras from Titian's *The Flaying of Marsyras* is central, alongside an image taken from a sculpture of Marsyras derived from a 1944 postcard from Rome's Palazzo Conservatori.[19] These images evoke the widely reproduced 1943 photos of the corpses of Fascist dictator Benito Mussolini and his coterie. The work also incorporates a photo of a skinned German soldier.[20] It is the luxurious and rich use of paint – many layered and dense – that synthesizes the imagery. In a sea of red-brown – it is a massive composition – O'Donoghue expresses anguish at the destructive and very painful course of war.

Memorials in Sculpture and Architecture

In general, the more modern and avant-garde of Europe's twentieth-century sculptors did not receive requests to commemorate the events of the Great War. Any commissioned figurative sculpture tended to question war and generate a cool response. The same attitude motivated post-1945 sculptors both European and American. In war memorials the division between sculpture and architecture is fluid.

The World Wars

The major memorials are those of the First World War. In many cases, the Second World War's dates were simply added on to the monuments of the Great War. The most widely recognized memorials for this war are therefore those to the Holocaust. Specifically anti-war expressions are rare in memorials, even if some counter-memorials come close.

The British sculptor Charles Sargeant Jagger's best-known memorial is *The Royal Artillery Memorial* (1921–1925) at Hyde Park Corner in London. It consists of a carved-stone 23.37 cm howitzer gun atop a stone plinth, with artillery scenes worked in relief on the four sides. Four bronze figures – officer, driver, shell carrier, and dead soldier – appear on each side. These figures reveal Jagger's artistic motivations. Unlike the prevailing idealism – as in the Vimy Memorial figures (see below) – Jagger's models have rugged and workman-like features, which earned him a 'realist' label. Yet details of their uniforms and equipment convey symbolic meaning, and their strikingly symmetrical poses reflect the influence of primitive art.

Eric Gill carved small local memorials across Britain. *Our Lord Driving the Moneychangers out of the Temple* (1923), for the University of Leeds, was a low relief cast in contemporary dress and was vilified.[21] It shares in Jagger's primitive look and, in its linear narrative, resembles the figures on the *Royal Standard of Ur* (see Chapter 1). Jacob Epstein, another British sculptor, had declared his abhorrence of war in *Rock Drill* (1913–1916), which looks like General Grievous, the villain in *Star Wars Episode 3*.[22] Epstein's ongoing dislike of the conflict comes across in his thin, attenuated, sorrowful *Risen Christ* (1917–1919), which, like Gill's relief, generated little rapture.[23]

The Frenchman Émile Antoine Bourdelle's memorial sculptures, such as *France Supporting the Wounded Soldier* (1924–1928), share in the English sculptors' more primitive, Middle Ages-inspired style.[24] Also owing much to medieval carving, the German sculptor Ernst Barlach's work conveys deep emotion with simple yet dynamic planes and lines. His First World War memorial for Güstrow Cathedral, Germany (1927), is extraordinarily moving and places a floating – almost flying – figure over a tombstone laid into the floor, which bears the dates 1914–1918 and (added later) 1939–1945. The piece underlines the common view of the war as redemptive, with death a means to salvation. The figure's intense facial expression depicts the moment – 'We shall be changed,' in Handel's *Messiah* – at which earthly death becomes eternal life.

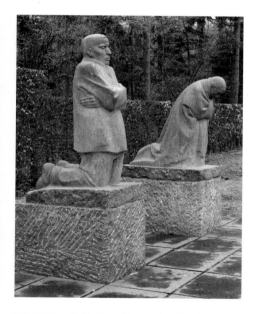

Käthe Kollwitz's meditative woodcuts on loss – her son, Peter, died in the war on the German side – culminated in an extraordinary sculpture of mourning parents (she and her husband) that speaks to everyone who has lost a child. In 1932, this very personal piece – *Memorial to the Fallen* – had its dedication at Vladslo military cemetery in Flanders, where her son lies. The sculptor Wilhelm Lehmbruck was himself a victim of the war. After penning an agonized poem asking for death, he took his own life in 1919. Two of his sculptures, *The Fallen Man* and *Seated Youth*, epitomize in their unhappy gestures his and his subjects' despair at the continuing conflict.[25]

29. Käthe Kollwitz, *Memorial Depicting the Artist and Her Husband Mourning Their Dead Son, Peter Kollwitz, Memorial to the Fallen* (1931).

The Romanian sculptor Constantin Brancusi paved the way for abstract sculpture that meditated on death,

love, loss of life, and trauma in his monuments for his fallen compatriots at Targu Jiu (1936–1938). The works are a cosmic representation of the stages of human life, from birth (the Silence Table) to death (the Endless Column, a twenty-nine-metre version of the funeral poles common in south-eastern Romania). Between them – within, as it were, the span of a human life – stands the Kiss Gate, symbol of marriage. Around the Silence Table, twelve symbolic chairs represent the passage of time. From the table, on the river's edge, the water's flow implies that life is always moving forward; the visitor moves thence to the Endless Column, representative of eternity.

First World War memorial architecture has two giants: Edwin Lutyens and Walter Allward. Lutyens designed the extraordinary British war memorial at Thiepval in France (1928–1932) – the *Memorial to the Missing* – which bears the names of 72,000 British soldiers whose bodies remain lost. It looks like a vast, stepped memorial arch of brick and stone. Lutyens also designed the stark Cenotaph in central London, the site of that city's annual Remembrance Day ceremonies, and the prototypes for the empty tombs and grave markers of the numerous Allied overseas cemeteries. His work lacks figurative detail. The other significant First World War memorial in France is the work of the Canadian Walter Allward. The Vimy Ridge Memorial (1921–36) echoes Lutyens's work in the simplicity of its architecture – two white pylons on a stepped base – but adds twenty allegorical figures, which promote common goals of the time such as truth, hope, knowledge, and charity. The Menin Gate (1923–1927) by Sir Reginald Blomfield is moving because of its association with Ypres and the 54,896 British and Commonwealth missing of Flanders engraved on its walls more so than it is for its architectural genius.

The Second World War generated no great national architectural memorials such as those of Lutyens and Allward and the range of quality varies; as in Barlach's case above, many countries just added the new dates to their existing First World War memorials. Instead, the horrors of Hitler's Final Solution, which killed more than eleven million men, women, and children, a majority of them Jewish, has given rise to the most memorials. Furthermore, many artists who have come to maturity since 1945 have created powerful work that constitutes almost a collective memorial. If you are an artist, if you are Jewish, and if the Holocaust haunts your experience, then it almost invariably informs some of your work. Meditations on the theme have come from Christian Boltanski, Melvin Charney, and Fabio Mauri, to name a few. Never the less, while the Holocaust has increasingly become a subject of art and architecture, some Germans wonder whether monuments in Germany mourn acts of violence or assuage collective guilt.

The French architect Georges-Henri Pingusson's Mémorial des Martyrs de la Déportation (1962) is one of the earliest architectural memorials to Nazi persecution. It is behind Notre Dame Cathedral in Paris. It is difficult to find, and descent into it is like leaving one world and entering another, as Paris disappears. A bare and simple

space encourages contemplation and reflection; the only view out is through a grate overlooking the Seine. The actual memorial to the 200,000 French deportees to the Nazi camps consists of lit glass beads; visitors cannot enter it because its space is narrow and constricted. As in so many memorials, the words of great writers – in this case, French – inscribed on the walls convey what many find too painful to articulate.

The American Sol LeWitt's *Black Form: Dedicated to the Missing Jews* appeared first in Münster, Germany, in 1985 and, after demolition and rebuilding, in Hamburg in 1987. The black cuboid stands in front of and parallel to the impressive Altona Town Hall at one end of the Platz der Republik. The black-painted structure, 5.5 x 2 x 2 metres, consists of light concrete blocks built on a foundation. The artist wanted no inscription. Two plaques on either side explain the piece's origin in the history of Altona's Jewish community. The controversy over its installation (Hamburg refused to purchase it) raises the familiar issues of site and reception as politically effective tools for both artists and patrons. Elsewhere in Germany, the American Richard Serra's sculpture *Berlin Junction* (1987) commemorates victims of Nazi euthanasia.

In the National Gallery of Art's Sculpture Garden in Washington, DC, stands Magdalena Abakanowicz's figurative sculptural group, *Puellae* (Girls) (1992).[26] These headless, rigidly posed young bodies represent the artist's response to Nazi totalitarianism in Poland during her wartime youth. As a child she heard about a group of Polish children who froze to death during transport to Germany in cattle cars. The figures contrast bleakly with their verdant surroundings, which heightens their power.

As in earlier works by Bruce Nauman and Joseph Beuys, the British artist Rachel Whiteread (winner of the Turner Prize in 1993) presents as the final artwork the cast of the negative space defined by an object, rather than replicating the object itself. Her simplified, abstract transformations of familiar forms, including bathtubs, chairs, and mattresses, often recall minimalist sculpture. *Untitled (Library)* is one of a series of works related to the Holocaust Memorial in Vienna, designed by Whiteread and inaugurated in 2000 after a chequered genesis.[27] The concept of libraries and books as historical repositories of knowledge and memory is an important one for the artist. In the Vienna memorial, multiple cast-concrete slabs form a block some four metres high with sides that are approximately nine metres by seven. Here, the artist inverted a room-sized library – once common in Viennese homes – by casting the space between pages of books and surrounding shelves. The absent volumes leave the imprint of their unique dimensions and coloured page ends, suggesting both the personal stories of the roughly 66,000 Austrian Jews (traditionally 'People of the Book') who perished during the Holocaust and the general devastation that the war caused. Whiteread has not replicated what the Nazis destroyed, which is the stuff of memory, but provided a space for memories to flourish.

The Holocaust Memorial that opened in Berlin in May 2005 consists of 2,711 concrete slabs, a few over two metres high. They are just under a metre apart and seem to

undulate like waves across the vast city space. The memorial is the size of three football fields – Germany's biggest. From a distance it looks like a series of graves, but close up the uneven heights create a disorienting maze. The intent is that the visitor, lost in the jungle of slabs, will feel vulnerable and aware of the fragile nature of security. Civic ordinances required the planting of forty-one trees, which the American architect Peter Eisenmann located haphazardly so as not to create a sacred place. Eisenmann designed the memorial with original input from artist Richard Serra. Publisher Lea Rosh and historian Eberhard Jäckel first presented the idea for a memorial in 1988, and its tortured route to completion speaks volumes about Holocaust remembrance in Germany. The government rejected the first proposal, the result of a 1994 competition. Peter Eisenmann's proposal won the second, 1997 competition, and the government approved construction in 1999. Building almost halted in 2003 when the public learned that the company providing 'graffiti protection' had an affiliate that had made Zyklon B – the gas that the Nazis used in the gas chambers. Construction stopped for several months.

Daniel Libeskind had more recognition as an architectural theorist than as a builder until he completed the Jewish Museum in Berlin (2001) – a memorial more than a museum – and then received the commission for the memorial to 9/11 in New York (2003). The portrayal of absence fascinates him:

> I am very much interested in the cultural significance of the void – the void of public space, and the void of memory. What is the void's cultural presence today? What is its form and repression? What might it have been historically? How does it look? How does one encounter it or how does one not encounter it?[28]

The Jewish Museum resembles a broken Star of David – a zigzag of sorts – but jagged lines also break its zinc-clad exterior wall surfaces. Connecting lines between locations of historic events and locations of Jewish culture in Berlin form the basis of the design. Libeskind has also referenced expressions of the disappearance of Jewish culture in the city. These ideas are conveyed through the crooked paths through the building and by the existence of spaces that visitors cannot enter. Inside, intersecting structures disrupt the dark, empty concrete spaces. We grasp the empty spaces not by the traditional means of exterior walls but by internal interruptions. Libeskind insisted that the museum have no front door and no windows at ground level; he wanted Jewish history to be a hidden element in the context of German history. As a result, the entrance is underground.

Particularly in Germany, where memories of Nazism evoke monumental sculptures by official artists such as Arno Breker, counter-monuments have also had appeal. Often invisible, or designed to become so over time, they attack the concept of a site of memory and a memorial's power to influence public opinion. Fearing memorials' ability

to replace memory, designers create instead invisible memorials that they equate with forgotten memory. By not replacing memory, they allow other memories to survive intact.

A whole series of anti-monuments has marked post-1945 Germany, ranging from sunken structures in Kassel (by Horst Hoheisel) to disappearing obelisks in Harburg. Jochen Gerz and Esther Shalev-Gerz's *Monument against Fascism* (1986) is a disappearing obelisk. Constructed as a four-sided, steel column, twelve metres high, it would descend over time into the ground, essentially disappearing, which it did in 1993. The outside of the column had a lead coating, soft enough to write on.

Other monuments and counter-memorials remind us that war affected many millions outside Germany and that disgust at war has not, and is not, necessarily driven by the facts of the Holocaust, appalling as they are. David Smith's celebrated *15 Medals for Dishonor* (1939–1940) is a very early example that relates to the outbreak of the Second World War and is a significant document of US anti-war feeling. The medals depict the devastation of war, ignorance, prejudice, poverty, illness, and environmental destruction. Created during the rise of fascism in Europe in the 1930s, they are perhaps the least known of Smith's major works. Four belong to the Hirshhorn Museum in Washington, DC.[29] They vary in shape from round to oval, and their small narrative scenes speak to war's consequences. Inspiration clearly came from the First World War and the Spanish Civil War. Smith earned fame for his large, abstract, geometric sculptures, so these tiny, figurative works represent a surprising and highly personal departure.

In acknowledgment, perhaps, of the lack of designated Second World War memorials in Britain, the Imperial War Museum commissioned Renato Niemis's memorial installation, *Counting the Cost* (1997), for the American Air Museum at Duxford, England.[30] Fifty-two glass panels bear engraved outlines of 7,031 aircraft, one for each US plane missing in action in operations from Britain during the Second World War. The scale is 1:240. Niemis replaced the traditional engraved name with an engraved aircraft, reflecting the 'tallies' that airmen painted on their planes' fuselages. The sculpture's shape evokes the formation flying so common in the war. Glass provides a transparency that suggests air. While the extent of the losses is immediately apparent, the lack of a name or a face reduces the sculpture to a suggestion of something like 'collateral damage.' It honours the machinery of war rather than the people who operated it.

Memorials to War after 1945

The second half of the twentieth century has been characterized by literally hundreds of wars encompassing the civil, the ethnic, the religious, the guerrilla, and the defensive. The result has been a plethora of memorials that range from the traditionally national to the personal and idiosyncratic and can be both celebratory and condemnatory at one and the same time. Many are clearly counter-memorials or sculpted forms of anti-war art.

During the 1960s, the era of the early Cold War and the beginning of the Vietnam War, the USA gained a number of counter-memorials. Over forty years, Robert Morris executed a large variety of drawings and works on paper about war. He prepared the thirteen *Crisis Drawings* in October 1962 during the Cuban Missile Crisis. He bought a New York tabloid newspaper on each day of the crisis and covered most of the paper with grey acrylic paint; the newspaper is visible through the paint. The *War Memorials* series proposed a planned destruction of the American landscape as a memorial to war. *Infantry Archive – to Be Walked on Barefoot* was to consist of 'acrylic blocks cast around nude corpses. Each soldier to exhibit a different type of wound.'[31]

Claes Oldenburg drew inspiration from the commodities of post-1945 culture. *Lipstick (Ascending) on Caterpillar Tracks* (1969–1974) combines the prevailing fear of war with consumerism.[32] He described an unbuilt memorial:

> The War Memorial began as a pat of cold hard butter in a crossed slit of a hot baked potato, projected up in scale. The crossed slits made me think of an intersection of streets, and I developed this resemblance. I picked the most crucial intersection I knew, which is where Broadway and Canal Street cross, connecting Long Island with New Jersey and Wall Street to the rest of the country. Also, I've read it's the target, which, according to experts, would be the most efficient in the New York area for a nuclear drop. The butter became concrete, and it ended as an ironic anti-war monument.[33]

Edward Kienholz conceived *The Non-War Memorial* in 1970. His original conception was ambitious: the finished work was to sit on a seventy-five-acre meadow on a river in Idaho. The land, originally a field of alfalfa and clover, would undergo ploughing or chemical destruction, and assistants would fill 50,000 army uniforms with wet clay and spread them around the field at random. The purchaser of the memorial would pay workers – artists, students, activists, and local residents – to spend a summer making visual a non-war. They would place 500 uniforms on the land each day, seven days a week. The work would take more than three months, and a museum would then care for the memorial for five years. By that time, the uniforms would have rotted and the clay dissolved, so that the land would be ready for ploughing and replanting with alfalfa. In 1972, as a testimony to the American dead in Vietnam, Kienholz added to his planned memorial a book with 45,647 images of bodies to represent them. He also included those who had died of other causes, who numbered 10,023. The memorial never saw completion as the artist envisaged it, but it survives in three small versions of his original conception that his wife later assembled.[34]

Bill Woodrow's Cold War sculptures cast in bronze from found objects – such as *Refugee* (1989) – look a bit like traditional war memorials.[35] *Refugee* resembles a broken wheelbarrow, whose contents are pouring out of it. Works such as this in the 1980s

reflected artists' attempts to blend postmodernism and conservative traditionalism, à la British Prime Minister Margaret Thatcher. Found objects equated with popular culture but harked back to tradition and the conservative ethos. Specifically, *Refugee,* by its very title, counters the usual bronze subject of hero or sacrificial victim.

Maya Lin's Vietnam Veterans Memorial on the Mall in Washington, DC, consists of two reflective granite walls totalling 151 metres in length, set into the ground. The walls meet at a 125-degree angle – one pointing to the Washington Monument, the other to the Lincoln Memorial. The walls carry the names of the 59,939 soldiers who died or went missing in action – in chronological, not alphabetical order. Maya Lin saw the reflective granite as mirror-like, so visitors could see themselves in the names. The memorial is incredibly popular; visitors leave mementos and photos to honour the people remembered there. The design harks back to traditional Great War memorials such as Sir Reginald Blomfield's The Menin Gate at Ypres (1923–1927), but it adds the minimalism of sculptors such as Richard Serra.

Eric Fischl's *Tumbling Woman* (2001) commemorates victims of the attack on the World Trade Center. It is a sculpture of a woman falling from what seems to be a great height to certain death.[36] Fischl added the words of a poem he had written for the sculpture's initial display at New York's Rockefeller Center: 'We watched, disbelieving and helpless, on that savage day. People we love began falling, helpless and in disbelief.' Public outcry ensured the sculpture's removal despite Fischl's defence of its intention, which was to express the vulnerability of the human condition. The sculpture is Rodinesque, so criticism centred on its subject matter, clearly too painful for many observers.

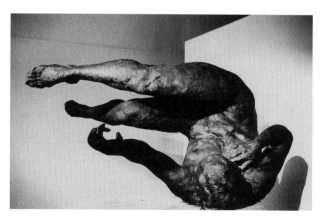

30. Eric Fischl, *Tumbling Woman* (2001).

War memorials provoke debate. Libeskind's 2003 plan for the memorial to 9/11 is yet to go up, as interest groups, including the bereaved, battle for their vision of its meaning. The Canadian First World War memorial at Vimy Ridge in France is an

interesting example of this debate. In 1921, the competition for the memorial was won on the basis of a design that reduced the reasons for the conflict and the consequent soldiers' deaths to allegorical symbols such as justice, sacrifice, and honour. By the time the monument was unveiled in 1936, while the allegorical symbols remained, in response to public pressure the walls were now engraved with the names of every Canadian soldier who had lost his life in France and had no known grave. The memorial had become both a national monument to the war and a symbolic grave for every individual who had died in its cause and whose remains had never been identified. Here, national interest was able to accommodate individual grief.

Epilogue

The Beat Goes On

What is war art? Is it a battlefield scene with churned-up blood-red earth, driving rain, smoking ruins, scattered corpses, and twisted metal detritus, all lit by white diagonal stripes of searchlights and the brilliant firework colours of exploding star shells? Is it courage in the tired, drawn features of Victoria Cross winners and tragedy in the weary, frightened faces of the ordinary men and women who lived only long enough to be portrayed? Is it teamwork in the charges of galloping horses, the billowing sails of ships-of-the line, the humming squadrons of bomber aircraft, and the concentration of myriad factory workers? Is it the elegant monuments to victory and the spare, minimalist memorials to tragedy? Is it brutal in-your-face gratuitous violence? Is it a gentle, meditative wash of colour depicting no man's land? This book has tried to explain that it is both what you expect and what you need. It is humankind portrayed at its best and at its worst. It is the record of civilization when life takes second place to death. It is the place where we reflect and remember.

War is one of the great themes of art. Another is religion and the two are inevitably intertwined, often in the interests of political gain. Indeed, the pages of another book could be filled with visual examples from each of the world's spiritual and indigenous traditions showing how often conflict has been depicted in religious art. This book, although geographically limited, has shown that war art has always been part of human culture, from the time of the Assyrians, if not before, to the present day. It was the writer John Ruskin who proclaimed more than 100 years ago that 'Great nations write their autobiographies in three manuscripts:- the book of their deeds, the book of their words, and the book of their art.'[1] War art speaks to all three books and, as such, forms one of the defining elements of any culture and also one of its significant legacies.

War art functions in many different ways in society. Its use as a political tool is a constant. For the Assyrians, it was the foundation of empire. War art in the form of

sculpted battle reliefs showed who had won and where the power lay. When Europe was building its empires in the sixteenth through to the nineteenth centuries, massive battle paintings in the halls of kings and emperors signified the winning side and the dwelling place of power. This role was harnessed by governments in the First World War, which organized official art programmes to document success for future use. War art's muscle has also been recognized by the opponents of war who have used it to publicly critique military operations and interventions such as the Vietnam War.

Curiously, there is also a hermaphrodite quality to war art since it can, in certain circumstances, be both justificatory and oppositional. This quality is particularly apparent in war memorials. Some of the great monuments to the First World War that have been created by celebrated artists to honour the dead are also memorials to national hubris. Many who visit any of the vast, grave marker-laden cemeteries of the western front enter feeling a deep sense of respect for the millions of dead and leave with a profound sense of the terrible waste and folly of war. The paintings, sculptures, photographs, and drawings that are a part of war art also provide a place where visitors can remember and honour. Like cemeteries, exhibitions of war art and war memorials are sites of memory for many people. Whether what is viewed can be regarded as entirely truthful has been a subject of debate in this book.

More prosaically, war art also marks the twists and turns of art history. The extent to which war has influenced art is difficult to judge. In most cases the approaches to art making used by artists in wartime were well established in times of peace. War has, however, made crooked any modernist trajectory, any Whiggish art historical path and, instead, often persuaded artists that there are lessons to be learned in the past. In the First World War, for example, many of the more modern approaches to composition were jettisoned by their practitioners in favour of a return to more traditional forms. And there are countless examples of artists revisiting earlier examples of war art, the compositions of Goya and Picasso being perhaps the most prominent. Dada, the anarchic art form that emerged in Europe at the beginning of the Great War and held sway intermittently for a short period afterwards, rejected it all and, in so doing, perhaps can lay claim to being the only art movement born of conflict.

In 2004, the world's military spending totalled $1,035 trillion in US dollars, and over twenty wars were taking place all over the globe. Given such statistics, it seems highly likely that war art will continue to be part of global culture – as record, memorial, protest, and celebration – just as it has been for the 10,000 years that this book has surveyed.

Notes

Introduction

1. Storr, 'The Weapon and the Wounded', in Spero, *The War Series*. The exhibition was shown in New York at Galerie Lelong, October–November 2003, and in Paris, Galerie Lelong, May–June 2004.
2. Storr, 'The Weapon and the Wounded', 9.
3. Wyndham Lewis, *A Canadian Gun Pit*, 1918, oil on canvas, 304.8 x 363.2 cm, National Gallery of Canada, Ottawa (transfer from the Canadian War Memorials).
4. Wyndham Lewis, *A Battery Shelled*, 1918–1919, oil on canvas, 183 x 317.5 cm, Imperial War Museum, London.

Chapter 1. Ten Thousand Years of War Art to 1600

1. Anonymous, *Venus of Willendorf*, c.25,000–20,000 BC, stone, 11.1 cm (ht), Naturhistorisches Museum, Vienna, Austria.
2. Anonymous, *Royal Standard of Ur*, c.2700 BC, panel inlaid with shell, lapis lazuli, and red limestone, c.21.59 x 49.53 cm, British Museum, London.
3. Anonymous, *Victory Stele of Naram-Sin*, c.2300–2200 BC, pink sandstone, c.2 m (ht), Musée du Louvre, Paris.
4. Anonymous, *Ashurnasirpal II at War*, c.875 BC, limestone relief sculpture, c.1 m (ht), British Museum, London.
5. Anonymous, *Ishtar Gate*, c.575 BC, glazed brick, 14.33 m (ht), Pergamon Museum, Berlin.
6. Anonymous, *Palette of Narmer*, c.3000 BC, slate, 63.5 cm (ht), Egyptian Museum, Cairo.

7. Anonymous, *Painted Chest, Tomb of Tutankhamen, Thebes*, c.1350 BC, c.5 m (wi), Egyptian Museum, Cairo.

8. Anonymous, *The Warrior Vase*, c.1200 BC, c.35.56 cm (ht), National Museum, Athens.

9. The remains of the marble pedimental sculptures, which are slightly over life size, are in the museum at Olympia, Greece.

10. Anonymous, *Altar of Zeus and Athena, Pergamon*, c.175 BC, Antikensammlung, Staatliche Museen zu Berlin.

11. Anonymous, *The Battle of Issus*, c.80 BC, House of the Faun, Pompeii, mosaic, 3.13 x 5.82 m, Museo Nationale, Naples.

12. Napoleon's version stands in the Place Vendôme in Paris.

13. Anonymous, *St Michael the Archangel*, early sixth century, leaf from an ivory diptych c.43.8 x 13.97 cm, British Museum, London.

14. Anonymous, *Bayeux Tapestry*, 1070–1080, embroidered wool on linen, 50.8 cm x 70.4 m, Musée de Peinture, Bayeux.

15. Andrea del Castagno, *Pippo Spano*, c.1448, fresco, 250 x 154 cm, Galleria degli Uffizi, Florence.

16. Simone Martini, *Guidoriccio da Fogliano*, 1328, fresco, 340 x 968 cm, Palazzo Pubblico, Siena.

17. Ambrogio Lorenzetti, *Good Government*, 1339, fresco, 2.96 x 7.70 x 14.40 m (room size), Palazzo Pubblico, Siena.

18. Paolo Uccello, *The Battle of San Romano*, c.1455, tempera on wood, 182.88 x 317.6 cm, National Gallery, London.

19. Donatello, *Erasmo da Narni (Gattamelata)*, c.1445–1450, bronze, c.340 cm high, Plaza del Santo, Padua.

20. Andrea del Verrocchio, *Bartolommeo Colleoni*, c.1483–1488, bronze, c.4 m (ht), Campo dei Santi Giovanni e Paolo, Venice.

21. Antonio Pollaiuolo, *Battle of the Ten Nudes*, c.1465, engraving, c.38.1 x 58.42 cm, Metropolitan Museum of Art, New York (bequest of Joseph Pulitzer, 1917).

22. Luca Signorelli, *The Damned Cast into Hell*, 1499–1504, fresco, 7 m (wi), San Brizio Chapel, Orvieto Cathedral.

23. Michelangelo, *The Last Judgement*, 1534–1541, fresco, 13.7 x 12.2 m, Sistine Chapel, the Vatican, Rome.

24. Leonardo da Vinci, as quoted in Susan Sontag, 'Looking at War', *New Yorker* (9 December 2002), 93.

25. Albrecht Altdorfer, *The Battle of Alexander at Issus*, 1529, oil on wood, 160.02 x 116.84 cm, Alte Pinakothek, Munich.

26. Albrecht Dürer, *The Four Horsemen of the Apocalypse*, c.1498, woodcut, c.38.1 x 27.9 cm, Metropolitan Museum of Art, New York (gift of Junius S. Morgan).

Chapter 2. War Art, 1600-1900

1. Diego Velázquez, *The Surrender of Breda*, 1634, oil on canvas, 307 x 367 cm, Prado, Madrid.

2. Jacques Callot, *The Miseries and Misfortunes of War*, etching series, 1633, each c.7.5 x 18.5 cm, British Museum, London.

3. Peter Paul Rubens, *The Massacre of the Innocents*, 1611–1612, oil on panel, 142 x 182 cm, National Gallery, London (on loan from a private collection).

4. Peter Paul Rubens, *Minerva Protects Pax from Mars*, 1629–1630, oil on canvas, 203.5 x 298 cm, National Gallery, London.

5. Peter Paul Rubens, *The Horrors of War*, 1637–1638, oil on canvas, 206 x 342 cm, Palazzo Pitti, Florence.

6. Nicolas Poussin, *The Rape of the Sabine Women*, 1633–1634, oil on canvas, 154.6 x 209.9 cm. Metropolitan Museum of Art, New York.

7. Jacques-Louis David, *The Intervention of the Sabine Women*, 1799, oil on canvas, 385 x 522 cm, Musée du Louvre, Paris.

8. Francis Hayman, *The Charity of General Amherst*, 1761, oil on canvas, 71 x 91.5 cm, Beaverbrook Collection of War Art, Canadian War Museum, Ottawa.

9. Quoted in C. P. Stacey, 'Jeffery Amherst', *Dictionary of Canadian Biography*, 23.

10. From the description of 1762, as quoted in Solkin, *Painting for Money*, 195.

11. Only one of these – the oldest known Wilton sculpture – survives, in the collection of the National Portrait Gallery in England. However, three copies exist of the other two plasters. The National Gallery of Canada holds one – a marble carving, based probably on one of the missing secondary versions. The other two are almost identical casts of the third secondary sculpture. One, the finest in surviving detail, is in the Canadian War Museum's collection in Ottawa. The other was originally in the possession of John Graves Simcoe, first Lieutenant-Governor of Upper Canada (Ontario). His family retained it after his death, but it later went missing and has now been identified in a private collection in London, England.

12. Benjamin West, *The Death of General Wolfe*, 1770, oil on canvas, 151.1 x 213.4 cm, National Gallery of Canada, Ottawa (transfer from the Canadian War Memorials, gift of the Duke of Westminster, 1918).

13. Jacques- Louis David, *The Oath of the Horatii*, 1784, oil on canvas, c.4.27 x 3.35 m, Musée du Louvre, Paris.

14. John Singleton Copley, *The Death of Major Peirson, 6 January 1781*, 1783, oil on canvas, 2.52 x 3.66m, Tate Gallery, London.

15. Francisco de Goya, 'And There's Nothing One Can Do About It', plate 15, *The Disasters of War*, c.1808–1813, 1863 edition, etching, drypoint, burin and burnisher, 14.2 x 16.8 cm, National Gallery of Canada, Ottawa.

16. Francisco de Goya, *The Third of May, 1808*, 1814, oil on canvas, 2.6 x 3.45 m, Museo del Prado, Madrid.

17. Carle Vernet, *Morning of Austerlitz*, 1804, oil on canvas, 380 x 644 cm; *Battle of Marengo*, 1804, oil on canvas, dimensions unknown; both Musée national du Chateau de Versailles et des Trianons, Versailles.

18. Horace Vernet, *The Gate at Clichy*, 1820, oil on canvas, 98 x 131 cm, Musée du Louvre, Paris.

19. Antoine-Jean Gros, *Napoleon at the Battle of Eylau*, 1808, oil on canvas, 521 x 784 cm, Musée du Louvre, Paris.

20. Théodore Géricault, *The Charging Chasseur*, 1812, oil on canvas, 349 x 266 cm, Musée du Louvre, Paris.

21. Jacques-Louis David, *Napoleon at the Great St Bernard Pass*, 1800, oil on canvas, 260 x 221 cm, Musée national de Malmaison, Rueil-Malmaison.

22. Théodore Géricault, *Wounded Cuirassier*, 1814, oil on canvas, 358 x 294 cm, Musée du Louvre, Paris.

23. Eugène Delacroix, *Liberty Leading the People*, 1830, oil on canvas, 260 x 325 cm, Musée du Louvre, Paris.

24. Jean-Auguste-Dominique Ingres, *Joan of Arc at the Coronation of Charles VII in the Cathedral of Reims*, 1854, oil on canvas, 240 x 178 cm, Musée du Louvre, Paris.

25. Édouard Manet, *The Execution of the Emperor Maximilian*, 1867, oil on canvas, 252 x 305 cm, Kunsthalle, Mannheim, Germany. Three other versions exist.

26. Lady Elizabeth Butler, *Missing*, 1873. The location of this painting is unknown and it exists only in photographs. See Usherwood and Spencer-Smith, *Lady Butler*, 26.

27. Lady Elizabeth Butler, *Calling the Roll after an Engagement, Crimea* (or *The Roll Call*), 1874, oil on canvas, 91 x 182.9 cm, HM the Queen, London.

28. Hunt, *Pre-Raphaelitism and the Pre-Raphaelite Brotherhood*, II, 305.

29. Harrington, 'Illustrating the Last Victorian War', 29.

30. Henri Rousseau, *War* or *Discord on Horseback*, 1894, oil on canvas, 114 x 195 cm, Musée d'Orsay, Paris.

Chapter 3. British Art and the First World War

1. Walter Sickert, *The Soldiers of King Albert the Ready*, 1914, oil on canvas, 196.2 x 152.4 cm, Graves Art Gallery, Sheffield.

2. Christopher Nevinson, *Returning to the Trenches*, 1914, oil on canvas, 51.2 x 76.8 cm, National Gallery of Canada, Ottawa (transfer from the Canadian War Memorials); Umberto Boccioni, *Charge of the Lancers*, 1915, tempera and collage on paste-board, 32 x 50 cm, collection Ricardo and Magda Jucker, Milan; Marcel Duchamp, *Nude Descending a Staircase, No 2*, 1912, oil on canvas, 147 x 89 cm, Philadelphia Museum of Art (Louise and Walter Arensberg Collection).

3. Christopher Nevinson, *Paths of Glory*, 1917, oil on canvas, 45.7 x 61 cm, Imperial War Museum, London.

4. William Orpen, *Changing Billets, Picardy*, 1918, oil on canvas, 91.5 x 71 cm, Pyms

Gallery, London.

5. William Orpen, *To the Unknown British Soldier in France*, 1921–1928, oil on canvas, 154.2 x 129.2 cm, Imperial War Museum, London (presented by the artist in memory of Earl Haig, 1928).

6. Eric Kennington, *The Kensingtons at Laventie*, 1915, oil on glass, 137.2 x 160 cm, Imperial War Museum, London.

7. Quoted in Paul Nash, *Outline: An Autobiography and Other Writings*, London: Faber and Faber, 1949, 210–11.

8. Paul Nash, *We Are Making a New World*, 1918, oil on canvas, 71.2 x 91.4 cm, Imperial War Museum, London.

9. Paul Nash, *The Menin Road*, 1919, oil on canvas, 182.9 x 317 cm, Imperial War Museum, London.

10. Stanley Spencer, *Travoys arriving with Wounded at a Dressing-Station at Smol, Macedonia*, 1919, oil on canvas, 183 x 218.5 cm, Imperial War Museum, London.

11. As cited in Mount, *John Singer Sargent*, 297.

12. John Singer Sargent, *Gassed*, 1918–1919, oil on canvas, 231 x 611 cm, Imperial War Museum, London.

13. William Nicholson, *The Canadian Headquarters Staff*, 1918, oil on canvas, 243.1 x 289.2 cm, Beaverbrook Collection of War Art, Canadian War Museum, Ottawa (transfer from the National Gallery of Canada, Canadian War Memorials). This painting was the highlight of the exhibition *William Nicholson (1872–1949): British Painter and Printmaker*, Royal Academy, London, England, 30 October 2004–23 January 2005.

14. Albrecht Dürer, *The Knight, Death, and the Devil*, 1513, copperplate engraving, 24.5 x 18.9 cm, Fitzwilliam Museum, Cambridge.

15. William Roberts, *The First German Gas Attack at Ypres*, 1918, oil on canvas, 304.8 x 365.8 cm, National Gallery of Canada, Ottawa (transfer from the Canadian War Memorials).

16. David Bomberg, *Sappers at Work: A Canadian Tunnelling Company* (Second Version), 1919, oil on canvas, 305 x 244 cm, National Gallery of Canada, Ottawa (transfer from the Canadian War Memorials).

17. Cork, *A Bitter Truth*, 229. El Greco, *Christ Driving the Traders from the Temple*, c.1600, oil on canvas, 106.3 x 129.7 cm, National Gallery, London.

18. Charles Sims, *Sacrifice*, c.1918, oil on canvas, 415.2 x 409 cm, Beaverbrook Collection of War Art, Canadian War Museum, Ottawa (transfer from the National Gallery of Canada, Canadian War Memorials). The study for this is in the collection of the Imperial War Museum.

19. John Byam Shaw, *The Flag*, 1918, oil on canvas, 198 x 365.5 cm, Beaverbrook Collection of War Art, Canadian War Museum, Ottawa (transfer from the National Gallery of Canada, Canadian War Memorials).

20. Canadian War Museum War Artist File, John Byam Shaw.

21. Tippett, *Art at the Service of War*, 81–7.

22. Derwent Wood, *Canada's Golgotha*, 1918, bronze, 83 x 63.5 cm, Beaverbrook Collection of War Art, Canadian War Museum, Ottawa (transfer from the National Gallery of Canada, Canadian War Memorials).

23. *Peace is the Dream* was on view at the Canadian War Museum from 30 March 1992 to 8 October 1992.

Chapter 4. Other Nations in the Great War and Later

1. I am indebted to Jacqueline Strecker's essay 'Australian Artists Paint the War' for the material in this section, which is used with permission.

2. George Bellows, *Edith Cavell*, 1918, oil on canvas, 114.3 x 160 cm, Museum of Fine Arts, Springfield, Massachusetts (James Philip Gray Collection).

3. George Bellows, *The Barricade*, 1919, oil on canvas, 126 x 212.7 cm, Birmingham Museum of Art, Birmingham, Alabama.

4. Childe Hassam, *Red Cross Drive, May 1918*, 1918, oil on canvas, 90 x 59.7 cm, May Family Collection, USA.

5. Thomas Hart Benton, *Impressions, Camouflage: WWI*, 1918, watercolour on paper, 60 x 71 cm, private collection, USA.

6. Marsden Hartley, *Portrait of a German Officer*, 1914, oil on canvas, 173 x 105 cm, Metropolitan Museum of Art, New York (Alfred Stieglitz Collection).

7. Natalia Goncharova, *Mystical Images of War*, 1914, 14 lithographs on paper, each 33 x 25 cm, the British Library, London.

8. Kazimir Malevich, *Private of the First Division*, 1914, oil and collage on canvas, 53.7 x 44.8 cm, Museum of Modern Art, New York.

9. Gino Severini, *Armoured Train in Action*, 1915, oil on canvas, 115.8 x 88.5 cm, Museum of Modern Art, New York (gift of Richard S. Zeisler).

10. Fernand Léger, *The Card Game*, 1917, oil on canvas, 129 x 193 cm, Kröller-Müller Museum, Otterlo.

11. Félix Vallotton, *Verdun, an Interpreted Picture of War*, 1917, oil on canvas, 114 x 146 cm, Musée de l'Armée, Paris.

12. Georges Rouault, *'Obedient unto Death, even the Death of the Cross'*, 1926, etching, aquatint, and heliogravure, 58 x 42 cm, City Art Gallery, Birmingham.

13. Oskar Kokoschka, *Knight Errant*, 1915, oil on canvas, 89.5 x 180 cm, Solomon R. Guggenheim Museum, New York.

14. Albin Egger-Lienz, *The Nameless Ones, 1914*, 1916, oil on canvas, 243 x 475 cm, Heeresgeschichtliches Museum, Vienna.

15. Otto Dix, 'Wounded Soldier (Autumn 1916, Bapaume)', 1924, Plate 6, *War*, 1924, etching and aquatint, 19.7 x 29 cm, National Gallery of Canada, Ottawa.

16. Otto Dix, *Flanders*, 1934–1936, oil and tempera on canvas, 200 x 250 cm, Staatliche

Museen zu Berlin – Preussischer Kulturbesitz, Nationalgalerie.

17. Max Beckmann, *Resurrection*, 1918, oil on canvas, 345 x 497 cm, Staatsgalerie, Stuttgart.

18. Max Ernst, *Celebes*, 1921, oil on canvas, 125.4 x 107.9 cm, Tate Gallery, London.

19. Max Slevogt, *The Answerable (The Unknown, Masked, Wades with Innumerable Corpses on His Back through a Sea of Blood)*, 1917, stone and aluminium plate lithograph, 54 x 39 cm, Leicester Museum and Art Gallery.

20. George Grosz, *Punishment*, 1934, watercolour, 69.8 x 32.1 cm, Museum of Modern Art, New York (gift of Mr and Mrs Erich Cohn).

21. Paul Klee, *'Once Emerged from the Gray of Night'*, 1918, watercolour and ink on paper, 22.5 x 15.9 cm, Zentrum Paul Klee, Bern.

22. Pablo Picasso, *Guernica*, 1937, oil on canvas, 3.5 x 7.8 m, Museo Reina Sofia, Madrid.

Chapter 5. The Second World War

1. WAAC, 'Ministry of Information. Artists' Advisory Committee. Terms of Reference' (GP/72/A (1), 2, as cited in Foss, 'British Artists of the Second World War', fn. 20, 213.

2. Newton, *Art for Everybody*, 15. Newton was an artist and critic.

3. Paul Nash, *Battle of Britain*, 1941, oil on canvas, 121.9 x 182.8 cm, Imperial War Museum, London.

4. Paul Nash, *Totes Meer*, 1940–1941, oil on canvas, Tate Gallery, London (presented by the War Artists Advisory Committee).

5. Paul Nash to E. M. O'R. Dickey, War Artists Archive, Imperial War Museum, London.

6. Paul Nash, *Battle of Germany*, 1944, oil on canvas, 122 x 183 cm, Imperial War Museum, London.

7. These are all in the collection of the Imperial War Museum, London.

8. Henry Moore, *Pink and Green Sleepers*, 1941, wash and crayon, 36.8 x 55.5 cm, Tate Gallery, London.

9. Edward Ardizzone, *In the Shelter*, 1940, watercolour on paper, 18.6 x 24.7 cm, Imperial War Museum, London.

10. Foss, 'It's Not a Bad Life Sometimes', 17.

11. Elsie Hewland, *A Nursery-School for War Workers' Children*, 1942, oil on canvas, 55.8 x 45.7 cm, Imperial War Museum, London.

12. Ethel Gabain, *A Child Bomb-Victim Receiving Penicillin Treatment*, 1944, oil on canvas, 76.2 x 63.5 cm, Imperial War Museum, London.

13. Laura Knight, *Ruby Loftus Screwing a Breech-Ring*, 1941, oil on canvas, 86.3 x 101.9 cm, Imperial War Museum, London.

14. Mervyn Peake, *Glass-Blowers 'Gathering' from the Furnace*, 1943, watercolour on paper, 50.8 x 68.5 cm, Imperial War Museum, London.

15. Graham Sutherland, *The City: a Fallen Lift Shaft*, 1941, gouache on paper, 64.7 x 111.7 cm, Imperial War Museum, London.

16. Duncan Grant, *St Paul's*, 1941, oil on canvas, 91.4 x 60.9 cm, Imperial War Museum, London.

17. Clark to Grant, 7 July 1941, Imperial War Museum War Artists Archive ART/WA2/3/68, 25.

18. Henry Carr, *Incendiaries in a Suburb*, 1941, oil on canvas, 72.8 x 91.8 cm, Imperial War Museum, London.

19. Edward Bawden, *Refugees at Udine*, 1945, watercolour on paper, 55.2 x 76.2 cm, Imperial War Museum, London.

20. Paul Bullard, *British Prisoners of War, Italy*, 1946, oil on canvas, 51.4 x 76.4 cm, Imperial War Museum, London.

21. Leslie Cole, *British Women and Children Interned in a Japanese Prison Camp, Syme Road, Singapore*, 1945, oil on canvas, 66 x 92 cm, Imperial War Museum, London.

22. Anthony Gross, *Battle of Arakan, 1943: Men of the 7th Rajput Regiment Resting on South Hill with a Parasol Captured near the Mayu River on the Rathedaung Front*, 1943, ink wash on paper, 35.8 x 51.4 cm, Imperial War Museum, London.

23. Leonard Rosoman, *A Crater in the Naval Dockyard, Hong Kong*, 1945, oil on canvas, 54.6 x 74.9 cm, Imperial War Museum, London.

24. Eric Ravilious, *HMS* Ark Royal *in Action*, 1940, watercolour on paper, 42.5 x 57.7 cm, Imperial War Museum, London.

25. Carel Weight, *Recruit's Progress: Medical Inspection*, 1942, oil on canvas, 50.8 x 81.2 cm, Imperial War Museum, London.

26. Sidney Nolan, *Dream of the Latrine Sitter*, 1942, oil on hardboard, 45.6 x 122.2 cm, Australian War Memorial, Canberra.

27. Russell Drysdale, *Soldier*, 1942, oil on hardboard, 60.3 x 40.7 cm, Australian War Memorial, Canberra.

28. William Dobell, *The Billy* Boy, 1943, oil on cardboard on hardboard, 70.2 x 53.4 cm, Australian War Memorial, Canberra.

29. Stella Bowen, *Bomber Crew*, 1944, oil on canvas, 86.1 x 63.3 cm, Australian War Memorial, Canberra.

30. From an interview with Nora Heysen, 25 August 1994, Oral History Collection, National Library of Australia, http://www.nla.gov.au/exhibitions/noraheysen/war/war.html. Accessed 10 April 2006.

31. Vasko Taskovski, *Riders of the Apocalypse*, 1971, oil on canvas, 115 x 137 cm, People's Army Club, Belgrade.

Chapter 6. British and American War Art, 1945-1989

1. Anselm Kiefer, *Shulamite*, 1983, oil, acrylic, emulsion, shellac, straw, and fragments of wood cut on canvas, 290 cm x 370 cm, Saatchi Collection, London.

2. Anselm Kiefer, *Seraphim*, 1983-1984, oil, straw, emulsion, and shellac on canvas, 320.55 x 330.71 cm, Solomon R. Guggenheim Museum, New York (purchased with

funds contributed by Mr and Mrs Andrew M. Saul).

3. Anselm Kiefer, *Poppy and Memory: The Angel of History*, 1989, lead, glass, and poppy, 250 x 630 x 650 cm, collection Erich Marx, Berlin.

4. Philip Guston, *Bombardment* (1937–1938), oil on wood, 116.8 cm (diam.), private collection, New York.

5. These works were last exhibited together at the Jewish Museum, New York, 19 January–13 April 1997.

6. Morris Louis, *Untitled (Jewish Star)*, 1951, magna on canvas, 86.36 x 72.39 cm, Jewish Museum, New York.

7. Jasper Johns, *Star*, 1954, oil, beeswax, and housepaint on newspaper, canvas, and wood with tinted glass, nails, and fabric tape, 57.15 x 49.53 cm, Menil Collection, Houston, Texas.

8. The Salmagundi Club, originally the Salmagundi Sketch Club, was founded in 1871 and is one of the oldest art organizations in America.

9. Spero, *The War Series*, unpaginated frontispiece quote.

10. Storr, in Spero, *The War Series*, 10.

11. Storr, in Spero, *The War Series*, 13.

12. Bird et al., *Nancy Spero*, 55.

13. Nancy Spero, *The Male Bomb*, 1966, gouache and ink on paper, 61 x 91.4 cm, collection unknown (illustrated in Spero, *The War Series*, 2003, 30).

14. Nancy Spero, *Gunship*, 1966, gouache on paper, 61 x 91.4 cm, collection John Sacchi.

15. Nancy Spero, *Victims, Holocaust*, 1968, gouache and ink on paper, 63.5 x 100.3 cm, collection unknown (illustrated in Spero, *The War Series*, 2003, 49).

16. Nancy Spero, *Crematorium Chimney*, 1967, gouache and ink on paper, 80.7 x 58.7 cm, collection unknown (illustrated in Spero, *The War Series*, 2003, 40).

17. Bird et al., *Nancy Spero*, 13.

18. Nancy Spero, *Male Bomb/Swastika*, 1968, gouache and ink on paper, 91.2 x 60.7 cm, collection unknown (illustrated in Spero, *The War Series*, 2003, 41).

19. Nancy Spero, *Christ and the Bomb*, 1967, gouache and ink on paper, 68.6 x 86.4 cm, Hiroshima City Museum of Contemporary Art.

20. Nancy Spero, *The Bug, Helicopter, Victim*, 1966, gouache and ink on paper, 48.3 x 59.1 cm, collection unknown (illustrated in Spero, *The War Series*, 2003, 17).

21. Spero quoted in 'A Conversation with Leon Golub and Nancy Spero', in Golub and Spero, *War and Memory*, 45.

22. Nancy Spero, *Peace*, 1968, gouache and ink on paper, 48.3 x 60.3 cm, collection unknown.

23. See for example, Nancy Spero, *El Salvador*, 1986, handprinting and printed collage on paper, 95.6 x 63.7 cm, collection unknown, and *Nicaragua*, 1986, handprinting and printed collage on paper, 60 x 97.5 cm, collection unknown (illustrated in Golub and Spero, *War and Memory*, 82).

24. See, for example, Nancy Spero, *The Ballad of Marie Sanders: The Jew's Whore*, 1994, dimensions variable, collection unknown (illustrated in Golub and Spero, *War and Memory*, 90).

25. Golub, *Mercenaries*, 6.

26. Golub, *Mercenaries*, 7.

27. Leon Golub, *Mercenaries IV*, 1980, acrylic on linen, 304.8 x 584.2 cm, Saatchi Collection, London.

28. Leon Golub, *Interrogation III*, 1981, acrylic on linen, 300 x 415 cm, Eli Broad Family Foundation, Santa Monica.

29. Golub and Spero, *War and Memory*, 29.

30. Golub and Spero, *War and Memory*, 36.

31. Leon Golub, *Gigantomachy II*, 1966, acrylic on linen, 289.56 x 731.72 cm, collection unknown (illustrated in Golub, *Gigantomachy*, 8–9).

32. Leon Golub, *Napalm III*, 1969, acrylic on linen, 277.5 x 390 cm, collection unknown (illustrated in Golub and Spero, *War and Memory*, 63).

33. Leon Golub, *Vietnam III*, 1973, acrylic on linen, 300 x 840 cm, collection unknown (illustrated in Golub and Spero, *War and Memory*, 68–69).

34. Golub and Spero, *War and Memory*, 36–7.

35. Golub, *Mercenaries*, 6.

36. Golub and Spero, *War and Memory*, 42.

37. Golub and Spero, *War and Memory*, 42.

38. John Heartfield, *The Meaning of the Hitler Salute: Little Man Asks for Big Gifts. Motto: Millions Stand Behind* Me, 1932, photograph, 38 x 27 cm, Metropolitan Museum of Art, New York.

39. Barbara Kruger, *We Don't Need Another Hero*, 1987, photographic silkscreen on vinyl, 276.9 x 533.4 cm, collection Emily Fisher Landau, New York.

40. Pablo Picasso, *War*, 1952, oil on hardboard, 470 x 1020 cm, Musée national, Vallauris.

41. Pablo Picasso, *Massacre in Korea*, 1951, oil on canvas, 109.5 x 209.5 cm, Musée Picasso, Paris.

42. Roy Lichtenstein, *Whaam!*, 1963, acrylic on canvas, 172.7 x 421.6 cm, Tate Gallery, London.

43. Robert Arneson, *General Nuke*, 1984, glazed ceramic and bronze on a granite base, 197.5 x 76.2 x 93.3 cm, Hirshhorn Museum and Sculpture Garden, Washington, DC (gift of Robert Arneson and Sandra Shannonhouse, 1990).

44. Colin Self, *Nuclear Bomber 1*, 2001, intaglio print from wood and metal objects on paper, 74.7 x 106.2 cm; *Stealth Bomber 1*, 2001, intaglio print from wood and metal objects on paper, 74.7 x 106.2 cm, both Imperial War Museum, London.

45. Colin Self, *Guard Dog on Missile Site*, 1966, graphite, collage, and pencil on paper, 54.6 x 75 cm, Imperial War Museum, London.

46. Colin Self, *Beach Girl: Nuclear Victim*, 1966, fibreglass, hair, cinders, polyurethane paint on plaster and hessian, rubber, nylon, c.150 cm (wi), Imperial War Museum, London.

47. Amanda Hopkinson, 'Introduction,' 11.

48. Kennard, *Dispatches*, 20, 83, 85. This poster could still be purchased at www.britart. co.uk in 2006.

49. Kennard, *Dispatches*, 28. One of the multiples – published by Leeds postcards – is in the collection of the Imperial War Museum. Peter Kennard, *A Postcard Home* (c.1983), photomontage on paper, 60.5 x 42.8 cm, Imperial War Museum, London.

50. In *Peter Kennard: Images for the End of the Century*, Gimpel Fils, London, months unknown, 1990.

51. Kennard, *Dispatches*, 46.

52. Kennard, *Dispatches*, 36.

53. Gilbert and George, *Victory March*, 1980, postcards on board, 66 x 127 cm, Imperial War Museum, London; *Battle*, 1980, postcards on board, 66 x 127 cm, Imperial War Museum, London.

54. Susan Hiller, *Happy Days*, 1985, collage, paint, and wallpaper on wallpaper, 290 x 305 cm, Imperial War Museum, London.

55. Helen Littman, *Women's Peace Movement Scarf*, 1986, wool challis, 1069 x 110 cm, Imperial War Museum, London (gift of English Eccentrics, 1986).

56. Wilcox, 'We are all Falklanders Now', 63.

57. Jock McFadyen, *With Singing Hearts and Throaty Roarings...*, 1983, oil paint and collage on card, 178 x 118 cm, Imperial War Museum, London.

58. Jock McFadyen, *Kurfürstendamm*, 1991, oil on canvas, 91.5 x 203.5 cm, Imperial War Museum, London.

59. Ian Hamilton Finlay and John Andrew, *A Wartime Garden*, 1989, limestone and painted fibreboard, 162 x 884 x 886 cm, Tate Gallery, London (purchased with assistance from the Patrons of New Art through the Tate Gallery Foundation, 1992).

60. John Kindness, *Sectarian Armour*, 1994, etched and gilded steel and brass, 60 x 40 x 30 cm , Imperial War Museum, London.

61. Willie Doherty, *Unapproved Road 2*, 1995, cibachrome print on aluminium, 122 x 183 cm, Imperial War Museum, London.

62. Kitson, *The Falklands War*.

Chapter 7. War Art Internationally, 1990-2005

1. http://www.iw.net/~jpollock/polqa/qa015Panel.html. Accessed 4 September 2005.

2. Golub and Spero, *War and Memory*, 42.

3. John Keane, *Mickey Mouse at the Front*, 1991, oil on canvas, 1730 x 1985 mm, Imperial War Museum, London.

4. Angela Weight, *Gulf*, 24.

5. John Keane, *We Are Making a New World Order*, 1991, oil and mixed media on canvas, 170.5 x 233 cm, Angela Flowers Gallery, London.

6. Mary Kelly, *Gloria Patri*, 1992, 31 units, screenprint and etching on polished aluminium, various sizes, collection unknown.

7. Mary Kelly interviewed by Josefina Ayerza. http://www.jca-online.com/kelly.html. Accessed 26 August 2005.

8. Mary Kelly, *Mea Culpa*, 1999, compressed lint, four 43.2 x 596.9 x 5.1 m panels, collection unknown.

9. Carson, 'Mea Culpa', 74–80.

10. Rozanne Hawksley, *Pale Armistice*, 1991, silk, linen gloves, leather gloves, nylon gloves, plastic funeral flowers, bone on silk padding over a metal frame, Imperial War Museum, London.

11. Notes attached to a letter from Rozanne Hawksley to Angela Weight, Keeper of Art, IWM, 20 April 1993.

12. Nicola Lane, *The Three Graces*, 1991, watercolour and gouache on paper, 18.8 x 27.9 cm; *Sunbathing Sergeants*, 1991, watercolour on paper, 69.5 x 99.6 cm, both Imperial War Museum, London.

13. Rasheed Araeen, *White Stallion*, 1991, photograph, collage, and wood on paper and wood, 54.1 x 66 cm (approximately nine parts), Imperial War Museum, London.

14. Paul Overy, 'The New Works of Rasheed Araeen', 13, 15.

15. Overy, 'The New Works of Rasheed Araeen' 15.

16. Graham Fagen, *Theatre*, 2000, multi-component installation (DVD, army benches, flooring), Imperial War Museum, London.

17. McClone, 'The Art of War', 14.

18. Crampton, 'Facing Fear: Peter Howson in Bosnia', 10.

19. Crampton, 'Facing Fear: Peter Howson in Bosnia', 11.

20. Jackson, *A Different Man*, 73.

21. Peter Howson, *Croatian and Muslim*, 1994, oil on canvas, 213 x 152.5 cm, collection David Bowie, New York.

22. Richard Cork, 'Suffering into Art: Howson and Bosnia', 40.

23. Peter Howson, *Plum Grove*, 1994, oil on canvas, 213 x 152.5 cm, Tate Gallery, London.

24. Jenny Holzer, *Abuse of Power Comes as No Surprise*, c.1984, T-shirt with screenprinting, Spencer Museum of Art, University of Kansas (gift of Alfred Willis).

25. *Jenny Holzer: Lustmord*, Barbara Gladstone Gallery, New York, 5 May–30 June 1994.

26. Jake and Dinos Chapman, *Hell*, 1998–2000, fibreglass, plastic and mixed media (9 parts), 8 parts 243.8 x 121.9 x 121.9 cm; 1 part 121.9 x 121.9 x 121.9 cm, formerly Saatchi Collection, London (destroyed).

27. Jake and Dinos Chapman, *Disasters of War*, 2000, 83 hand-coloured etchings, 24.5 x

34.5 cm, Saatchi Collection, London.

28. Jake and Dinos Chapman, *Disasters of War*, 1993, mixed media sculpture, displayed: 130 x 200 x 200 cm, Tate Gallery, London.

29. Jake and Dinos Chapman, *Great Deeds against the Dead*, 1994, mixed media with plinth, overall 277 x 244 x 152 cm, Saatchi Collection, London.

30. Jake and Dinos Chapman, *Insult to Injury*, 2003, reworked portfolio of 80 etchings (Francisco de Goya, *The Disasters of War*), 37 x 47 cm, private collection.

31. http://www.theatlasgroup.org. Accessed 14 October 2005.

32. Mona Hatoum, *The Light at the End*, 1989, angle iron, five electric heating elements, 8.7 x 3 m, UK Arts Council Collection.

33. http://www.artnet.com/magazine_pre2000/reviews/moore/moore5-21-98.asp. Accessed 14 October 2005.

34. Clifton Pugh, The *Vietnam Body Count*, 1966, oil and enamel on hardboard, 122 x 182.7 cm, Australian War Memorial, Canberra.

35. Trevor Lyons, *Journeys in My Head*, 1987, etching and aquatint on paper, images all c.35 x 30.2 cm, Australian War Memorial, Canberra.

36. Jan Senbergs, *News 1991*, 1991, acrylic on canvas, 213 x 290 cm, Australian War Memorial, Canberra.

37. Gordon Bennett, *Notes to Basquiat (Pink)*, 2002, acrylic on linen, 152 x 182.3 cm, Australian War Memorial, Canberra.

38. Arthur Boyd, *Nebuchadnezzar on Fire Falling over a Waterfall*, 1966–1968, oil on canvas, 183.5 x 175.9 cm, Art Gallery of New South Wales, Sydney.

39. Gertrude Kearns, *Somalia I: With Conscience*; *Somalia II: With Conscience* (both 1996), both acrylic on canvas, 287 x 114.3 cm, Beaverbrook Collection of War Art, Canadian War Museum.

40. All these works are in the collection of the Canadian War Museum.

Chapter 8. Other Types of War Art

1. Marc Chaimowicz, *Q. And babies? A. And babies*, 1969–1970, 63.82 x 96.84 cm, Political Art Documentation/Distribution, Museum of Modern Art, New York.

2. William Nicholson, *The Canadian Headquarters Staff*, 1918, oil on canvas, 243.1 x 289.2 cm, Beaverbrook Collection of War Art, Canadian War Museum, Ottawa (transfer from the National Gallery of Canada, Canadian War Memorials).

3. Roger Fenton, *The Valley of the Shadow of Death*, 1855, photographic print on salted paper, 28 x 36 cm, Library of Congress, Washington, DC.

4. Felice Beato, *Secundrabagh Palace*, 1857, albumen print, 24.13 x 29.21 cm, J. Paul Getty Museum, California.

5. Robert Capa, *Loyalist Militiaman at the Moment of Death, Cerro Muriano*, 5 September 1936, also known as *The Falling Soldier*, silverprint, 20.4 x 25.3 cm, Musée d'art contemporain, Montreal.

6. http://www.tvcameramen.com/lounge/Don_McCullin.htm. Accessed 19 August 2005.

7. Brutvan, *Sophie Ristelhueber*, 129.

8. Quoted in Brutvan, *Sophie Ristelhueber*, 180.

9. Ristelhueber, *West Bank*.

10. Jeff Wall, *Dead Troops Talk (A Vision after an Ambush of a Red Army Patrol, near Moqor, Afghanistan, Winter 1986)*, 1992, cibachrome mounted on a light box, 228.6 x 396.2 cm, private collection.

11. *SSSI Greenham Common*.

12. Paul Seawright, *Valley*, 2002, C-Type Fuji Crystal Archive print on aluminium, 101 x 126.5 cm, Portland Art Museum, Oregon.

13. Edward Hopper, *Smash the Hun*, 1918, gouache on illustration board, 24.1 x 15.5 cm, Charles Rand Penny Collection. Buffalo State College, New York.

14. I am indebted to the Imperial War Museum's records of the exhibition *Not Doodling but Drawing: Cartoons of the Falklands War 5 November 1982–10 January 1983* for much of the material included in this section.

15. Ralph Steadman, 'Flies on Meat', *New Statesman*, 14 May 1982, ink and watercolour on paper, collection the artist.

16. Michael Heath, 'Well I really enjoyed that war, it was better than the one last week', *The Spectator*, 26 June 1982, pen, ink, watercolour, and applied dot tone, collection the artist.

17. Ken Mahood, 'A Bigger Splash Somewhat Outside the Total Exclusion Zone', gouache, magic marker, and pencil, *Punch*, 2 March 1983, collection the artist.

18. The art department of the Imperial War Museum made a collection of images from various sites in the aftermath of the bombing of the World Trade Center on 11 September 2001. The author is indebted to this resource for this section.

19. www.peaceposter.org, designed by Pau Zegri, Barcelona, Spain, Imperial War Museum, London (Art Department).

20. www.mikeschuster.com/USA/UncleSam.html, Imperial War Museum, London (Art Department).

21. Imperial War Museum, London (Art Department).

22. Imperial War Museum, London (Art Department).

23. www.thebirdman.org/Index-DailyReads-FlagPoster.html, Imperial War Museum, London (Art Department).

24. Members.lycos.co.uk/freeposters/hpbimg/A4-cheap%20oil.gif, Imperial War Museum, London (Art Department).

25. Francisco de Goya, *Saturn Devouring One of His Sons*, 1821–1823, oil on canvas, 146 x 83 cm, Prado, Madrid.

26. Members.lycos.co.uk/freeposters/hpbimg/A4-cheap%20oil.gif, Imperial War Museum, London (Art Department).

27. femnitel.caltanet.it/talebani/talebani21.htm, Imperial War Museum, London (Art

Department).

28. tihlde.org/~larstr/wtc/, Imperial War Museum, London (Art Department).

Chapter 9. War Art as Memorial, War Art as Memory

1. Young, 'Memory and Counter-Memory', 61.
2. Fisher, 'A Memorial That Doesn't Measure Up'.
3. Sontag, 'Looking at War', 94.
4. Alex Colville, *Infantry, near Nijmegen, Holland*, 1946, oil on canvas, 101.6 x 121.9 cm, Beaverbrook Collection of War Art, Canadian War Museum, Ottawa (transfer from the National Gallery of Canada, Canadian War Records).
5. Young, *The Texture of Memory: Holocaust Memorials and Meaning*, 2–3.
6. Young, *The Texture of Memory*, 2–3.
7. Young, *The Texture of Memory*, 2–3.
8. Young, *The Texture of Memory*, xi.
9. Sherman, *The Construction of Memory in Interwar France*, 8.
10. Cy Twombly, *Lepanto*, 2001, acrylic, wax crayon, and graphite on canvas, 12 panels, various sizes from 210.8 x 287.7 cm to 216.5 x 340.4 cm, private collection.
11. Walker's war works were included in an exhibition and catalogue entitled *A Theater of Recollection: Paintings and Prints by John Walker*.
12. McDonald, *Raymond Arnold*, unpaginated.
13. Raymond Arnold, '*Je me rapelle*' – *le Coquelicot*, 1999, etching on paper, 59.5 x 34 cm, Imperial War Museum, London.
14. Sidney Nolan, *Gallipoli Landscape with Steep Cliffs*, 1961, wax crayon and textile dye on cardboard, 25.4 x 30.4 cm, Australian War Memorial, Canberra.
15. Hamilton, *Hughie O'Donoghue*.
16. Hamilton, *Hughie O'Donoghue*, 138.
17. Hamilton, Hughie *O'Donoghue*, 23.
18. Hughie O'Donoghue, *Painting Caserta Red*, 2003, oil on linen canvas incorporating inkjet on gampi tissue and Japanese tissue, 366 x 732 cm, private collection. This painting gave its name to the exhibition of O'Donoghue's work at the Imperial War Museum, London, in 2003.
19. Titian, *The Flaying of Marsyas*, 1575–1576, oil on canvas, 212 x 207 cm, Czech Republic State Museum, Kromeriz.
20. Hamilton, *Hughie O'Donoghue*, 19.
21. Eric Gill, *Our Lord Driving the Moneychangers out of the Temple*, 1923, Portland stone, 168 x 459 cm, University of Leeds.
22. Jacob Epstein, *Torso in Metal from the 'Rock Drill'*, 1913–16, bronze, 70.5 x 58.4 x 44.5 cm, Tate Gallery, London.
23. Jacob Epstein, *Risen Christ*, 1917–1919, bronze, 218.5 cm (ht), Scottish National Gallery of Modern Art, Edinburgh.

24. Emile Antoine Bourdelle, *France supporting the Wounded Soldier*, 1924–1928, stone, 2.4 x 1.45 m, Monceau-les-Mines.

25. Wilhelm Lehmbruck, *The Fallen Man*, 1915–1916, stone cast, 78 x 240 x 82.5 cm and *Seated Youth*, 1916, bronze, 103 x 77 x 115 cm, both Lehmbruckhaus, Duisburg.

26. Magdalena Abakanowicz, *Puellae* (Girls), 1992, bronze, various heights, National Gallery of Art, Washington, DC (gift of the Morris and Gwendolyn Cafritz Foundation).

27. Rachel Whiteread, *Untitled (Library)*, 2000, dental plaster, polystyrene, fibreboard and steel, c.286 x 535 x 244 cm., Hirshhorn Museum and Sculpture Garden, Washington, DC (Joseph H. Hirshhorn Purchase Fund, 2000).

28. Daniel Libeskind, 'Trauma', 44.

29. David Smith, *Medal For Dishonor: Death By Gas*, 1939–1940, bronze, 26.1 x 28.8 x 3.3 cm; *Medal For Dishonor: Elements Which Cause Prostitution*, 1939, bronze, 22.0 x 26.6 x 2.1 cm; *Medal For Dishonor: Propaganda For War*, 1939–40, bronze, 24.2 x 30.1 x 2.4 cm; *Medal For Dishonor: War Exempt Sons Of The Rich*, 1939–40, bronze, 26.3 x 22.7 x 2.1 cm, all Hirshhorn Museum and Sculpture Garden, Washington, DC (gift of Joseph H. Hirshhorn, 1966).

30. Renato Niemis, *Counting the Cost*, 1997, glass and steel, each panel 2 x 1 m, Imperial War Museum, Duxford.

31. Robert Morris, *Infantry Archive – to Be Walked on Barefoot*, 1970, ink and watercolour on paper, 67.3 x 101.6 cm, Whitney Museum of American Art, New York.

32. Claes Oldenburg, *Lipstick (Ascending) on Caterpillar Tracks*, 1969–1974, Cor-Ten steel, steel, aluminium, cast resin; painted with polyurethane enamel, 7.2 x 7.6 x 3.3 m, Samuel F. B. Morse College, Yale University, New Haven, Connecticut.

33. Haskell, *Claes Oldenburg*, 17.

34. Edward Kienholz, *The Non-War Memorial*, 1970, sand-filled, Vietnam-era American military uniforms, brass and wood plaque, framed typed text, and podium with offset-printed book, no fixed dimensions, Whitney Museum of American Art, New York (gift of Nancy Reddin Kienholz).

35. Bill Woodrow, *Refugee*, 1989, bronze with colour, 140 x 210 x 161 cm, Imperial War Museum, London (purchased with the assistance of the Henry Moore Foundation and the National Art Collections Fund).

36. Eric Fischl, *Tumbling Woman*, 2001, bronze, 94 x 188 x 127 cm, Fondazione Cassa di Risparmio, Bologna.

Epilogue: The Beat Goes on

1. Ruskin, *St Mark's Rest*, 1.

Select
Bibliography

Primary Sources
Internet

The Sixties Project Presents: Decade of Protest, Political Posters from the United States, Cuba and Viet Nam, 1965–1975. http://lists.village.virginia.edu/sixties/HTML_docs/Exhibits/Track16.html. Accessed 13 September 2005.

Kudlick, Walter. 'U.S. Army Official War Artists.' Doughboy Center (2 April 1999). http://www.worldwar1.com/dbc/artists.htm. Accessed 15 October 2005.

Museums

Imperial War Museum, London, England.
 Art Department
 Images of Aftermath of September 11, 2001
 War Artists Archive
Museum of Modern Art, New York, USA.
 Library
 Franklin Furnace Archive Materials.
 Archives pamphlet file: miscellaneous uncatalogued material. War, 2000.

Printed Sources
Unattributed Sources

Anselm Kiefer: Bücher, 1969–1990. Stuttgart: Edition Cantz, 1990.
Anthony Gross RA: Battle Lines. London: Imperial War Museum, 1981.

Art Exhibition by Men of the Armed Forces, sponsored by 'Life'. [New York: Time Inc., c.1942].

Art in Action: The Making of Commemorative Art, 1918–1988. Canberra: Australian War Memorial, 1990.

The Art of Memory: Holocaust Memorials in History. New York: Jewish Museum, 1994.

Art of War: 1914–18, 1939–45: An Exhibition of Paintings and Drawings by Canadian and British Artists Produced during the Two Great Wars. London: Canadian High Commission, 1994.

As Soldiers See It/by the Fort Custer Army Illustrators. [New York]: American Artists Group, Inc. [1943].

Barbara Kruger. Melbourne: Museum of Modern Art at Heide, c.1996.

British Surrealists at War. New York: Guillaume Gallozzi [gallery], [1988].

British War Art of the 20th Century: The Official War Artists' Record of the Two World Wars. (microfiche) London: Minidata, 1982.

British War Artists. London: The Curwen Press, [1940].

Burnt Whole: Contemporary Artists Reflect Upon the Holocaust. Washington: Washington Project for the Arts, 1994.

Canadian Battlefields Memorials Commission. Ottawa: Thomas Mulvey, 1920.

Canadian War Memorials Exhibition. London: Royal Academy, 1919.

Carel Weight. A War Retrospective. London: Imperial War Museum, 1995.

A Concise Catalogue of Paintings, Drawings and Sculpture of the First World War, 1914–1918. 2nd ed. London: Imperial War Museum, 1963.

A Concise Catalogue of Paintings, Drawings and Sculpture of the Second World War 1939–1945. London: Imperial War Museum, 1964.

C. R. W. Nevinson. The Great War and After. London: MacLean Gallery, 1980.

Decade of Protest: Political Posters from the United States, Viet Nam, Cuba, 1965–1975. Santa Monica, California: Smart Art Press, 1996.

Drawings and Paintings of the Second World War. London: Imperial College, 1980.

Edward Bawden: Travels of a War Artist 1940–1945. London: Imperial War Museum, 1983.

England in Wartime: An Exhibition of Pictures by Contemporary Painters. London: Leicester Galleries, 1940.

'Entartete' Kunst: Typescript Inventory. Reichsministerium für Volksaufklärung und Propaganda, [1942?].

Eric Kennington: War Artist. London: Imperial War Museum, 1980.

Eric Ravilious: Imagined Realities. London: Imperial War Museum and Philip Wilson Publishers, 2003.

An Exhibition of Drawings by Edward Ardizzone, Official Artist 1940–45. London: Imperial War Museum, n.d.

Exhibition of War Pictures. London: Artists' International Association, 1941.

Fighting China. New York: Museum of Modern Art, 1942.

Four War Artists. Ottawa: Canadian War Museum, National Museums of Canada, 1981.

George Bellows and the War Series of 1918. New York: Hirschl & Adler Galleries, 1983.

Graphic Work by First World War Artists. Kaltzahn Gallery Ltd., 1966.

Gulf Artists Continue Tradition. [United States: n.d.].

Henry Moore: War Drawings. London: Imperial War Museum, 1975.

The Housing of the Canadian War Memorials. London, 1919.

'Images of War: From the Exhibition Art of the Forties.' *MoMA* 6 (winter 1991): 8–9.

Images of War: War Artists, 1939–1945. Liverpool: Bluecoat Gallery, 1974.

In Search of Artists and Heroes, 1915–1990. Canberra: Australian War Memorial, 1991.

Ivor Hele: The Soldier's Artist. Canberra: Australian War Memorial, 1984.

Leonard Rosoman: A War Retrospective, 1939–45. London: Imperial War Museum, 1989.

Life's Picture History of World War II. New York: Time, 1950.

M_ARS: Kunst und Krieg: Neue Galerie Graz am Landesmuseum Joanneum. Ostfildern-Ruit: Hatje Cantz, 2003.

Mary Kelly. London: Phaidon Press, 1997.

Memorial Exhibition: The War Artists. Folkestone: New Metropole Arts Centre, 1964.

Military Munnings, 1917–1918. Ottawa: Canadian War Museum, 1993.

Most Treasured Records: Art Exhibited at the Opening of the Memorial in 1941. Canberra: Australian War Memorial, 1991.

My God! We're Losing a Great Country; Art and Society. An Exhibition for Peace, Designed by the Students of Parsons School of Design. Presented by the New School Art Center, New York, June 9–July 11, 1970. [New York: New School Art Center, 1970].

Nolan's Gallipoli: An Exhibition of Sidney Nolan's Gallipoli Series. Canberra: Australian War Memorial, 1978.

Not Doodling but Drawing: Cartoons of the Falklands War. London: Imperial War Museum, 1992.

Official War Artists Catalogue: Exhibition of Paintings, Drawings and Sculpture. Sydney: Art Gallery of New South Wales, 1944.

Paintings from the First World War: From the Canadian War Memorial Collection of the National Gallery of Canada. Ottawa: National Gallery of Canada, 1968.

Paintings of Naval Aviation. Abbott Collection, [n.d.].

Paintings of Naval Medicine. Abbott Collection, [n.d.].

Paintings of Special Subjects (alphabetically). War. Abbott Collection, [n.d.].

Paintings of United States Navy in Action. Abbott Collection, [n.d.].

Paul Nash: Aerial Creatures. London: Imperial War Museum, n.d.

Paul Nash. Through the Fire: Paintings, Drawings and Graphic Work from the First World War. London: Imperial War Museum, 1988.

Paul Seawright: Hidden. London: Imperial War Museum, 2003.

Persuasive Images: Posters of War and Revolution from the Hoover Institution Archives. Princeton, N. J.: Princeton University Press, c.1992.

Peter Howson: Bosnia. London: Imperial War Museum, 1994.

Protest and Hope: an Exhibition of Contemporary American Art. [New York: New School Art Center, 1967].

Rasheed Araeen. London: South London Gallery, 1994.

Robert Morris: Tekeningen, 1956–1983. Otterloo: Het Museum, c.1982.

Rodrigo Moynihan: Paintings and Drawings 1938-47. The End of the Picnic. London: Imperial War Museum, 1998.

Roger Fenton, Photographer of the 1850s. London: Yale University Press for the South Bank Board, 1988.

Send Me More Paint: Australian Art During the Second World War. Canberra: Australian War Memorial, 1989.

SSSI Greenham Common. New Work by John Kippin from a residency on Greenham Common 1998–2000. London: Imperial War Museum, 2001.

Stanley Spencer: Shipbuilding on the Clyde. London: Imperial War Museum, 1989.

Stella Bowen: Art, Love and War. Canberra: Australian War Memorial, 2002.

Streeton: France 1918. Canberra: Australian War Memorial, 1984.

Susan Crile: The Fires of War. Saint Louis: Saint Louis Art Museum, 1994.

Sutherland; The War Drawings. London: Imperial War Museum, 1982.

A Theater of Recollection: Paintings and Prints by John Walker. Boston: Boston University Art Gallery, 1997.

Through Women's Eyes: Australian Women Artists and War 1914–1994. Canberra: Australian War Memorial, 1994.

The Trumpet Calls: Posters from Two World Wars. Canberra: Australian War Memorial, 1982.

Velikaia Otechestvennaia voina, 1941-1945 v proizvedeniiakh sovetskikh khudozhnikov = The Great Patriotic War of 1941-45 as depicted by Soviet Artists. [Text in Russian, English, French, and German] Moskva: Novosti, 1975.

Victors & Victims: Artists' Responses to War from Antiquity through the Vietnam War Era. Chicago: Smart Museum Publications, 1985.

Victory Parade: Canadian War Artists in Holland 1944/45. Delft, Netherlands: Legermuseum, 1990.

The Vietnam Experience: Art Exhibit. Vietnam Veterans Foundation, c.1981.

War and Memory: In the Aftermath of Vietnam: September 15/December 19, 1987: A Multi-Disciplinary Program of Visual Art, Commissioned Installations, Photography, Film, Video, Literature, Theater, Music and Public Discussions ... [et al]. Washington, D.C.: Washington Project for the Arts, [1987].

War Art, a Catalogue of Paintings done on the War Fronts by American Artists for 'Life'. [Chicago: Time Inc., 1943].

War Paintings and Drawings by British Artists Exhibited Under the Auspices of the Ministry of Information, London. New York: Redfield-Kendrick-Odell, 1919.

War Pictures by British Artists: Volume 1. War at Sea. London, New York, Toronto: Oxford

University Press, 1942.

War Pictures by British Artists: Volume 2. Blitz. London: Oxford University Press, 1942.

War Pictures by British Artists: Volume 3. R. A. F. London: Oxford University Press, 1942.

War Pictures by British Artists: Volume 4. Army. London: Oxford University Press, 1942.

War Pictures by British Artists: Volume 1. Women. London: Oxford University Press, 1943.

War Pictures by British Artists: Volume 2. Production. London: Oxford University Press, 1943.

War Pictures by British Artists: Volume 3. Soldiers. London: Oxford University Press, 1943.

War Pictures by British Artists: Volume 4. Air Raids. London: Oxford University Press, 1943.

The War Veteran's Center, 1944–1948: An Experiment in Rehabilitation through Art. [New York: The War Veteran's Center, 1948].

War Zones. Vancouver: Presentation House Gallery, 2000.

We Challenge War Art: November 15 through December 4; Puma Gallery. New York: Puma Gallery, [1943].

What Artists have to Say about Nuclear War. [Atlanta, Georgia]: Nexus, Inc., c.1983.

William Orpen: Politics, Sex and Death. London: Imperial War Museum, 2005.

Witness and Legacy: Contemporary Art about the Holocaust. Minneapolis-St. Paul: Minnesota Museum of American Art, 1995.

Attributed Sources

Amishai-Maisels, Ziva. 'Art Confronts the Holocaust.' In Monica Bohm-Duchen, ed. *After Auschwitz: Responses to the Holocaust in Contemporary Art.* London: Northern Centre for Contemporary Art in association with Lund Humphries, 1995.

— 'The Complexities of Witnessing.' *Holocaust and Genocide Studies* 2, no. 1 (1987): 123–47.

Anfam, David. 'Telling Tales – Painter Philip Guston's Career Examined.' *Artforum* 41, no. 9 (May 2003): 132–9.

Anzenberger, Joseph F. ed. *Combat Art of the Vietnam War.* Jefferson, North Carolina: McFarland, 1986.

Arneson, Robert and Jonathan David Fineberg. *Robert Arneson: War Heads and Others.* New York: Allan Frumkin Gallery, c.1983.

Ardizzone, Edward. *Diary of a War Artist.* London: Bodley Head, 1974.

Atterbury, Paul. 'Dazzle Painting in the First World War.' *The Antique Collector* (April 1975).

Aurich, James, ed. *Framing the Falklands War: Nationhood, Culture and Identity.* Milton Keynes: Open University Press, 1992.

Baigell, Matthew and Julia Williams, eds. *Artists against War and Fascism: Papers of the First American Artists' Congress.* New Brunswick, New Jersey: Rutgers University Press, c.1985.

Bates, Maxwell. *A Wilderness of Days: An Artist's Experiences as a Prisoner of War in Germany.* Victoria, Canada: Sono Nis Press, 1978.

Bawden, Edward. *Edward Bawden: War Artist, and His Letters Home 1940–45.* Menston, England: Scolar Press, 1989.

Beaton, Cecil. *Production. War Pictures by British Artists.* Second Series, no. 2. London: Oxford University Press, 1943.

Benton, Thomas. *Silent Service: In Memory of U.S.S.* Dorado. Abbott Collection Paintings of the U.S. Navy Submarine Force, [n.d.].

Benton, Thomas Hart. *The Year of Peril: A Series of War Paintings by Thomas Benton.* North Chicago, 1942.

Berger, Maurice. *How Art Becomes History: Essays on Art, Society and Culture in Post New-Deal America.* New York: Harper Collins, 1992.

— *Representing Vietnam, 1965–1973: The Antiwar Movement in America.* New York: Hunter College, 1988.

Biddle, George. *Artist at War.* New York: Viking Press, 1944.

Bird, Jon, Isaak, Joanna and Sylvère Lotringer. *Nancy Spero.* London: Phaidon, 1996.

Blaikley, Ernest. 'The Lighter Side of War Art.' *Studio* 135, no. 659 (Feb. 1948): 48–51.

Bodnar, John. *Remaking America: Public Memory, Commemoration and Patriotism in the Twentieth Century.* Princeton: Princeton University Press, 1992.

Bohm-Duchen, Monica, ed. *After Auschwitz: Responses to the Holocaust in Contemporary Art.* London: Northern Centre for Contemporary Art in association with Lund Humphries, 1995.

— 'Fifty Years On.' In Monica Bohm-Duchen, ed. *After Auschwitz: Responses to the Holocaust in Contemporary Art.* London: Northern Centre for Contemporary Art in association with Lund Humphries, 1995.

Bolloch, Joëlle. *War Photography.* Paris: Musée d'Orsay, 2004.

Boorman, Derek. *At the Going Down of the Sun, British First World War Memorials.* Dunnington Hall, Yorkshire, 1988.

Borg, Alan. *War Memorials.* London, 1991.

Bourke-White, Margaret. *'Dear Fatherland, Rest Quietly': A Report on the Collapse of Hitler's 'Thousand Years.'* New York: Simon and Schuster, 1946.

— *They Called it 'Purple Heart Valley'; a Combat Chronicle of the War in Italy.* New York: Simon and Schuster, 1944.

Boyd, Arthur. *Nebuchadnezzar.* London: Thames and Hudson, 1972.

Brandon, Laura. 'Aba Bayefsky: Official War Artist.' *Canadian Military History* 10, no. 2 (spring 2001): 69–70.

— 'The Art of Pegi Nicol MacLeod.' *Garrison* 2, no. 7 (Nov. 1993): 19.

— *The Art of War.* London: Canadian High Commission, 1994.

— *Art or Memorial?: The Forgotten History of Canada's War Art.* Calgary: University of Calgary Press, 2006.

— 'Battle Lines: Canadian Artists in the Field 1917–1919.' In *Battle Lines: Canadian and Australian Artists in the Field.* Canberra: Australian War Memorial, 2001: 13–17.

— 'Behold the Hero: General Wolfe and the Arts in the Eighteenth Century.' *Canadian Book Review Annual, 1998,* (fall 1999): 302.
— 'C. Anthony Law (1916–1996): Official War Artist.' *Canadian Military History* 6, no. 1 (spring 1997): 97–100.
— 'Canada's War Art.' *Dispatch* 10 (Jan. 2000): 4.
— 'Canada's War Artists.' *Airforce* 22, no. 3 (fall 1998): 24–29.
— 'The Canadian War Memorial that Never Was.' *Canadian Military History* 7, no. 4 (autumn 1998): 45–54.
— 'The Canadian War Museum's Art Collections as a Site of Meaning, Memory, and Identity in the 20th Century.' PhD dissertation, Carleton University, 2002.
— 'Carl Schaefer, War Artist, 1903–1995.' *Canadian Military History* 4, no. 2 (autumn 1995): 88–91.
— 'Colours of War: Works on Paper from the Canadian War Museum, 1914–1945.' *Canadian Military History* 10, no. 4 (autumn 2001): 39–41.
— 'Death So Noble: Memory, Meaning and the First World War.' *Material History Review* (spring 1998): 100–101.
— 'Emotion as Document: Death and Dying in the Second World War Art of Jack Nichols.' *Material History Review* 48 (fall 1998): 123–130.
— 'Francis Hayman's 'The Charity of General Amherst': A New Acquisition for the Canadian War Museum.' *Canadian Military History* 3, no. 2 (autumn 1994): 111–112.
— 'Genesis of a Painting: Alex Colville's War Drawings.' *Canadian Military History* 4, no. 1 (spring 1995): 100–104.
— 'George Campbell Tinning: War Artist 1910–1996.' *Canadian Military History* 5, no. 2 (autumn 1996): 57–61.
— 'The Group of Seven and the Great War.' *Peindre la Grande Guerre, 1914–1918. Cahiers d'études et de recherches du musée de l'Armée, Numéro 1.* Paris: Musée de l'Armée, 2000: 113–125.
— 'History as Monument: The Sculptures on the Vimy Memorial.' *Dispatch* 11 (Jan. 2000): 4.
— 'Jack Shadbolt: Artist of War (1909–1998).' *Canadian Military History* 8, no. 3 (summer 1999): 59–61.
— 'In Memoriam: Charles Comfort, War Artist 1900–1994.' *Canadian Military History* 3, no. 2 (autumn 1994): 95–96.
— 'Lest We Forget: Memory's Fragile Hold on our History.' Ottawa *Citizen,* 3 Sept. 2005, B5.
— 'Making Memory: *Canvas of War* and the Vimy Sculptures.' In Briton C. Busch ed., *Canada and the Great War: Western Front Association Papers.* Montreal: McGill-Queen's University Press, 2003: 203–15.
— 'Memorandum on the Curating of War.' In 'A Museum of War'. *Descant* 31, no. 1 (spring 2000): 59–67.

– 'Metal Canvas: Canadians and World War II Aircraft Nose Art.' *Canadian Book Review Annual, 1999* (fall 2000): 436–437.

– 'The Mysterious Mr. Russell, A Halifax Artist Rediscovered.' *Arts Atlantic* 15, no. 1 (spring 1997): 30–33.

– 'Naming Names: The War Art of Atlantic Canada, Part One.' *Arts Atlantic* 49, vol. 13, no. 1 (spring/summer 1994): 35–37.

– 'Naming Names: The War Art of Atlantic Canada, Part Two.' *Arts Atlantic* 50, vol. 13, no. 2 (fall 1994): 31–33.

– 'Normandy Summer – D-Day and after.' *Canadian Military History* 3, no. 1 (spring 1994): 26–36.

– 'Obituaries: Paul Goranson, Michael Forster and Caven Atkins,' *Canadian Military History* 11, no. 4 (autumn 2002): 53–58.

– 'Orville Fisher: Official War Artist (1911–1999).' *Canadian Military History* 9, no. 1 (winter 2000), 56–59.

– *Paragraphs in Paint: The Second World War Art of Pegi Nicol MacLeod.* Ottawa: Canadian War Museum, 1998.

– *Pegi By Herself: The Life of Pegi Nicol MacLeod, Canadian Artist.* Montreal and Kingston: McGill-Queen's University Press, 2005.

– 'Reflections on the Holocaust: The Holocaust Art of Aba Bayefsky.' *Canadian Military History* 6, no. 2 (autumn 1997): 67–71.

– 'Resurrection: Images of Belief in Canada's War Memorials.' In Robert B. Klymasz and John Willis eds. *Revelations: Bi-Millennial Papers from the Canadian Museum of Civilization.* Mercury Series 75. Hull: Canadian Museum of Civilization, 2001: 43–52.

– 'The Second World War Paintings of Lawren P. Harris.' *Canadian Military History* 2, no. 2 (autumn 1993), 28–32.

– 'Shattered Landscape: The Great War and the Art of the Group of Seven.' *Canadian Military History* 10, no. 1 (winter 2001), 58–66.

– 'Tom Wood (1913–1997): Naval War Artist.' *Canadian Military History* 7, no. 2 (spring 1998), 65–70.

– 'A Unique and Important Asset? The Transfer of the War Art Collections from the National Gallery of Canada to the Canadian War Museum.' *Material History Review* 42 (fall 1995), 67–74.

– 'War Art.' In Gerald Hallowell, ed. *The Oxford Companion to Canadian History.* Oxford: Oxford University Press, 2004.

– 'The War Art of Maurice Cullen.' *Arts Atlantic* 66 (spring 2000): 44–47.

– 'When War Art is not History.' *Canadian Military History since the 17th Century.* Ottawa: Department of National Defence, 2001: 499–505.

– and Hugh Halliday. 'Into the Blue: Pilot Training in Canada.' *Canadian Military History* 8, no. 1 (winter 1999), 59–64.

—, Serge Durflinger and Bill McAndrew. 'Blockhaus: Fortress Europe in Photographs.' *Dispatch* 3 (Jan. 1999): 4.

— and Dean Oliver. *Canvas of War*. Vancouver: Douglas & McIntyre, 2000.

—, Peter Stanley, Roger Tolson and Lola Wilkins. *Shared Experience Art and War – Australia, Britain and Canada in the Second World War*. Canberra: Australian War Memorial, 2005.

Brothers, Caroline. *War and Photography: A Cultural History*. London and New York: Routledge, 1997.

Bruckner, D. J. R., Seymour Chwast and Steven Heller. *Art against War: 400 Years of Protest in Art*. New York: Abbeville Press, c.1984.

Brutvan, Cheryl. *Sophie Ristelhueber: Details of the World*. Boston: Boston Museum of Fine Arts, 2001.

Burroughs, William S. *Painting and Guns*. New York: Hanuman Books, 1992.

Butlin, Susan. 'Women Making Shells: Marking Women's Presence in Munitions Work, 1914–1918, the Art of Frances Loring, Florence Wyle, Mabel May, and Dorothy Stevens.' *Canadian Military History* 5, no. 1 (spring 1996), 41–48.

— 'Landscape as Memorial: A. Y. Jackson and the Landscape of the Western Front, 1917–1918.' *Canadian Military History* 5, no. 2 (autumn 1996), 62–70.

Capa, Robert. *Images of War*. New York: Grossman Publishers, 1964.

Capet, Antoine. 'The Art of War: An 'Online' Exhibition at the National Archives, London.' H-Museum, H-Net Network for Museums and Museum Studies, 2005.

Carline, Richard. *Stanley Spencer at War*. London: Faber and Faber, 1978.

Carson, Juli. 'Mea Culpa: A Conversation with Mary Kelly–Interview.' *Art Journal* 58, no. 4 (winter 1999): 74–80.

Chaney, Ward and D. Christine Clearkin. *Richard Eurich (1903–1992), Visionary Artist*. London: Paul Holberton, 2003.

Chapman, Jake and Dinos. *Hell*. London: Jonathan Cape in association with the Saatchi Gallery, 2003.

Charlesworth, Hector. 'Reflections.' *Saturday Night* (Toronto) 1919, 2.

Chicago, Judy. *Holocaust Project: From Darkness into Light*. New York: Viking, 1993.

Churcher, Betty. *The Art of War*. Melbourne: The Miegunyah Press, 2004.

Clark, Kenneth. 'War Artists at the National Gallery.' *Studio* 123, no. 586 (Jan. 1942): 2–9.

Coale, Griffith Baily. *The Navy at War: Paintings and Drawings by Combat Artists*. New York: W. Morrow, c.1943.

Coldstream, William. *Soldiers. War Pictures by British Artists*. Second Series, no. 3. London: Oxford University Press, 1943.

Colville, Alex. *Alex Colville: Images of War*. Canada: Special Artists, A–Z, 1987.

Comfort, Charles Fraser. *Artist at War*. Toronto: Ryerson Press, 1956.

— *Charles Fraser Comfort: The War Years*. Canada: Special Artists, A–Z, 1979.

Conway, Martin. *A Concise Catalogue of Paintings, Drawings and Sculpture of the First World War, 1914–1918.* London, 1963.

Cook, Deanna. *Cold War Politics: Congressman George Dondero and Jackson Pollock: A Thesis.* M.A. thesis. Bowling Green, Ohio: Bowling Green State University, 1996.

Coote, Colin. *Army. War Pictures by British Artists.* [First Series] no. 4. London: Oxford University Press, 1942.

Cork, Richard. *A Bitter Truth: Avant-Garde Art and the Great War.* New Haven: Yale University Press, 1994.

— *David Bomberg.* New Haven: Yale University Press, 1987.

— ''A Harrowing Sight': Sargent and *Gassed.*' *Arts Review Yearbook,* 1990.

— 'Suffering Into Art: Howson and Bosnia.' In *Peter Howson: Bosnia.* London: Imperial War Museum, 1994.

Cornebise, Alfred E. *Art from the Trenches: America's Uniformed Artists in World War 1.* College Station: Texas A & M University Press, c.1991.

Crampton, Robert. 'Facing Fear: Peter Howson in Bosnia.' In *Peter Howson: Bosnia.* London: Imperial War Museum, 1994.

Crane, Aimée, ed. *Art in the Armed Forces: Pictured by Men in Action.* New York: Hyperion Press, 1944.

Crawford, Vivienne. *Portraits of People at War.* 1981.

Cumming, Robert. *Artists at War 1914–1918.* Cambridge, Kettle's Yard Gallery, 1974.

Cunningham, Scott, (ed). *World War III Illustrated: Confrontational Comics.* New York: Four Walls Eight Windows, c.1995.

Darracott, Joseph and Belinda Loftus. *First World War Posters.* London: Imperial War Museum, 1972.

De Hart [-Matthews], Jane Sherron. 'Art and Politics in Cold War America.' *American Historical Review* 81, no. 4 (October 1976): 762–87.

Dickerman, Leah. *Dada.* Washington, DC: National Gallery of Art, 2005.

Eberle, Matthias. *World War I and the Weimar Artists: Dix, Grosz, Beckmann, Schlemmer.* New Haven: Yale University Press, 1985.

Eby, Kerr. *Marines in Action.* Abbott Collection. [n.d.].

Fisch, Eberhard. *Guernica by Picasso: A Study of the Picture and Its Context.* Lewisburg: Bucknell University Press, 1988.

Fisher, Marc. 'A Memorial That Doesn't Measure Up.' Washington *Post.* 4 May 2004, B1.

Foot, M. R. D. *Art and War. Twentieth Century Warfare as Depicted by War Artists.* London: Headline, 1990.

Foss, Brian. 'British Artists and the Second World War with Particular Reference to the War Artists' Advisory Committee of the Ministry of Information.' PhD dissertation. London: University College, 1991.

— '"It's Not a Bad Life Sometimes": Edward Ardizzone's Paintings and Drawings of the Second World War.' Imperial War Museum *Review* 2 (1987): 15–22.

– 'Molly Lamb Bobak: Art and War,' in *Molly Lamb Bobak: A Retrospective.* Regina: MacKenzie Art Gallery, 1993.

– '"No Dead Wood": Henry Lamb and the Canadians.' *Canadian Military History* 6, no. 2 (autumn 1997): 62–66.

– *War Paint: Art, War, State and Identity in Britain, 1939–45.* New Haven: Yale University Press, 2006.

Fredericks, Pierce G. *The Civil War as They Knew It: Abraham Lincoln's Immortal Words and Mathew Brady's Famous Photographs.* New York: Bantam Books, 1961.

Freedberg, David and Jan de Vries, eds. *Art in History, History in Art: Studies in Seventeenth-Century Dutch Culture.* Santa Monica: Getty Center, 1991.

Fry, Gavin. *George Gittoes.* Sydney: Craftsman House in association with G+B Arts International, 1998.

Fry, Gavin and Anne Gray. *Masterpieces of the Australian War Memorial.* Adelaide: Rigby, 1982.

Fussell, Paul. *The Great War and Modern Memory.* Oxford: Oxford University Press, 1977.

Gallagher, Carole. *American Ground Zero: The Secret Nuclear War* (photography) Cambridge, Mass: MIT Press, c.1993.

Geist, Anthony L. and Peter N. Carroll. *They Still Draw Pictures: Children's Art in Wartime from the Spanish Civil War to Kosovo.* Urbana, Illinois: University of Illinois Press, c.2002.

Gernsheim, Helmut. *Roger Fenton, Photographer of the Crimean War, his Photographs and his Letters from the Crimea.* London: Secker & Warburg, 1954.

Giles, Carl H. and William Feaver [text]. *Giles, Fifty Years at Work/a Cartoonist Goes to War!* London: British Council, c.1994.

Golub, Leon. *Gigantomachy: Paintings by Leon Golub.* Trenton: New Jersey State Museum, 1975.

– *Leon Golub: Mercenaries and Interrogations.* London: Institute of Contemporary Arts, c.1982.

– and Nancy Spero, *Leon Golub and Nancy Spero, War and Memory.* Cambridge, Mass.: MIT List Visual Arts Center, c.1994.

Gray, Anne. *A. Henry Fullwood: War Paintings.* Canberra: Australian War Memorial, 1983.

Greeley, Robin Adèle. *Surrealism and the Spanish Civil War: Politics and the Surrealist Imagination.* PhD dissertation. Berkeley: University of California, 1996.

Guenther, Bruce. *States of War: New European and American Paintings.* Seattle, Washington: Seattle Art Museum, c.1985.

Griffiths, Anthony, Juliet Wilson-Bareau, and John Willett. *Disasters of War: Callot, Goya, Dix.* London: Hayward Gallery, 1998.

Hall, Melissa. *Modernism, Militarism and Masculinity: British Modern Art Discourses and Official War Art During the First World War.* PhD dissertation. State University of New York at Binghamton, 1994.

Hamilton, James. *Hughie O'Donoghue: Painting, Memory, Myth.* London and New York: Merrell, 2003.

Harries, Meirion and Susie. *The War Artists. British Official War Art of the Twentieth Century.* London, 1983.

Harrington, Peter. *British Artists and War. The Face of Battle in Paintings and Prints, 1700–1914.* London and Pennsylvania: Greenhill Books and Stackpole Books, 1993.

Harrington, Peter. 'Illustrating the Last Victorian War.' *Military History Quarterly* 14, no. 4 (summer 2002): 28–33.

Harrison-Hall, Jessica. *Vietnam Behind the Lines: Images from the War, 1965–75.* Chicago: Art Media Resources, 2002.

Hart, Susan Elizabeth. *Traditional War Memorials and Postmodern Memory.* MA thesis. Montreal, Canada: Concordia University, 2000.

Harvey, A. D. *A Muse of Fire: Literature, Art and War.* London: The Hambledon Press, 1998.

Haskell, Barbara. *Claes Oldenburg: Object into Monument.* Pasadena: Pasadena Art Museum, 1971.

Haskell, Francis. *History and its Images: Art and the Interpretation of the Past.* New Haven: Yale University Press, 1993.

Hatoum, Mona. *Mona Hatoum: The Entire World as a Foreign Land.* London: Tate Gallery, 2000.

Heath, Michael. 'Well I really enjoyed that war, it was better than the one last week.' (cartoon) *The Spectator* (26 June 1982).

Hess, Elizabeth. 'Vietnam: Memorials of Misfortune.' In Williams, Reese. *Unwinding the Vietnam War: From War into Peace/edited for Washington Project for the Arts by Reese Williams.* Seattle: Real Comet Press, 1987: 262–79.

Hichberger, J.W.M. *Images of the Army.* Manchester: Manchester University Press, 1988.

Hoff, Ursula. *The Art of Arthur Boyd.* With an Introduction by T. G. Rosenthal. London: André Deutsch, 1986.

Holme, R. 'British Artists Paint the War.' *Studio* 120 (Nov. 1940): 146–55.

Holzer, Jenny and Contemporary Arts Museum. [organized by Lynn M. Herbert] *Jenny Holzer, Lustmord.* Houston, Texas: Contemporary Arts Museum, c.1997.

Hopkinson, Amanda. 'Introduction,' in Kennard, *Dispatches from an Unofficial War Artist.* Aldershot: Lund Humphries, 2000.

Hunt, William Holman. *Pre-Raphaelitism and the Pre-Raphaelite Brotherhood,* vol. II. London: Macmillan, 1905.

Hunter, T. Murray. *Canada at Dieppe.* Ottawa: Canadian War Museum, National Museums of Canada, 1982.

Hyndman, Robert Stewart. *R. C. A. F. Overseas: A Display of Paintings in Oil and Water-Colours.* Canada: Special artists, A–Z. [n.d.].

Hynes, Samuel. *A War Imagined: The First World War and English Culture.* London, 1990.

Inglis, K. 'Men, Women and War Memorials.' *Daedalus* 116, no. 4 (1987): 35–59.

Inglis, K. S. *Sacred Places: War Memorials in the Australian Landscape.* Melbourne: Miegunyah Press, 1998.

Jaar, Alfredo. *Let There be Light: The Rwanda Project 1994-1998.* Barcelona, Spain: Centre d'Art Santa Monica, 1998.

— and Debra Bricker Balkan. *Alfredo Jaar: Lament of the Images.* Cambridge, Mass: MIT List Visual Arts Center, 1999.

Jackson, Alan. *A Different Man: Peter Howson's Art, from Bosnia and Beyond.* Edinburgh: Mainstream Publishing, 1997.

Johnson, Ken. 'Art and Memory.' *Art in America* 81, no. 11 (Nov. 1993): 90-99.

Johnson, Peter. *Front Line Artists.* London: Cassell, 1978.

Jones, Barbara and Bill Howell. *Popular Arts of the First World War.* London, 1972.

Kahn, Elizabeth Louise. *The Neglected Majority: 'Les Camoufleurs,' Art History, and World War I.* Lanham, Maryland: University Press of America, c.1984.

Keane, John. *John Keane: 'Bee Keeping in the War Zone': Paintings of Nicaragua: 4-26 March 1988.* London: Angela Flowers Gallery, [1988].

Keegan, John and Joseph Darracott. *The Nature of War.* New York: Holt, Rinehart and Winston, 1981.

Kennard, Peter. *Dispatches from an Unofficial War Artist.* Aldershot: Lund Humphries, 2000.

— *GLC Peace Posters: Despatches from an Unofficial War Artist, Photomontages by Peter Kennard.* London: Greater London Council [GLC], c.1983.

Kerin, James R. Jr. *The Korean War and American Memory.* PhD dissertation. University of Pennsylvania, 1994.

King, Alex. *Memorials of the Great War in Britain: The Symbolism and Politics of Remembrance.* Oxford: Berg, 1998.

Kirstein. Lincoln. *American Battle Painting, 1776-1918.* New York; The Museum of Modern Art, [1944].

Kitson, Linda. *The Falklands War: A Visual Diary.* London: Mitchell Beazley, 1982.

Knight, Laura. 'An Artist in the Nuremberg Courtroom.' *Listener* 35, no. 892 (14 Feb. 1946): 199.

— *Women: War Pictures by British Artists.* Second Series; no. 1. London: Oxford University Press, 1943.

Kohlhöfer, Christof, Peter Kuper, and Seth Tobocman. *World War Three Illustrated.* N. Y. C.: S. Tobocman, P. Kuper, C. Kohlhöfer, 1980-c.1994.

Konody, P. G. *Art and War: Canadian War Memorials.* London: Colour, n.d.

— *Modern War: Paintings by C. R. W. Nevinson.* London, 1917.

Kunze, Max. *The Pergamon Altar: Its Rediscovery, History and Reconstruction.* Berlin: Staatliche Museen zu Berlin, 1991.

Leighten, Patricia. 'Picasso's Collages and the Threat of War, 1912-13.' *The Art Bulletin* (Dec. 1985).

Kuspit, Donald B. 'Uncivil War.' *Artforum* 21, no. 8 (April 1983) 34–43.

Lachin, Tersa Bohan. *'War and Remembrance': The War Memorial as Cultural Artifact.* Detroit: Ann Arbor UMI. [n.d].

Landau, Ellen G. *Artists for Victory.* Washington: Library of Congress, 1983.

Lane, James. W. 'Mars and Ars Britannica: England Expects Every Artist to Do His Duty.' *Art News* 40 (Aug. 1941) 13,17, 28.

Lewinski, Jorge. *The Camera at War: A History of War Photography from 1848 to the Present Day.* London: W. H. Allen & Co., 1978.

Lewison, Jeremy, ed. *Käthe Kollwitz 1886–1945 The Graphic Works.* Cambridge: Kettle's Yard Gallery, 1981.

Libeskind, Daniel. 'Trauma.' in Hornstein, Shelley and Florence Jacobowitz. *Image and Remembrance: Representation and the Holocaust.* Bloomington and Indianapolis: Indiana University Press, 2003.

Lindey, Christine. *Art in the Cold War: from Vladivostok to Kalamazoo, 1945-1962.* London: Herbert Press, 1990.

Lloyd, Jill. 'Otto Dix–War'. *A Cycle of Etchings by Otto Dix.* London: Goethe Institute, 1988.

Maclear, Kyo. *Beclouded Visions: Hiroshima-Nagasaki and the Art of Witness.* Albany, NY: State University of New York Press, c.1999.

Mahood, Ken. 'A Bigger Splash Somewhat Outside the Total Exclusion Zone.' (cartoon) *Punch* (2 March 1983).

Mallory, Keith, and Arvid Ottar. *The Architecture of War.* New York: Pantheon Books, [1973].

Malvern, Sue. *Modern Art, Britain and the Great War: Witnessing, Testimony and Remembrance.* New Haven: Yale University Press, 2004.

– 'War As It Is: The Art of Muirhead Bone, C. R. W. Nevinson and Paul Nash, 1916–17.' *Art History Magazine* 9, no. 4 (Dec. 1986): 487–515.

Marcoci, Roxana. *Site of Contestation: Constantin Brancusi's World War I Memorial.* PhD dissertation. New York University, Graduate School of Arts and Science, 1998.

Mayo, James M. *War Memorials as Political Landscape: The American Experience and Beyond.* New York: Praeger, 1988.

McClone, Jackie. 'The Art of War,' Glasgow *Sunday Herald* (30 April 2000): 12–15.

McCloskey, Barbara , *Artists of World War II,* Westport, CT.: Greenwood, 2005.

McCormick, Ken and Perry, Hamilton Darby, eds. *Images of War: The Artist's Vision of World War II.* New York: Orion Books, 1990.

McDonald, Katherine. *Raymond Arnold: Double Camouflage / Hymen Skins.* Australian Galleries, 1999.

McGreevy, Linda F. *Bitter Witness: Otto Dix and the Great War.* New York: P. Lang, c.2001.

McKernan, Michael. *Here is Their Spirit: A History of the Australian War Memorial, 1917–1990.* St. Lucia and Canberra: University of Queensland Press and the Australian War Memorial, 1991.

McLean, Ann Hunter. *Unveiling the Lost Cause: A Study of Monuments to the Civil War Memory in Richmond, Virginia, and Vicinity.* PhD dissertation. University of Virginia, 1998.

Metson, Graham and Cheryl Lean. *Alex Colville: Diary of a War Artist.* Halifax: Nimbus Publishing, 1981.

Michalski, Sergiusz. *Public Monuments: Art in Political Bondage 1870–1997.* London: Reaktion, 1998.

Michaud, Eric. *The Cult of Art in Nazi Germany.* Trans. by Janet Lloyd. Stanford: Stanford University Press, 2004.

Milton, Sybil and Ira Nowinsky. *In Fitting Memory: The Art and Politics of Holocaust Memorials.* Detroit: Wayne University Press, 1992.

Minear, Richard H. *Dr. Seuss Goes to War: The World War II Editorial Cartoons of Theodor Seuss Geisel.* New York: New Press, c.1999.

Mitchell, Mary Elizabeth. *The Paint and Clay Corner: A Wartime Service by the Newark Museum at Camp Kilmer, New Jersey, 1943–1944.* Newark, N.J., 1944.

Monson, R. *A Selection of Australian War Memorial Paintings with the Story of the Artists.* Sydney, 1971.

Moore, Jake. *Yellow, No Sleep at Night: A Site Specific Installation by Jake Moore.* Banff, Alberta, Canada: Walter Phillips Gallery, [2000].

Morris, Jerrold. *Canadian Artists and Airmen, 1940–45: A Wartime Memoir.* Toronto: Morris Gallery, [1974].

Mount, Charles Serrill. *John Singer Sargent: An Autobiography.* London: Crescent Press, 1957.

Murray, Joan. *Canadian Artists of the Second World War.* Oshawa: The Robert McLaughlin Gallery, 1981.

Nash, Paul. *Outline: An Autobiography and Other Writings.* London: Faber and Faber, 1949.

Newton, Eric. *Art for Everybody.* London: Longmans Green, 1943.

— *War Through Artists' Eyes: Paintings and Drawings by British War Artists.* London: John Murray, 1945.

Nisbet, Peter, ed. *Anselm Kiefer: The Heavenly Palaces, Merkabah.* Cambridge, Mass.: Harvard University Press; New Haven: Yale University Press, 2003.

Orde, Cuthbert. *Pilots of Fighter Command: Sixty-four Portraits.* London: George P. Harrap & Company, 1942.

Overy, Paul. 'The New Works of Rasheed Araeen.' In *Rasheed Araeen.* London: South London Gallery, 1994.

Paret, Peter. *Art as History: Episodes in the Culture and Politics of Nineteenth-Century Germany.* Princeton: Princeton University Press, 1988.

— *Imagined Battles: Reflections of War in European Art.* Chapel Hill: University of North Carolina, 1997.

Paris, Michael. *Warrior Nation: Images of War in British Popular Culture, 1850–2000.* London: Reaktion, 2000.

Pearce, Herbert. 'War Pastels by Eric Kennington.' *Studio* 123, no. 586 (July 1943): 16–21.

Peters-Corbett, David. *Wyndham Lewis and the Art of Modern War.* Cambridge, New York: Cambridge University Press, 1998.

Peake, Mervyn. *Titus Groan.* London: Eyre, 1946.

Peck, Glenn C. and Gordon K. Allison. *George Bellows and the War Series of 1918.* New York, 1983.

Penny, Nicholas. 'English Sculpture in the First World War.' *Oxford Art Journal*, November 1981.

Peress, Gilles. *Farewell to Bosnia.* Scalo; New York, 1994.

Perspex. 'Art Notes: The Stimulus of War.' *Apollo* 37 (1943): 44–45, 55.

Phillips, Christopher and Patrick. *Nash and Nevinson in War and in Peace: The Graphic Work 1914–1920.* London, Alpine Club Gallery, 1977.

Picasso, Pablo, Steven A. Nash, Robert Rosenblum, Brigette Baer et al. *Picasso and the War Years, 1937–1945.* New York: Thames and Hudson; [San Francisco]: Fine Arts Museums of San Francisco, 1998.

Pick, Daniel. *War Machine: The Rationalisation of Slaughter in the Modern Age.* New Haven: Yale University Press, 1993.

Pittore, Carlo, and Broccoli Bunch. *Alert & Spread: International Non-Violent Campaign to Initiate Talks to Resolve All Problems in the Middle East Now.* Bowdoinham, Maine: Broccoli Bunch, Abraham Lincoln Brigade, [1991].

Polcari, Stephen. *From Omaha to Abstract Expressionism: American Artists Respond to World War II.* New York: Baruch College, 1995.

Prez, James. *War/James L. Prez.* [S.l.: s.n.], 1991.

Rawls, Walton H. *Wake Up, America!: World War I and the American Poster.* New York: Abbeville Press, c.1988.

Reep, Edward. *A Combat Artist in World War II.* Lexington: University Press of Kentucky, [1987].

Reynolds, Francis J. *Collier's New Photographic History of the World's War: Including Sketches, Drawings and Paintings made by Artists at the Front.* New York: P. F. Collier, c.1919.

Rhodes, Anthony. *Propaganda: The Art of Persuasion: World War II.* New York: Chelsea House Publishers, 1976.

Richmond, Herbert William. *War at Sea: War Pictures by British Artists.* [First Series]; no. 1, London: Oxford University Press, 1942.

Ristelhueber, Sophie. *Aftermath: Kuwait 1991.* London: Thames and Hudson, 1992.

– *West Bank.* London: Thames and Hudson, 2005.

Roberts, William. *Memories of the War to End War 1914–18.* London: Canada Press, 1974.

Robertson, Heather, ed. *A Terrible Beauty: The Art of Canada at War.* Toronto: J. Lorimer, 1977.

Roeder, George H. (Jr.). *The Censored War: American Visual Experience during World War II.* New Haven: Yale University Press, 1993.

Rosenthal, Nan. *Anselm Kiefer: Works on Paper in the Metropolitan Museum of Art.* New York: The Museum, c.1998.

Ross, Alan. *Colours of War: War Art 1939–45.* London: Jonathan Cape, 1983.

Rothenstein, John. 'Paul Nash as War Artist.' In Margot Eates, ed. *Paul Nash: Paintings, Drawings and Illustrations.* London: Lund Humphries, 1948.

– 'War and the Artist.' *Apollo* 37, no. 5 (May 1943): 111–13.

Ruskin, John. *St. Mark's Rest: The History of Venice.* Kent: William Allen, 1877.

Rutberg, Jack V. *Hans Burkhardt, the War Paintings: a Catalogue Raisonné.* Northridge, California: Santa Susana Press, c.1984.

Sacco, Joe. *Palestine.* Seattle: Fantagraphics, 1996.

– *Safe Area Gorazde: The War in Eastern Bosnia 1992–95.* Seattle: Fantagraphics, 2000.

Seago, Edward. *Peace in War.* London: Collins, 1943.

Seddon, Richard. 'War Art of the Past.' *Studio* 125, no. 603 (June 1943): 161–72.

Senie, Harriet. *Contemporary Public Sculpture: Tradition, Transformation, and Controversy.* New York: Oxford University Press, 1992.

Sherman, Daniel J. *The Construction of Memory in Interwar France.* Chicago: The University of Chicago Press, 1999.

Shipley, Robert. *To Mark Our Place: A History of Canadian War Memorials.* Toronto: NC Press, 1987.

Sillars, Stuart. *Art and Survival in the First World War Britain.* London, Macmillan, 1987.

Silver, Kenneth E. *Esprit de Corps. The Art of the Parisian Avant-Garde and the First World War, 1914–1925.* Princeton: Princeton: Princeton University, 1989.

Sinaiko, Eve, and Anthony F. Janson. *Vietnam: Reflexes and Reflections: The National Vietnam Veterans Art Museum.* New York: H.N. Abrams, c.1998.

Skipwith, Peyton. 'Bombardment of the Coast near Trapani, Sicily, by HMS *Howe* and *King George V*, 12 July 1943.' In Ward Chaney and D. Christine Clearkin. *Richard Eurich (1903–1992), Visionary Artist.* London: Paul Holberton, 2003.

– 'Foreword.' *The Art of War 1914–1918. Wyndham Lewis, Paul Nash, C. R. W. Nevinson, William Roberts.* London: The Morley Gallery, 1971.

Smith, David, and Lewison, Jeremy et al. *David Smith: Medals for Dishonor 1937–1940.* [Leeds]: Henry Moore Centre for the Study of Sculpture, Leeds City Art Galleries, 1991.

Smith, Levi P. III. *Objects of Remembrance: The Vietnam Veterans Memorial and the Memory of the War.* PhD dissertation. The University of Chicago, 1997.

Solkin, David H. *Painting for Money.* New Haven: Yale University Press, 1993.

Sontag, Susan. 'Looking at War.' *The New Yorker* (9 Dec. 2002) 82–98.

Speck, Cathy. *Painted Ghosts: Australian Women Artists in Wartime.* Melbourne: Craftsman House, Thames and Hudson, 2004.

Spender, Stephen. *Air Raids. War Pictures by British Artists.* Second Series, no. 4. London: Oxford University Press, 1943.

Spero, Nancy. *Nancy Spero: The War Series.* Milan: Charta, c.2003.

Spiegelman, Art. *In the Shadow of No Towers.* New York: Pantheon, 2003.

— *Maus: And Then My Troubles Began.* New York: Pantheon, 1986.

— *Maus: A Survivor's Tale.* New York: Pantheon, 1991.

Stacey, C. P. *Dictionary of Canadian Biography,* vol. 4. Toronto: University of Toronto Press, 1979.

Stanley, Peter. *What Did You Do in the War, Daddy? A Visual History of Propaganda Posters.* Melbourne and New York: Oxford University Press, 1983.

Stansky, Peter, and William Miller Abrahams. *London's Burning: Life, Death and Art in the Second World War.* Stanford, California: Stanford University Press, 1994.

Steadman, Ralph. 'Flies on Meat.' (cover) *New Statesman* (14 May 1982).

Steichen, Edward, Christopher Phillips, and the United States Naval Aviation Photographic Unit. *Steichen at War.* New York: Abrams, 1981.

Storr, Robert. 'The Weapon and the Wounded,' in Spero, Nancy. *The War Series.* Milan: Charta, c.2003.

Strecker, Jacqueline. 'Australian Artists Paint the War.' In *Battle Lines: Canadian & Australian Artists in the Field, 1917–1919.* Canberra: Australian War Memorial, 2001: 20–22.

Sturken, Marita Louise. *Cultural Memory and Identity Politics: The Vietnam War, Aids, and Technologies of Memory.* PhD dissertation. University of California, Santa Cruz, 1992.

Sugarman, Martin A. *God Be With You: War in Croatia and Bosnia-Herzegovina: Photographs.* Malibu, California: Sugarman Productions, c.1993.

Sujo, Glenn. *Legacies of Silence: The Visual Arts and Holocaust Memory.* London: Philip Wilson Publishers, 2001.

Sullivan, George. *Mathew Brady: His Life and Photographs.* New York: Cobblehill Books, c.1994.

Sutro, Sarah. *Act Against Nuclear War.* [Mass.?: s.n.], c.1983.

Tassi, Roberto. *Sutherland: The Wartime Drawings.* London: Sotheby Parke Bernet, 1979.

Thé, Robert. *Under Fire.* [1994].

Thompson, Vivian Alpert. *A Mission in Art: Recent Holocaust Works in America.* Macon, Georgia: Mercer University Press, 1988.

Thomas, C. David. *As Seen By Both Sides: American and Vietnamese Artists Look at the War.* Boston: Mass: Indochina Arts Project, William Joiner Foundation; Amherst, MA: Distributed by the University of Massachusetts Press, 1991.

Tillmans, Wolfgang. *Soldiers, the Nineties.* Köln: W. König, c.1999.

Tippett, Maria. *Art at the Service of War: Canada, Art and the Great War.* Toronto: University of Toronto Press, 1984.

— *Lest We Forget*. London, Ontario. London Regional Art Gallery and Museum, 1989.

Toll, Nelly. *When Memory Speaks: The Holocaust in Art*. Westport, Conn.: Praeger, 1998.

— *Without Surrender: Art of the Holocaust*. Philadelphia: Running Press, 1978.

Tolson, Roger. 'A Common Cause: Britain's War Artists Scheme.' In *Shared Experience: Art and War, Australia, Britain and Canada in the Second World War*. Canberra: Australian War Memorial, 2005: 43–53.

Topolski, Feliks, and James Laver. *Britain in Peace and War*. London: Methuen & Co. Ltd., 1941.

Twombly, Cy, Richard Howard, and Kirk Varnedoe. *Cy Twombly, Lepanto: a Painting in Twelve Parts*. New York: Gagosian Gallery, c.2002.

Unrau, Don, and Jeffrey Hoone. *Don Unrau: Vietnam, War Stories and Meditations: August 26-October 23, 1994*. Syracuse, N. Y.: [Robert B. Menschel Photography Gallery], Schine Student Center, Syracuse University, [1994].

Usherwood, Paul and Jenny Spencer-Smith. *Lady Butler: Battle Artist 1846–1933*. London: National Army Museum and Alan Sutton, 1987.

Varga, Margit. 'Britain Mobilizes Her Artists. What about America?' *Magazine of Art* 34, no, 6 (June–July 1941): 298–303.

Vaughan, Keith. 'War Artists and the War.' *Penguin New Writing* 16 (March 1943): 108–17.

Viney, Nigel. *Images of Wartime. British Art and Artists of World War I. Pictures from the Collection of the Imperial War Museum*. Newton Abbot, Devon: David & Charles, 1991.

Weber, John Paul. *The German War Artists*. Columbia, S.C.: Cerberus Book Co., c.1979.

Weber, John Pitman, and Shifra M. Goldman. *John Pitman Weber: Art of Social Conscience: a Mid-Career Retrospective in Three Parts: The War Images, 1967–73, Images of Conscience, 1977–83, Signs of a Journey, 1986–91*. Valparaiso, Ind.: Valparaiso University Museum, 1991.

Weight, Angela. *John Keane: Gulf*. London: Imperial War Museum, 1992.

— 'The Kensingtons at Laventie – a Twentieth Century Icon.' *Imperial War Museum Review*, no. 1, 1986.

— 'War Art or War Record?' *National Art Collections Fund* (spring 1995): 34–37.

Werner, Hans. 'Nothing Phoney: from his War Paintings Onward, Alex Colville's Art Wrestles Order out of Chaos.' *Canadian Art Magazine* 4, no. 3 (fall 1987): 70–77.

Wheeler, Monroe, ed. *Britain at War*. New York: Museum of Modern Art, 1941.

White, A. Seaton. 'The President's Address: 'Art and War.'' *National Society of Art Masters Journal* 13, no 3 (Jan. –Feb. 1941) 49–54.

Whittock, Arnold. *War Memorials*. London, 1946.

Wilcox, Tim. '"We are all Falklanders Now": Art, War and National Identity.' In Aurich, *Framing the Falklands War: Nationhood, Culture and Identity*. Milton Keynes: Open University Press, 1992.

Wilkinson, Norman. "The Dazzle Painting of Ships' 10 July 1919.' Reprinted in *Camouflage*. Scottish Arts Council: Edinburgh and London, 1988.

Williams, Val. *Warworks: Women, Photography and the Iconography of War.* London: Virago, 1994.

Wodehouse, R. F. 'The Canadian War Memorials Collection at Ottawa.' *Studio International* (Dec. 1968) 235.

— *A Check List of the War Collections.* Ottawa: National Gallery of Canada, 1968.

— 'David Milne: 1918–19. Art and War.' *National Gallery of Canada Bulletin*: (1963): 18–23.

— 'Orpen Portraits in the Canadian War Memorials Collection.' *National Gallery of Canada Bulletin* (1965) 20–31.

Yarborough, Bessie Rainsford. *Exhibition Strategies and Wartime Politics in the Art and Career of Edvard Munch, 1914–21.* PhD dissertation. University of Chicago, 1995.

Young, James E. *At Memory's Edge: After-Images of the Holocaust in Contemporary Art and Architecture.* New Haven: Yale University Press, 2000.

— 'Memory and Counter-Memory: Towards a Social Aesthetic of Holocaust Memorials.' In Monica Bohm-Duchen, ed. *After Auschwitz: Responses to the Holocaust in Contemporary Art.* London: Northern Centre for Contemporary Art in association with Lund Humphries, 1995.

— *The Texture of Memory: Holocaust Memorials and Meaning.* New Haven: Yale University Press, 1993.

Index